CREATIVE
PORTRAIT
PHOTOGRAPHY

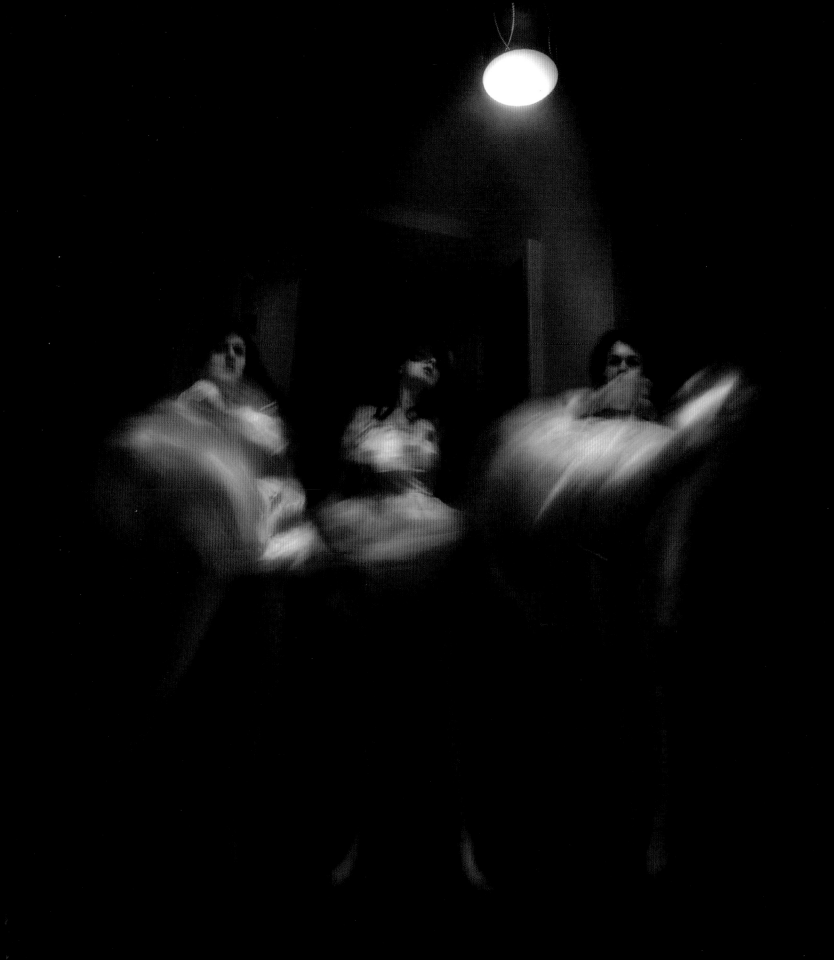

NATALIE DYBISZ

a.k.a. MISS ANIELA

CREATIVE
PORTRAIT
PHOTOGRAPHY

An Imprint of Sterling Publishing Co., Inc.
New York

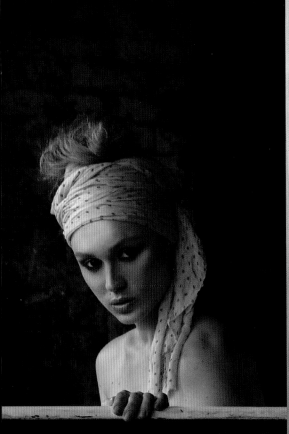

Creative Portrait Photography

Library of Congress Cataloging-in-Publication Data

Dybisz, Natalie, 1986-

 Creative Portrait Photography / Natalie Dybisz.

 pages cm

 ISBN 978-1-4547-0403-4 (pbk.)

 1. Portrait photography—Handbooks, manuals, etc.
I. Title.

 TR575.D93 2012

 779--dc23

 2011048327

10 9 8 7 6 5 4 3 2 1
First Edition
Published by Pixiq
An Imprint of Sterling Publishing Co., Inc.
387 Park Avenue South, New York, N.Y. 10016
© The Ilex Press Limited 2012
This book was conceived, designed, and
produced by:
ILEX, 210 High Street, Lewes,
BN7 2NS, United Kingdom

All photographs in this book are copyright
Natalie Dybisz unless otherwise noted.
Photographs featured in the *Artist Showcase*
chapter are copyright to featured
photographers as noted.

Cover image: *Raven* by Miss Aniela.
Model: Andria Aletrari. Dress by Lenka
Padysakova. Styling by Villy Kontonikolaki,
makeup by Krystalo, hair by Hellie Last.

Distributed in Canada by Sterling Publishing,
c/o Canadian Manda Group, 165 Dufferin Street
Toronto, Ontario, Canada M6K 3H6

Every effort has been made to ensure that
all the information in this book is accurate.
However, due to differing conditions, tools,
and individual skills, the publisher cannot be
responsible for any injuries, losses, and other
damages that may result from the use of the
information in this book. Because specifications
may be changed by the manufacturer without
notice, the contents of this book may not
necessarily agree with software and equipment
changes made after publication.

If you have questions or comments about
this book, please contact:
Pixiq, 67 Broadway, Asheville, NC 28801
(828) 253-0467

Manufactured in China
All rights reserved
ISBN: 978-1-4547-0403-4

For information about custom editions,
special sales, premium and corporate
purchases, please contact Sterling Special
Sales Department at 800-805-5489 or
specialsales@sterlingpub.com. For
information about desk and examination
copies available to college and university
professors, requests must be submitted
to academic@sterlingpublishing.com.
Our complete policy can be found at
www.larkbooks.com (about/contact).

CONTENTS

INTRODUCTION

WHEN INTRODUCING A SUBJECT AS VAST AS PORTRAITURE, it is necessary to define this type of photography, and how this book relates to such a long tradition of art. A portrait is defined as a display of the likeness of a person or a group of people, but the meaning of portraiture and the artistic role it plays depends on the context of the piece itself. In short, why do we make portraits at all, and who are they for?

The meaning of portraiture all comes down to its aim. A portrait can be created for the subject or sitter themselves, for another client, or for the photographer's own purposes. My own beginnings in photography were synonymous with self-portraiture. I used myself to provide a human element within scenes lit with improvised light sources to show something I wasn't entirely sure of at the outset, sometimes fuelled by a subconscious personal or emotional motive that was later interpreted in different ways by different viewers. As I progressed I worked with other models, not just to counteract certain restrictions in using myself, but to diversify—to photograph different bodies and faces, and to engage in the new shooting experiences that photographing others provides. I have created portraits of other people that reflect their purposes, my own purposes, and sometimes a mixture of both. A portrait can exist to tell, to show, or simply to display a semblance in the most observational sense. In documentary photography, a portrait can appear to be a chance encounter with another human being that gives the impression that the photographer has seized the moment and recorded the subject's appearance "just as it is." Driven by a desire to record real people in their element—candid or semi-candid, unstyled, trendily deadpan, dishevelled even—these photographers seek to make a statement about that particular person or their situation. Portraits can also be fictional and contrived. In what is known as *tableaux vivant* ("living pictures"), photographic portraiture can almost cross over into the realm of painting, giving a result that elevates and embellishes the subject. If we keep moving in the direction of this extreme we come to fashion photography, where the subject becomes literally a "model:" an actor posing for a commercial purpose, styled and made up appropriately, polished to represent perfection in order to sell something.

Throughout the winding path of my photography career so far I have encountered a tension between the two extremes: I want my images to be bold and striking (maybe with the help of a stylist or a specially selected location), but I also want a story to unfold organically, and a sense of candidness and naturally-occurring juxtapositions to develop. I don't want everything falsified, and I want some spontaneity to seep into the process. It's no accident then that a lot of my early self-portraits weren't necessarily created with a heavily storyboarded masterplan. Though the situations were set up specifically to be photographed, they were also open to numerous chance events during the process and therefore relied heavily on my own instincts.

This book is structured using stories rather than technique because, as all artists know, artmaking often does not follow a linear path. The creation of photographic portraiture hinges upon the efforts we make to fuse preparation, location, inspiration, and model to create more than just a replica of what we see before us: to allow something alchemical to happen between the model and photographer—something more than just a click of the shutter. All of my pictures have had these key moments occur during both the shooting and processing, and they have all had different, unique processes of coming about. The stories in this book are divided according to environment: natural, urban, and those shot in regular interiors. At the same time, this division is not entirely rigid, and there are overlaps: it simply gives focus to the sense of adventure involved in moving from one location to the next. For instance, some images would work well in the nature chapter as well as the urban, and some images span both.

This book provides a different look at portraiture as we conventionally know it, and there are very few ordinary headshots or standard likenesses that might be encountered in formal portrait photography. This book is devoted to exploring portraiture at its most creative—that is, to portraits with context, story, and constructed elements. The contributors have been carefully chosen to showcase a new generation of artists whose representations of the human being are uncommonly imaginative: from the conceptual thinking behind the subtle nuances in the work of Susannah Benjamin, to the fairytale *tableaux* of Kirsty Mitchell's *Wonderland* and its hand-crafted props.

This book offers something different to the world of contemporary portrait photography: a fusion of the often sober messages found in sophisticated contemporary photography with the wider appeal, sheen, and visual arrest of mainstream portraiture found in various facets of commercial photography.

▶ **MARIA (2010)**
Model Maria Procopi, from a shoot in Hackney, East London (see more images on pages 68–71). The use of location, costume, color, close-up, and pose all contribute to this slightly quirky fashion portrait.

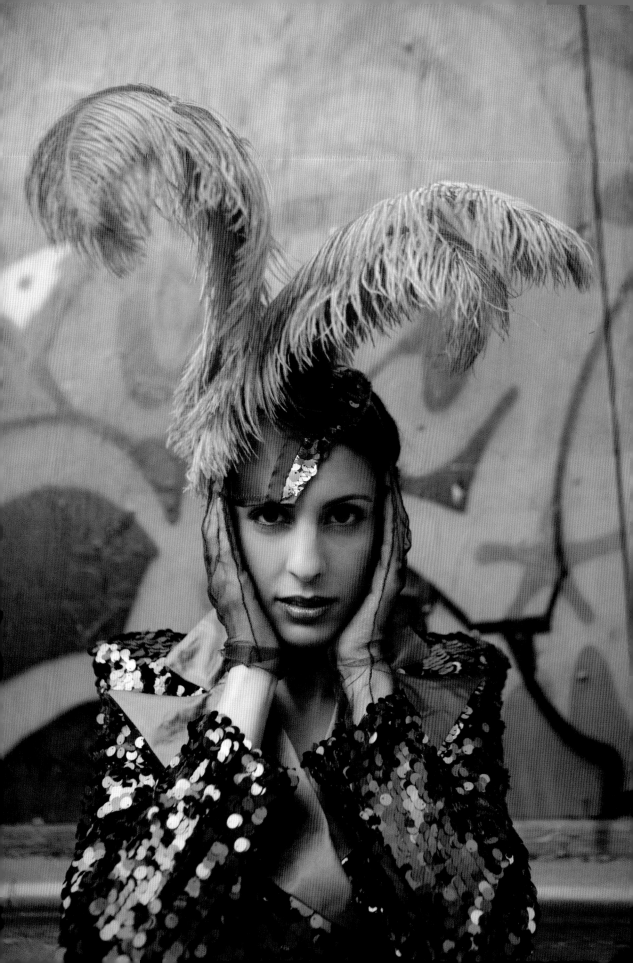

CHAPTER 1
APPROACHING PORTRAITURE

THERE IS PORTRAITURE THAT EXPRESSES YOU, PORTRAITURE THAT EXPRESSES THE SUBJECT, AND PORTRAITURE THAT EXPRESSES BOTH. WHILE PORTRAITURE IS ALL ABOUT THE HUMAN CONDITION, WHETHER WE SHOOT A CONTRIVED IMAGE OR A SUBJECT "UNPOSED," ALL PHOTOGRAPHY IS A FORM OF MEDIATION. UNDERSTANDING OUR OWN DIRECTION IN PORTRAITURE REQUIRES US TO SHOOT AS MUCH AS WE CAN, WHATEVER KIND OF PORTRAITURE THAT MAY BE, TO DISCOVER WHAT WE MOST DESIRE.

THE SAYING "practice makes perfect" can be applied to photography, even though the words themselves are somewhat inappropriate. The word "practice" seems to imply working in private on your photography, only to expose the finished product to judgement in a world where there is no one judge. The word "perfect" wrongly suggests that we should seek an infallible quality, which is simply impossible due to the subjectivity of art. Instead, it's your own "practice," as in your own act of "doing," that performed on a regular basis, brings together your ambitions with reality. The more you physically create work, the more you will learn—not only about the technically skilled aspects of photography—but about your own approach, which really is the key to developing your own workflow as an artist.

The more I shoot, the more I realize that there are certain qualities I seek in an image, and the better I become at recognizing those needs earlier on. These qualities include depth, motion, and lighting, all of which I talk about in this chapter. However, it is inaccurate to assume that the more experienced you get at photography, the quicker you will get at taking a photo idea from concept to execution. There will always be surprises, and that is in the very nature of art. One of my most important lessons in growing as a photographer was in accepting idiosyncratic elements of my own approach, much of which involves embracing unpredictability; a quality I thought might seem amateurish compared to other photographers. I realised that my approach was already representational of my methods, and in a manner of speaking, already

level with other photographers, who are equally imperfect. The fact is that others will always seem to be one step ahead, but this perspective is a fallacy; like an observer charting a plane's progress across the sky, from the outside it seems quiet, peaceful, and serene. However, viewed from the inside it reveals a rickety, unstable interior with any number of uncomfortable conditions for the traveller. Other photographers' methods will always differ, but are not inherently inferior or superior to your own. They are simply irrelevant—a comforting self-assuring reminder that, in a sense, you are your own artist (though of course we can always cherry-pick tips and pointers from others).

In this chapter I also address the importance of editing, but not merely in terms of Photoshop adjustments. The images on-camera are an unrefined set that can be meaningless; the selection process—choosing an image from a set of possibly hundreds of others—needs as much artistic thought and direction as the shooting stage. It is no different to adding another layer of brushstrokes to a painting, or shaping the detail on a sculpture. The processing we now perform on computers is akin to the image retouching and enhancements that were possible in the days of the darkroom, but the accessibility of digital photography means the possibilities are almost endless, and the tools available increasingly sophisticated.

▶ **WITHOUT MY UMBRELLA (2010)**
This is a self-portrait shot in the garden of a London house one happy solitary morning. Using the water from the hose that took on the appearance of rain, I conveyed the mood of a spring shower: rejuvenation and a new beginning.

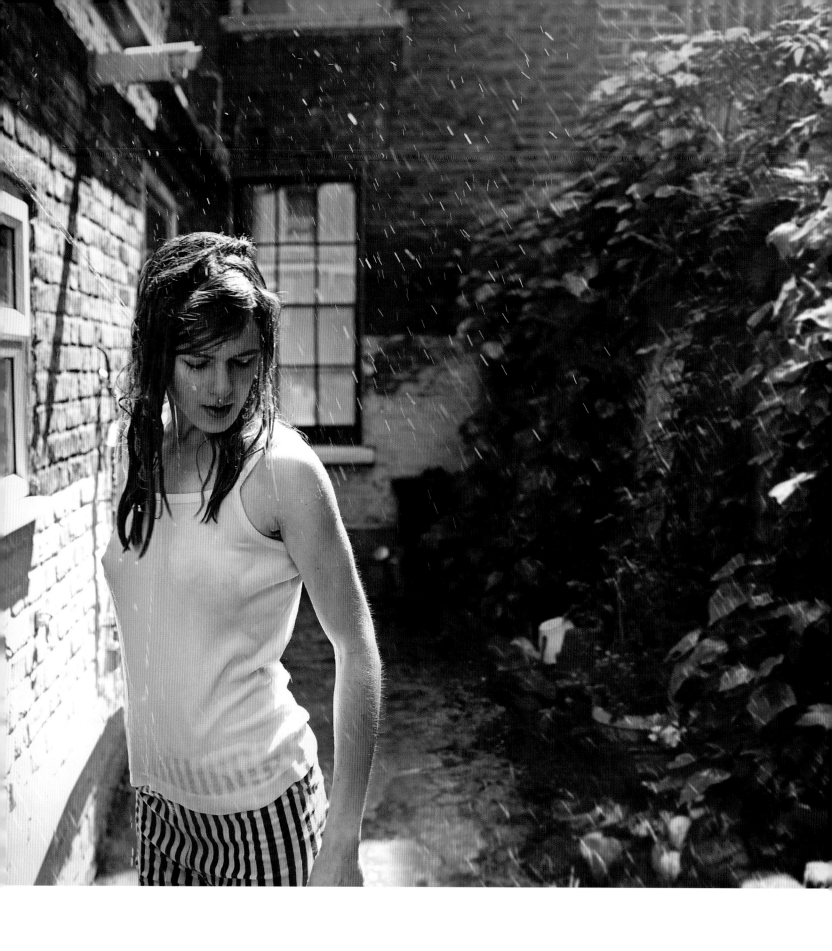

THE PORTRAITIST AS ARTIST

PHOTOGRAPHY IS A POWERFUL MEDIUM, AND REPRESENTS MANY THINGS TO DIFFERENT PEOPLE. MOST OF AN IMAGE'S POTENTIAL FOR IMPACT IS COMPLETELY DEPENDENT ON THE VIEWER'S OWN TASTE, EXPERIENCES, AND EXPECTATIONS.

PHOTOGRAPHY IS AN ART, and while society seems to find it immensely difficult to define art, it really needn't be as complex or debatable. Forget everyone and everything else for a moment—art is whatever the artist says it is, whether it is liked or not, bought or not, esteemed or not.

The artistic form of photography is one that is often confusing because it is so bound up with the science of making a photograph. Having struggled for decades to be recognized as an art form, not all photography produced is intended to be enjoyed as art. This book is specifically about portrait photography as art, which means that all of the images within this book have been produced with that intent in mind. Even in the photography that was produced for commercial purposes there was something more than simply copying a semblance of a person; there was the wish, however subtle, to move the viewer.

There are innumerable different genres within photography, and yet "photography" is often discussed so generally, with most debates about photography occurring as a result of confusion around different purposes of the photographic image. For example, while one commercial photographer might use careful technique to light a subject to its most realistic semblance—for specific use in a textbook or brochure—another plays with motion blur and candid crops to be able to convey something more akin to emotion than reason, to use the image in fashion or fine art—a world away from the aims of the other photographer. Equally, either photographer's image could be criticized by someone approaching from the opposing mindset. In my own career, I have spent much time puzzling over my place within photography, mainly entwined in a conflict between following the conventions of the fine-art world, and the expectations in the fields of fashion and commercial photography. I have wondered about my direction, whether it's possible to pursue more than one direction at the same time, and even if it's possible to fuse them.

For me as a photographer, the most important thing is to continue creating photography as art: that is, for the majority of it to be produced independently, personal work produced by a desire to express myself through a visual form. However, as I am inspired by imaginative and compelling advertising, film posters, cinema, and beautiful or challenging fashion photography, I cannot ignore my continuing ambition to produce commissioned work that can be seen on other platforms besides the gallery wall of fine art. I also recognize that the fine-art world is limited to those who have the disposable income to buy art; I want my work to penetrate to multiple circles, not just to the elite.

It is grounding for everyone to learn, and remember, that you do not have to be a genius to create art. That does not necessarily mean everyone can be an artist or photographer, but it quashes the notion of only extraordinary people being able to produce art. After all, if art can be anything you say it is, and if we all have a consciousness able to interpret the world, then the craft behind producing art—the actual photographic skill—is just something that requires mastering to help better the delivery and execution of that art. I find it fascinating, and a little sad, to see how obsessed people can get with insecurities over equipment, technique, and the level of success of their work. It is comforting to note that an "artist" exists outside of the measurements of all those things. You are an artist because you create art. Whether people like what you make, whether your skills are recognized as competent, or whether or not you have won an award, held an exhibition, or have gained any other kind of accomplishment is another topic and mostly relates to popularity, reputation as a photographer beyond just artistic circles, and whether or not you can make money from your work. In the last chapter of this book I explore these more mercenary topics in further detail.

◄ **HARMONY STRING (2011)**
From my earliest days in photography, I have felt strongly that craft and presentation are as important as "message." Not in the sense that there should be a general bible of craft the artist should internalize before beginning to create, but more that we should feel encouraged to explore photography in imaginative ways and embrace the creative possibilities of the visual medium, without feeling that the conceptual intent is enough.

THE PORTRAITIST AS ARTIST

DEFINING AN ARTIST

While the main criterion needed to be an artist is to simply have the intent to create art, this should not be confused with the simple desire people have to "be an artist." That is, achieving the label should not be the primary aim. Wanting to fit in with other artists, craving recognition from the outset, and worrying about your technical capabilities are all misguided feelings that should be cast out. Looking at other artists' work and studying the history of art is beneficial, and some might argue is greatly important, but I believe this should be balanced with a certain withdrawal from outside sources: a determination to draw guidance only from within yourself. This will not guarantee unique photography—far from it, for we are all consciously and subconsciously inspired by everything around us, photographic or not. Absolute originality is the unicorn of art, and should be dismissed as mythical. The pursuit of an artist should be to constantly remix their inspirations, adding a certain personal element that only they can offer into the blend, and mixing all of the "done before" ideas with other references to reemerge as new art. This is not just in one picture, but across a whole body of work— across a whole lifetime's worth of bodies of work. That persistence, even if it can't be called originality, is one that intelligently explores, rediscovers, and reknits everything gone before, and as a result is authentic, and thus unique. That personal persistence and artistic drive, in my own definition, is what makes a real artist.

People wanting to learn photography and to pursue it—for whatever reason, including those who want to be artists—can often put too much dependence on books, magazines, workshops, videos, and other kind of tutorial material. They can also look at the work of other artists too obsessively, and doubtless feel desperation, insecurity, and confusion as a result. Of course, everyone who starts out in photography is inspired by something or someone, and it can take time to shed the initial signs of that influence, but it is crucial to establish self-esteem in first believing in the validity of your own artistic expression as a foundation upon which to healthily build inspiration from other artists and sources. When you continue to make more and more work, you will see that your development lies in your own work itself: it is the main place you will find inspiration, guidance, and indeed everything you need to know about how to create your next piece. As an artist, it is by keeping close contact with your materials (in our case, that is the camera, software, models and so on), and in continuing to produce work, that you will improve your skills and also establish to yourself what your intended concepts are. This is not to be confused with simply improving technique, as that is only one part of the process, but rather forcing yourself into the process of production that actually gets your work made. Sitting and worrying, comparing yourself to others, over-planning and over-thinking, and fear of failure or imperfection simply leads to inertia. That is why I have always been eager to speak of how liberating it is to simply "go out and do" photography and engage in creating as soon as you spark an interest in the art. That is why I have often discouraged studying photography at college or university without accompanying the experience with hands-on activities, practical pursuits, the physical creation of artworks, and thus engaging in the "real world" so that the world of study does not seem to be such a false, insulated idyll once you leave it.

Guidebooks often focus solely on technique, the way to execute ideas without much attention placed on the content or concepts of photography. Then there are books about artists which tend to focus only on the end products of an esteemed artist's process with minimal text, where there is too little about technique or process, as it is not intended to encourage the reader to create their own art. This book that you hold in your hands is the happy medium, full of stories that take into account everything during the process of producing artistic and conceptual portrait photography. You, the reader, are invited to look into the hopes, gambles, intentions, mechanics, struggles, and happiness behind each photograph to glean more than one kind of information and inspiration, with the full encouragement and assurance that art—that creative portrait photography—is also made by you.

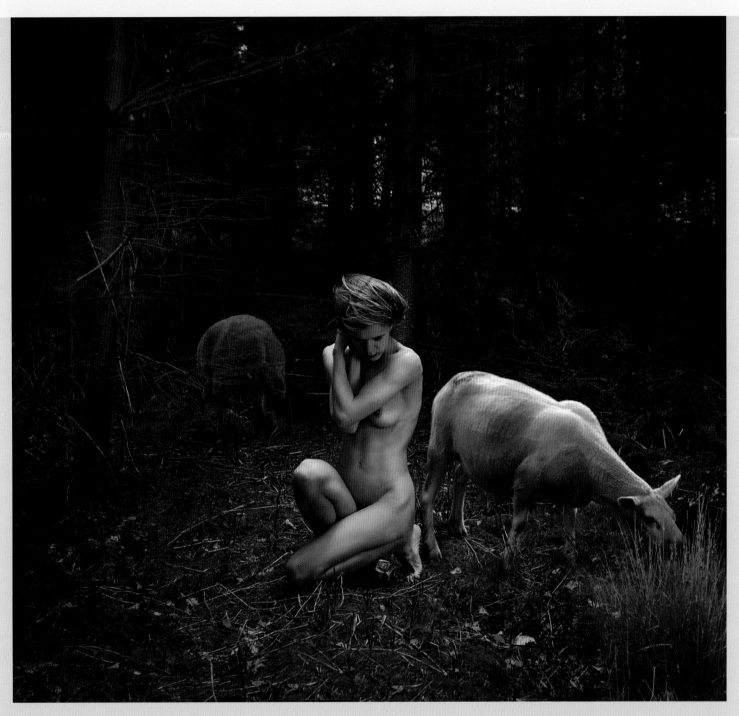

▲ WHILE STOCKS LAST (2011)
Thinking about concept has become increasingly important to me,
though I am careful to try not to overthink my images. The first real
"topic" I have felt drawn to is the world itself, the environment, and the
pictures that surround us every day. I want to let aspects of heightened
reality disrupt an image of otherwise tranquil beauty or peace.

APPROACHING A PORTRAIT

THE MOST FUNDAMENTAL ASPECT TO THE DIRECTION OF A PORTRAIT SHOOT IS WHAT SETS THE BOUNDARIES: THE PURPOSE OF THE SHOOT, WHETHER IT IS FOR SOMEONE ELSE, OR FOR THE PHOTOGRAPHER'S OWN OPEN-ENDED USE. THIS LARGELY COMES DOWN TO WHO THE IMAGES ARE FOR, WHICH DICTATES THE CONTENT. HOWEVER, EVEN IN A COMMISSIONED SHOOT THE PHOTOGRAPHER MAKES AUTONOMOUS DECISIONS ON ALL THE AESTHETIC FACTORS.

PURPOSE

I feel that my whole photographic life is almost a mission to psychoanalyze myself through my photography, to discover what I am trying to do, what makes a good photograph, and why a certain image worked when another did not. Breaking a portrait down into key areas such as composition, lighting, and concept is greatly beneficial to any artist seeking to understand photography as a learnable skill, but much more importantly, for the developing photographer it's also invaluable in understanding photography as an art, and thus a method of understanding your own style of that art.

The main question I ask myself when going into a shoot, and hence the crux of most shoots, is "how do I best bring together this subject with this location?" The entire book dedicates itself to answering that question, but the following pages directly address the things that influence how the subject and location come together: the subject's personality, the available context (props and location), lighting, and the intended mood or message. In bringing those together, it is about applying depth, color, decisions on motion or pose, and post-production to bring out a portrait to its fullest potential in line with the artist's vision. From here I will look at each of these factors.

MESSAGE

Whether I photograph myself or another person, there are always surprises. When I shoot a self-portrait, I have to allow for the randomness of composition that can result from not being able to frame myself in-shot, and when shooting another model, I often allow their personality, strengths, and limits to lead their poses and behavior. The fact that I most frequently use natural lighting often contributes to a whimsical "caught" quality, and when it comes to meaning, I never work solidly on delivering a message as if it were arriving at a door in a pizza box. Instead, I go into a shoot with something in my head—be it an inspirational film scene, or a photographer I discovered in a book or magazine, a prop I found in a charity shop, a photogenic piece of flowing fabric, or a location with quirks I want to somehow capture with a human element. My work is most always visually led: that is, I shoot until I see something I like, and wait for meaning to arrive. I allow the piece to tell me something, rather than impressing a preconceived idea onto the piece. The photographer Philip Lorca DiCorcia said, "if you put yourself in a meaningful situation, meaning will find you . . . if you try to put meaning into something as a way of adding content, it always falls flat" (*British Journal of Photography*, May 2011). What I have found fascinating is the way that one's subconscious mind can work when shooting: often, we don't know what the message is—it's up to the picture, or our viewers, to tell us. I encourage photographers to not worry about rigidly conveying a set message and to instead build upon an initial thought, to allow shape, lighting, and color to come together, and to move with the fluid spirit of a shoot.

PERSONALITY

The word "model" is a funny one. Some photographers dislike it for being a detached way of describing a human being, almost as though the subject literally becomes an inanimate object. It implies that the person posing is acting for the camera, which is not always the case. However, it's a word I mainly use out of necessity. Whether the main purpose of a portrait is to parade a garment or tell a story, I find that the model almost always has an impact on the result of the image to some degree.

Sometimes a model can become chameleonic, bending to every whim or desire of the photographer, which ultimately means that the same model can be used multiple times. The vision of some artists is subjected upon the models and locations in a manner that reigns in the variables and keeps their style recognizable, while for other photographers the personality of the model is unleashed and allowed to break free through an image, to color it essentially with the model's own personality, maybe not playing the role so much as a "model," but more a portrayal of their own self. The direction of a portrait depends heavily on the photographer's direction; if they have a preplanned idea, they will be much more inclined to instruct the model's every move. When a photographer is shooting more open-endedly, waiting to be inspired by the model or the scene, it is more likely that the model will do something unexpected and perhaps inspire the photographer. A perfect example of this in my own work are the images of Grace on the car on pages 60–61.

ON SET

Although I admire several genres of photography, it is shooting portraiture that is my passion. Placing the human element into a context is my instinctual way of making artistic sense of a location, no matter how interesting it may look by itself.

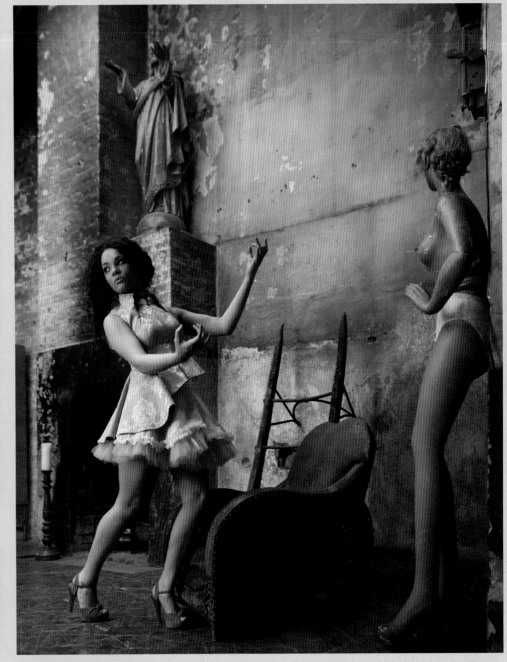

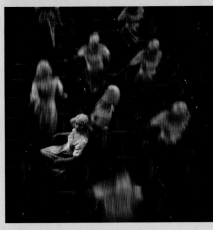

▲ AISLES (2011)
Shot with model Ruby True in a theatre during a workshop (see more on page 88). For this image I wanted to make use of the vast seating area by shooting from the balcony, gaining a higher vantage point to shoot a motion-filled multiplicity composite.

▲ DEVOTION (2011)
During this fashion production shoot, I was intrigued by the parallels between the mannequin and the statue of Jesus. I wanted the model to stand between the two very different icons and strike a pose to play "the fashion model" juxtaposed between the two.

LIGHTING

AS FAR AS EQUIPMENT GOES, IT SHOULD BE REMEMBERED THAT A PHOTOGRAPHER DOESN'T NEED A TOP-END DSLR TO CREATE STUNNING PORTRAITS. A BETTER CAMERA MIGHT ALLOW YOU TO TAKE PICTURES IN LOWER LIGHT, AT A FASTER SPEED, OR WITH BETTER RESOLUTION, BUT THE PROGRESSION OF CAMERA IMPROVEMENTS DOES NOT NECESSARILY CORRELATE TO THE SUCCESS OF YOUR WORK.

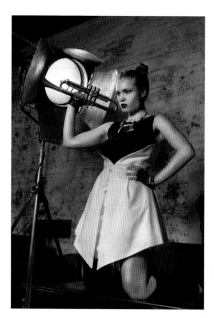

◄ **ZANE WITH TRUMPET (2011)**
This portrait of Zane involved a tricky and rather ambitious positioning. I wanted to keep the lamp at the correct exposure behind her trumpet, which I achieved by producing a semi-HDR portrait.

▼ **ZANE (2011)**
This portrait was shot in the corner of a dark, run down building, and was lit by bouncing the light from outside using a reflector.

THE CAMERA ITSELF CAN ONLY OFFER TECHNICAL IMPROVEMENTS, and what will always matter more is intention and content. However, as far as the immediate technical considerations go, one of the most important (along with lenses) is lighting. For some photographers, lighting is the very first consideration, above anything else. Photographs are, essentially, constructed from different volumes and qualities of light. However, when it comes to approach I tend to think first about the setup and intended mood, and then tweak the lighting around those elements.

NATURAL LIGHTING

You could spend your whole career using natural lighting if you so wished. Lighting gear simply gives you more control in creating a certain ambience wherever and whenever you want. It is my instinctive aim to eliminate the need for artificial lighting wherever I can: if it's possible to work with ambient light, I naturally go ahead with it, as in the image of Zane (right). I shot the image *Rising in the East* (page 77) in a studio with natural light coming through the skylight. Soft and diffused, it made a perfect synergy with a shot taken outside in the same diffused light to make the final composited rooftop portrait.

Sunset and sunrise can be rewarding times to shoot because the gentle sun, low in the sky and warm in appearance, becomes a magical source of lighting in itself. On pages 50–51 there are two dystopian-themed portraits I made at these times of the day in Malibu and in Dungeness.

In any level of sunlight, there are great benefits to using a reflector—and being such a cheap and minimal piece of equipment, I recommend at least taking along a reflector on a shoot, especially if you are not taking lighting equipment. For both indoor and outdoor shoots, a reflector can have a great effect, filling in shadows and going a long way to illuminating a scene.

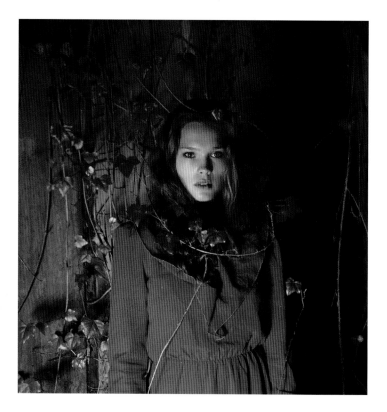

A notable example of where I've used a reflector with natural light are my portraits of band Visions of Trees on pages 72–73. I also shot the images of Grace on the car (pages 60–61) with a Photoflex LitePanel (a large freestanding reflector).

HDR (HIGH DYNAMIC RANGE)

When it comes to lighting a high-contrast set-up, where for example the subject is near strong light entering through a window or against a bright sky, there are different lighting options to consider. I might expose for the background and light the subject with flash, but alternatively (or when flash is not possible), I auto-bracket the image for an HDR image. I take multiple shots (usually three) of the same frame, and merge them in Photomatix, a piece of software that produces HDR images from different exposures of the same scene. By creating an HDR image, I achieve the correct luminance and exposure across all parts of the frame, where the camera would usually have to choose between exposing for the shadows or the highlights.

HDR is not generally observed to be suitable for portraits because an animate subject moves very slightly between the shots, inevitably causing ghosting. Where possible, I keep the model in a still enough position so this doesn't happen—but this is usually only effective in itself as a solution when the model can lay down flat or sit down firmly against something, without any breeze or movement whatsoever (such as in the wide tub shot on page 85). The main solution I use is to mask over ghosted areas from one of the original exposures, basically inserting a small non-HDR element into the image and applying subtle tonal changes to make it match. Examples of where I have combined exposures for a HDR or semi-HDR portrait in this manner include *Zane With Trumpet* (opposite), *Memento* (page 98), and *Moored* (page 51). Each had a slightly different approach to the HDR process, described on their respective pages. I don't always wish for the dramatic effect of opening up the shadows in a picture, and sometimes I choose to work purposefully on one dark exposure to maintain realism or mystique, as was the case in the processing of *Heatstroke* on page 49.

IMPROVISED LIGHTING

Many of my self-portraits have been shot with what I refer to as "improvised" lighting sources: that is, objects that emit light within the frame, but which aren't technically natural or professional lighting. These have included flashlights, candles, lamps, an operating light in a derelict hospital, and a stage spotlight. Most of the time, these behave in the manner of ambient or natural lighting, and often means that I can engross myself in the mood of the environment without worrying about the myriad possibilities present in introducing a new light element that can be manipulated in countless ways. At other times, the light is either too weak and needs creative post-processing (for example candlelight), or too strong and needs careful shooting in case of over-exposure, such as the operating lamp on page 57 (auto-bracketing for HDR would be a good idea in this case). At other times I find that these objects are best when accompanied by another lighting source—it really depends on the situation.

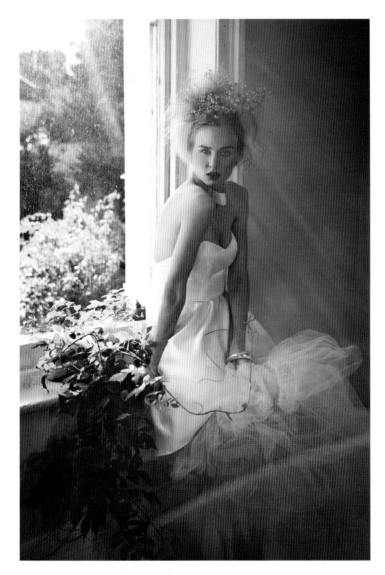

◄ OLLA (2011)
This portrait was shot with just the light from the window and the ambient light from a modeling lamp.

LIGHTING

▼ **SHE OUTSMARTED NURTURE (2009)**
This was an unusual situation for me, shooting a multiplicity self-portrait (with assistance from my partner Matthew) and mixing in-camera motion blur with light from a flash unit.

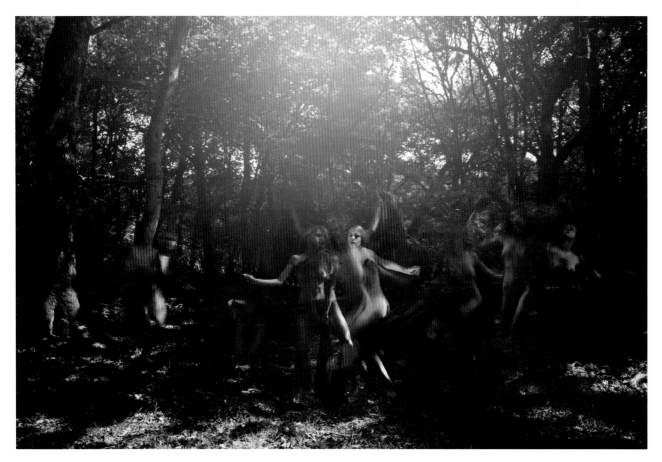

CONSTANT LIGHTING

Constant lighting is similar to the lighting quality achieved when using improvised sources (discussed on the previous page). It has the same tungsten (orange) appearance, and offers the same advantage of the ability to see the actual effect of the lighting in real time. I enjoy using constant lighting, and did so, especially at the start of my foray into using professional gear, because of my previous tendency to use improvised sources. I find it empowering to see the scene before I shoot. Depending on your intention for the final image, it is usually necessary to change the white balance to tungsten so that the images are not over-saturated, especially if the image is a fashion portrait showing a lot of the model's skin and face. I shot *In the Swing* with constant lighting, and also *Something Moved Her* (page 101).

FLASH LIGHTING

The lighting method I use least is flash, but I have certainly enjoyed its benefits and increasingly experiment with it in my photography in both subtle and bold ways. I shot the portrait of Ariana in *Cobalt* with a flash positioned to one side, achieving dramatic shadows on her neck and on the folds of her dress, but lighting her face evenly.

I have shot numerous long exposures in my work where flash would have been fairly detrimental to the final effect, such as *An Impromptu Performance* on page 2. However, there are situations where the potential for blur that comes with the use of a longer exposure is not appropriate and the aim is to pull the subject away from the background to outline them cleanly and sharply—often the norm in fashion portrait photography. I like to use a split-lighting technique whereby the flash is positioned to one side of the subject, crossing

THE PROCESS
The lighting setup for
In the Swing.

▼ IN THE SWING (2011)
Similar to the portrait of Zane with the trumpet on the previous page,
the light behind my model Claudia's head here proved awkward. Rather than
move the lamp, I wanted to include it as a quirky element. Instead of auto-
bracketing the shots and producing an HDR image, I chose to expose the
background and light the scene with constant lighting positioned camera-left.

▲ COBALT (2011)
Model Ariana lit with a Photoflex
TritonFlash inside a small
octodome. The use of flash in
this portrait was appropriate,
giving the model a striking
appearance amongst a dark,
busy environment.

the path in front of them, increasing the image's depth and the model's
stature. My images of model Sam in an abandoned laboratory (pages 66–67)
were shot with one TritonFlash positioned in this way.

A subtle use of flash is evident in my self-portrait with a snake, *Double Bind*
(pages 40–41). The flash highlighted the body, snake, and face, and also put
catchlights in the eyes—which is one of my favorite reasons to use lighting,
whether constant or flash. Rarely achievable with natural lighting unless you
are using a reflector (as in *Loopy Lupinus* on pages 44–45), catchlights can be
surprisingly conducive to the overall look of a portrait such as *Conduit* on page
66, where Sam's twinkling, almost filmic gaze is the central focus of the
viewer. Catchlights can even be faked in Photoshop, but I prefer to capture
them straight in-camera with use of well-aimed lighting or reflector.

CONTEXT AND MOTION

THE SUBJECT'S RELATION TO THEIR SURROUNDINGS CHANGES DEPENDING ON THE USE OF MOTION, STILLNESS, AND PROPS, AND BECOMES THE FOUNDATION UPON WHICH THE ARTIST MAKES A STATEMENT WITH THEIR FINAL WORK. DIFFERENT CHOICES CAN MAKE THE SUBJECT JAR AGAINST THEIR ENVIRONMENT, OR BLEND INTO IT.

A S I LIST THE ASPECTS THAT NEED TO BE considered when taking a photographic portrait and break them down into an order that makes sense, it is important to note that the process will never be as linear as it might appear. I will of course have made logistical and aesthetic preparations beforehand for the location, equipment, lighting, and styling of the shoot, but I have learnt not to stress about preplanning the actual content of the portrait down to the very last detail. The possibilities that I open myself up to on the day often complete an image in a way I could never have anticipated.

CONTEXT

I have always favored "real" locations over studio environments, so much so that I found it appropriate to organize this book by location: natural and urban. Following that, the chapter on interiors cover some of the few times where I've used a studio environment. Although many photographers use studios to highly creative effect, I have so far found my mind boggled and my drive reduced to inertia by the blank canvas of a studio. I prefer to choose a location in which I have limits to work with, and that will provide a higher chance of producing a portrait that will relate to the viewer in a stronger way than a setup that is obviously completely contrived. That is, I aim to merge the contrived with the candid, and hence the real with the surreal. I also like the idea of having my location "ready-made," whether it be my own home or garden, an abandoned building with peeling wallpaper and rotting floors, or a forest with natural depth and a backdrop upon which I can set a few props.

Props are hugely beneficial in building or extending the narrative of a portrait beyond the surface, but at the same time you need to find the appropriate place for props in a composition so they do not burden the frame or break the shape constructed within it. Attractive props can sometimes be misleading. There is an art to knowing exactly how best to incorporate objects into a portrait; I strive to use them to add something to the narrative and embellish the scene, but without cluttering it or detracting from the subject unless the prop is particularly interesting. When I look through my portraits, I see that the most effective props are those with which a model can easily interact, for example an object they can hold naturally. Outfits and accessories can become stimulating shapes within themselves in a portrait, as in Grace's poodle puffs on pages 60–61, or Maria's cabaret outfit on pages 7 and 70. I also enjoy using large props, such as a bathtub, bike, or car—and the clock used in *Intervals* (opposite). However, larger objects can also prove the most difficult to work with effectively. They often require the photographer to back away to shoot them in their entirety, which means it then proves difficult to get close enough to the model to create an intimate portrait incorporating the prop.

MOTION

A large portion of my portraiture features motion of some kind. Some images involve motion caught or frozen, as in *Crosswinds* (opposite). Others have implied motion where the subject is simply holding an action pose, such as *Every Day is a Holiday* on pages 58–59, or action intentionally or partially blurred in-camera such as in *The Spectators* on pages 90–91.

Early on, I was very attracted to using the motion of a subject's hair or outfit to add interest to a standard portrait, even if the motion was only one component in the image. For example, the movement of Bella's hair in *Performing the Past* on pages 86–87 adds a dynamic element to an otherwise static portrait. Sometimes, when I am struggling to identify an element of interest, I might ask the model to walk towards me, flick their hair, or move their outfit. Motion or implied motion is not always appropriate, but I often find it's a good option to try, even just as an idea while warming up at the beginning of a shoot. For example, I feel that the motion I experimented with when shooting *Half-life* on pages 36–37 didn't add anything to the picture, and I instead favored the mood portrayed by the static nude figure.

◄ **CROSSWINDS (2009)**
This semi-sepia-toned self-portrait is an example of using motion as well as multiplicity in an image. The movement was created by the wind making the dress billow out and create this striking shape.

▼ **INTERVALS (2011)**
I was fascinated by this big clock while shooting my model, Sandra. I liked the simplicity and boldness of composition, and the richness of color achieved once I had applied a Curves adjustment. I wanted the appearance of the clock to be beyond the ordinary, so I added a hint of surrealism simply by duplicating the original clock hands.

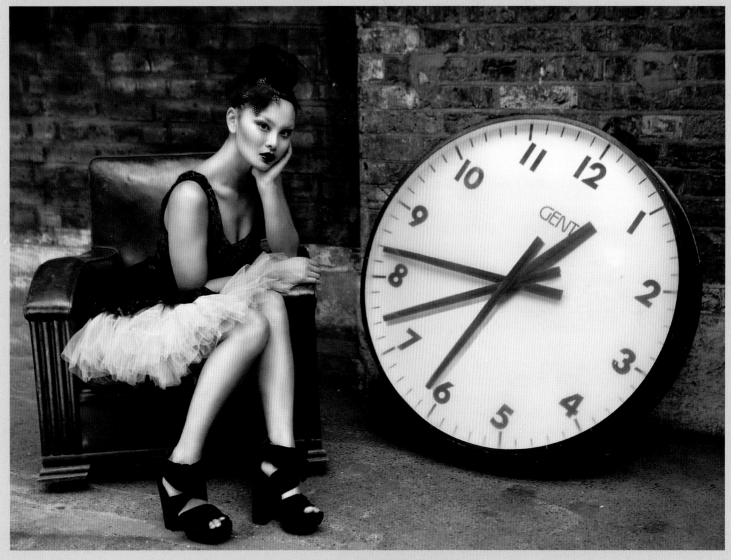

SHAPE AND DEPTH

IN MY VIEW, FOR A PORTRAIT TO BECOME COMPLETE THE SUBJECT HAS TO TAKE ON A PARTICULAR SPATIAL ROLE WITHIN THE FRAME. THE IMAGES IN THIS BOOK PRESENT COLOR, STORY, MESSAGE, AND MOOD, BUT I FIND SHAPE TO BE A VERY IMPORTANT ELEMENT.

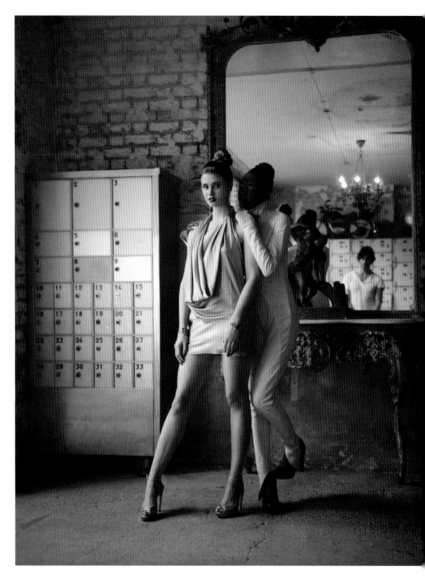

SHAPE

In creative portrait photography, people become shapes, and even static shapes can appear to become animate, in a curious interplay between different forms in the frame.

A good example is *Corolla* (opposite), which was shot at a workshop I co-hosted in LA. The goal was to produce a levitation-style shot, so I posed the model Katie on the arm of a chair, falling backwards while at the same time appearing to kick a globe into the air. However, on putting the images together afterwards, I felt completely intrigued when I was cutting out my layers in Photoshop and temporarily moved one pair of legs over another. A shape appeared that I couldn't resist, and I was inspired to continue constructing the illusion that the girl in the picture had four legs. I felt inspired by the surreal work of fashion photographer Guy Bourdin, and spent some time tweaking the final crop and processing to make the final composition of the shape look right. I was unsure about the result at first, but as time went on and the illusion solidified I was happy with the final result. I don't always create my portraits with the intention of reflecting the realistic physicality of the person I am photographing, whether that is myself or another model. In this case the shape felt right, and I obeyed my instincts. The same principle applies strongly to my sculpture-inspired image *Incestipede* on pages 46–47.

Very often you will not be able to plan to create a certain shape. The shape that strikes you as right for the image can come when you least expect it, or in a way you didn't anticipate, and may not be present in one frame, but might develop when multiple pictures are composited together, as in *Corolla* (opposite), *The Spectators* (pages 90–91), and *Her Fleeting Imprint* (page 78). It might even happen after an image has been cropped or flipped. Creating a shape that inspires me is the most important aspect I seek to satisfy when working on an image: once the shape "clicks," the image becomes final. It is about providing a full-circle experience that satisfies the eye and the mind in the same instant.

DEPTH

A principle challenge I find in shooting any kind of portrait is getting close enough to a subject to achieve detail and intimacy while also leaving enough space to capture the context of the props and environment. There is a fine line between allowing context for a narrative, and cluttering the frame. Sometimes we might be inclined to include more of the surroundings and then crop later—especially when using a camera with high resolution. However, I rarely find that method to be useful. The sense of depth to the subject is sacrificed in a wider shot, and the same intimacy cannot be achieved by drastic cropping.

One's proximity to a subject has a lot to do with lenses. While we might commonly associate typical portraiture with a focal length of 50mm or more, throughout this book you will find that all kinds of lenses are used. Some are

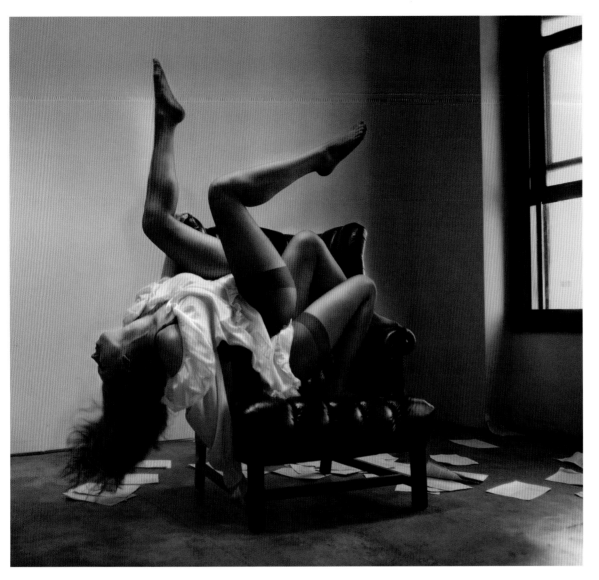

wide shots, showing a great deal of context, others are very shallow close-ups where a telephoto lens was used. For a lot of my images I use a 24-70mm ƒ/2.8 zoom lens, which conveniently allows for a variety of shots. It is wide enough to shoot images at a location such as the disused satellite dishes on pages 72-75, but can also be used to shoot portraits like the ones of Ayla on pages 84-85.

I always strive to achieve my desired shape and depth in-camera, but it also comes down to selection: for example for *Unrest* on pages 34-35, I show the variety of shots I took and the reasons for choosing the final mid-shot. However, at other times interesting depth effects can be achieved by using more than one image in different kinds of composite. An example is where images are stitched or merged together in the manner of a panorama, either tilted to one side, up, or down. *Suspended* on page 87 was created using this technique, while *Double Bind* on pages 40-41 was produced with a different background that offered cleaner, more absorbing surroundings.

There are other ways to achieve the effect of depth in an image—it's something with a certain mystique that I am continually trying to crack. Depth is about making a portrait jump off the page or screen, about giving it layers in both senses of the word. Smoke or mist behind a subject can help achieve the effect, such as the mist in *The Morning They Met the Clouds* on page 43, or using HDR to incorporate background detail as in *Body Repairs* on pages 62-63 to contribute to a layered look. Using lighting is also about creating separation between subject and background. All of these techniques are covered in more detail in the portrait stories later on.

COLOR AND POST-PRODUCTION

IN MY OWN WORK THE USE OF COLOR IS GENERALLY VERY BOLD.
EVEN IN MY BLACK-AND-WHITE IMAGES THE USE OF TONE AND THE
TWEAKING OF EACH COLOR CHANNEL IS VITAL TO THE FINAL IMPACT OF
MY PORTRAITS. YOUR USE OF COLOR HAS AN INTEGRAL RELATIONSHIP
WITH YOUR INDIVIDUAL APPROACH TO POST-PRODUCTION: TWO
DIFFERENT PHOTOGRAPHERS CAN END UP WITH DRAMATICALLY DIFFERENT
RESULTS—EVEN WITH PORTRAITS TAKEN IN THE SAME TIME AND PLACE.

COLOR

Color is the final touch applied after everything previously discussed that goes into the making of a striking portrait: the subject and their styling, the location, and the lighting. I find that post-production is the point at which all those elements begin to mingle: where colors can be separated from one another, deepened, saturated, and adjusted. Throughout this book are many examples of portraits that have been brought to life by post-production in terms of final aesthetic impact. I usually find that in a colorful portrait there are no more than two main colors that I have enhanced, and I may have actively muted the others to keep the mood of the piece uniform. Examples of images in which striking color choices have been applied include *Half-life* (pages 36–37) and *A Blot on the Horizon* (page 33).

For *Deliverance* (opposite), I wrapped myself in a long piece of black-and-white net fabric and posed in several different positions, making sure to wave the fabric to make it move and flow. My partner Matthew, who often assists me on my shoots, was lying on the ground firing the shots from a low, somewhat unusual vantage point. A flash setup was assembled to one side, on a stand with a shoot-through umbrella. It was sunset, and quite dark in the garden, but the flash balanced the light against the purple sky, illuminating the figures I created and thus allowing me to move at speed to get into position. This enabled us to capture the wonderful color of the sky without having to compromise on shutter speed. When I put the composite together in Photoshop, I enhanced these colors in Curves. The purple of the sky, and red of the hair together with the swishing black and white made for a dynamic and electric image, with the figures frozen in time like sculptures. Color is a key factor I seek to satisfy when feeling for an image's sense of completion, and here, the composition clicked.

POST-PRODUCTION

Even in my simplest compositions, I find digital post-production to be an invaluable step in the polishing of the final images. In some portraits, using Photoshop is a necessary stage to form the compositions through layering, and hence the final shape of the portrait. On other images, such as the portraits of Maria in Hackney (pages 68–71), applying a style in the Raw workflow program Capture One Pro (followed by adjustments to Curves in Adobe Photoshop) added subtle yet distinguishable differences. The changes transformed the photographs from everyday "shots out of camera," to finished "images."

I fully recommend shooting in Raw, a lossless format, the main reason being that Raw allows the most flexibility for post-production changes, particularly for adjusting exposure, and hence provides the best foundation for potentially destructive editing. A good Raw workflow program which will also allow for batch-processing is necessary for when you are outputting more than one file from the same shoot—the most popular are Capture One Pro and Lightroom. You can also use Adobe Photoshop's Camera Raw plug-in, but this doesn't provide such an easily streamlined experience as a separate program.

In Photoshop I do a variety of things to different portraits. As well as adjust colors and tones in Curves and Color Balance, I straighten lines with the Transform tool, make subtle crops, gently airbrush skin using the Clone Stamp and Patch tools (depending on the kind of portrait being produced), apply subtle vignettes, dodge and burn areas, and so on. I often work on compositing images, not always necessarily for surreal results such as levitation, multiplicity, or distorted bodies, but often just to get the best combination of elements in one final portrait, such as in *Heatstroke* (page 49).

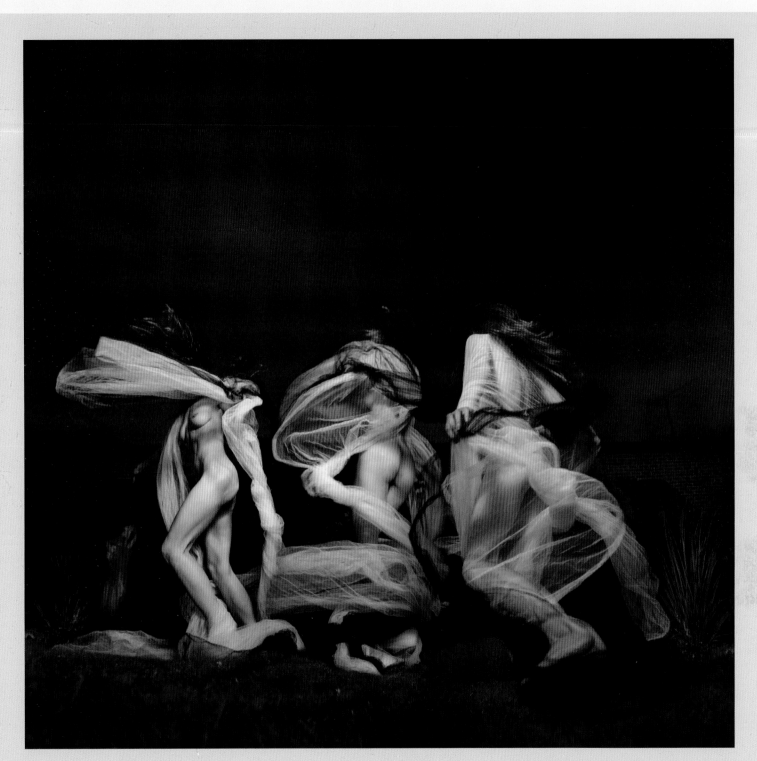

▲ DELIVERANCE (2011)
I liked the traveling line created by the figures once I brought them together, and how it anchored the electric mood given by the sky and their red hair.

CHAPTER 2
PORTRAITS IN NATURE

THIS CHAPTER EXPLORES PORTRAITS THAT USE NATURE AS THEIR
ENVIRONMENT OR THEME. THE DEPTH OF A NATURAL SCENE AND THE
DRASTIC CHANGES IN COLOR AND MOOD THAT OCCUR WITH THE PASSING
OF EACH SEASON HAVE LONG PROVIDED INSPIRATION TO ALL KINDS OF
ARTISTS, AND PROVIDES THE PERFECT AMBIENT PHOTOGRAPHIC BACKDROP.
WITH LIGHT AND SHADOWS THAT CHANGE FROM ONE HOUR TO THE NEXT,
AND A SCENE THAT IS ANGRILY COLORED OR RENDERED PLACID BY THE
TEMPERAMENT OF THE WEATHER, THE SAME NATURAL SCENE CAN
REPRESENT BOTH A NIGHTMARE AND A DREAM.

AS A CHOICE OF SHOOTING ENVIRONMENT, a rural location can often be the most practical place to shoot and can provide the seclusion and peace necessary to set up a striking visual scene. Lakes, beaches, woods, fields, and gardens full of flowers can provide compelling contexts for imaginative pictures of posing subjects.

I am generally drawn to nature when I want to produce a portrait with breathing space—a space that can be serene or stark, depending on the season and the way that I am using the particular landscape. A natural scene is the perfect environment for timeless images—an image can be made as ageless as you wish, depending on your direction of your subject and the styling of their clothing.

I have enjoyed exploring how evocative natural landscapes can be during less palatable times of the year; nature can be the most interesting when it sheds its appearance of physical life, replaced instead by the brown of dead matter in the autumn and winter. Used in parallel with the nude figure, creative portraits can become about the human element abstracted amongst the features of a landscape.

Natural scenes can also present an all-too-featureless environment, requiring some thought as to the use of props, outfits, and poses to dramatize the subject. On pages 29–31 my portraits of Jane use a variety of dresses and accessories, and pose her in the sea, in a lake, and on a hill, while on pages 38–41 I use a snake as a prop for painting-inspired nude portraits. The chapter also includes portraits where nature, manifest in its typical green, is seen to overcome and seep through urban environments: the man-made overlapped by nature, seemingly unchecked.

▶ **DENUDED (2011)**
A self-portrait nude shot in the Ashdown Forest, Kent, in winter. The natural subdued autumnal tones became the perfect backdrop for the lightness of the nude flesh.

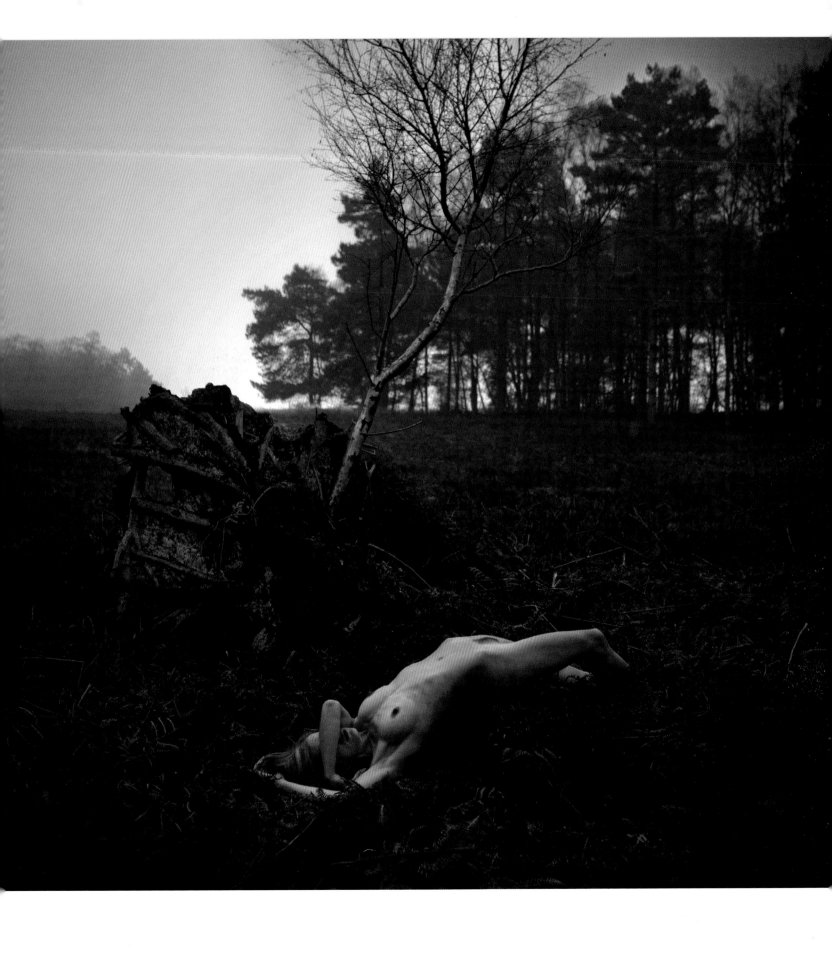

SUMMER SHOOT WITH JANE

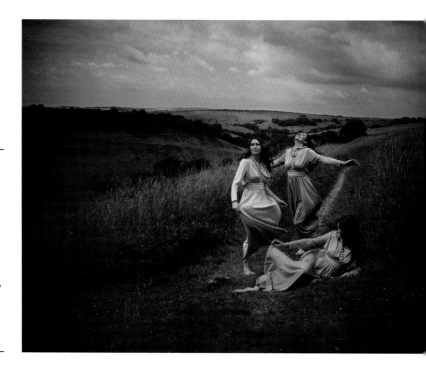

ONE OF MY FIRST REAL EXPERIENCES WITH EXTENSIVELY SHOOTING PHOTOS OF ANOTHER PERSON WAS THIS SERIES OF JANE, TAKEN BY HER PERSONAL REQUEST. JANE HAD FIRST SEEN MY WORK FEATURED IN A UK NEWSPAPER AND CONTACTED ME, INTERESTED IN BEING PHOTOGRAPHED IN MY STYLE AS SOMETHING SPECIAL TO CELEBRATE HER UPCOMING 40TH BIRTHDAY. CUE AN EXCITING COMMISSION . . .

I HAD DONE COMMISSIONED ASSIGNMENTS BEFORE, but this one was to extend over two days, so I sought the help of a stylist friend, Rachel Holland, to work on the look of the shoot. Jane lived over 200 miles away, so we had discussions via email about what she wanted from the commission in order to be ready to start as soon as she arrived in Brighton for the shoot. She had told me about the themes and moods she wanted to encapsulate in her images: the elements of water, fire, and earth, and about aspects of her own life; her law studies as well as her interest in crystals and astrology, and how these two passions conflicted and co-existed. I discussed the themes with Jane, referencing images from my own portfolio that she liked, and researched the work of other photographers online who had experimented with water in their work: puddles, lakes, and rain. I wanted first to make sure that I was on the right track to deliver what she wanted, but I had to balance this with bringing as much as I could artistically to the shoot. It is a necessary skill for a photographer to be able to strike a balance between fulfilling a brief yet also bring your individual point of view to a job, and I felt this was a great opportunity to test my ability in achieving both of those aims.

I consulted my stylist Rachel as early on as possible to create a dialogue between the three of us, and to decide on what makeup and clothing would be suitable for Jane. It became my job to confirm the locations, but I also wanted to run the suggestions past the other two so they could approve them. We decided on mostly natural locations including fields, a lake, the sea, and other countryside spots that I had previously used in my work, and also decided to incorporate secluded spots I had used before, so that on the day the logistics ran smoothly.

I used a Phase One 645DF medium-format camera with P40+ back with a selection of lenses for the entire shoot; it was a unique experience to use this gear as at the time I had mostly been using a Canon 40D. The superior quality of this equipment meant that my images were of considerably better resolution and the lenses (45mm, 80mm, and 150mm) allowed me to experiment with shallower and more dramatic depths of field than I had used before. Looking over the shots I'd taken, I noticed the magnificent dynamic range in the ripples of the sea, the textures visible in the ruined walls, reeds by the lake, and leaves on the trees. This is the "3D effect" delivered by larger sensors on medium-format cameras.

We started at Devils' Dyke in East Sussex, where we shot on a hill overlooking the dyke, and near a tree I had used in a previous image. I wanted to capture the motion of the wind around Jane, billowing through her dress as she posed overlooking the hills of the South Downs. Rachel's styling contributed greatly to Jane's organic, nymph-like look in the images. The same day, we moved along to a lake in Arundel, West Sussex, where Rachel gave Jane an Ophelia-style look.

◄ MOTHER, MAIDEN, CRONE (2009)

Jane was eager to use multiple selves in one shot similar to the style she had seen used in some of my self-portraits. The rolling hills of Devils' Dyke in East Sussex provided a great backdrop for photographing Jane, with the wind providing natural movement.

► JANE WAS HERE (2009)

A multiplicity shot created of Jane on the top of Devils' Dyke in Sussex. I added an inscription "Jane was here" to the wall (with the paint tool in Photoshop), to subtly personalize the scene.

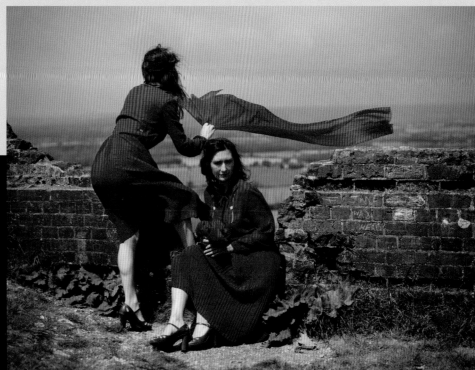

BEHIND THE SCENES

▲ JANE (2009)

Rachel's styling of Jane gave a beautiful ethereal feel to the series.

► FABRICATED (2009)

I love this shot of Jane because something is so timeless about her expression and the way she is holding the fabric, looking up toward the stylist. It is an example of one of those shots that simply work because they catch an almost "candid" moment—a split second where the subject suddenly becomes a perfect form within the frame.

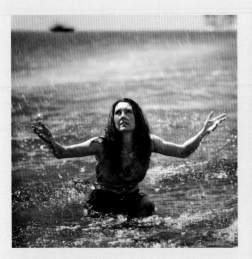

▲ THE DOWNPOUR (2009)

In the sea at Beachy Head. For this image, I incorporated the ship from another shot of Jane taken in this same session. I had made Jane splash the water around her, so that when I added a rain texture afterwards, it gave the appearance of rain falling down around her.

▲ ▶ DEPTH OF FIELD (2009)

I shot this portrait on a focal length of 150mm using a medium telephoto lens. Because it was a bright day, I used a shutter speed of 100 sec in order to achieve this shallow depth of field at ƒ/2.8, which allowed great detail for an interesting voyeuristic shot taken from some distance away.

PHASE TWO

The shoot with Jane was overall a blissful adventure within some stunning rural scenes, and after only the first day we had shot her in a total of eight outfits. Jane had seen many of the shots at the end of each day, but I was aware that she would not get a proper impression of the final results until I weaved some post-production magic into some of the more complex images I'd planned.

The next day, Jane and I went to Beachy Head. It was a rare hot British summer's day, and the color palette of the scene was akin to that of a Greek island: gorgeously blue. I wanted to shoot Jane in relatively simple, striking poses against the beautiful scene of sky and sea, using one prop: a hand mirror. I waded through the water to get closer to Jane while I shot and also to fill the foreground of the shots with water.

In post-production there were many shots from both days where a quick adjustment to Curves or Color Balance was all that was needed to enhance a scene that was already delicious in-camera due to the beautiful weather, quality of the equipment and lenses, and attention to detail in the styling. I processed the Raw files initially in Capture One, making batch changes to images from the same scene, then working on Curves adjustments in Photoshop, adding vignetting, and subtly retouching skin and eyes.

For the "multiplicity" image *Jane was Here* on page 29, I first posed her sitting on the wall, and then keeping the camera still, shot her again a step to the left, looking out at the view. I made a mental note of where in the frame Jane's head would be, so that the flaring scarf would be just above her, and in Photoshop deepened the tones of the image in Curves, which brought out the boldness of the red against the greens.

For *The Downpour* (opposite, top left), I shot the image in a certain way to be able to create the illusion of a stormy sea and falling rain. I asked Jane to splash the water as she crouched down so the surface of the sea appeared rippled, as if rain were falling into it. In Photoshop, I applied a texture of rain over the image, which would not have looked as convincing if there wasn't already water splashing and rippling in the original image. I cropped the image so that it was wider—almost square—but without losing the ship in the distance, as I wanted to draw the focus closer to her while keeping the context alive. I also adjusted Curves, applied vignetting, and increased the warm tones around her face to heighten the contrast between the blue of the sea and her skin, and to give the effect that the sky was opening up above her.

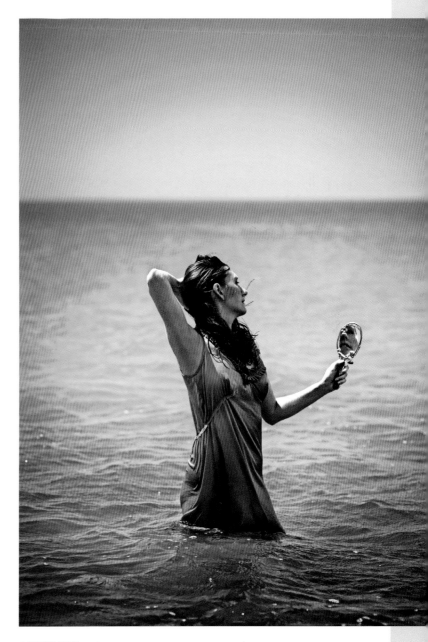

▲ **IN THE SEA(2009)**
This image of Jane was shot at Beachy Head. The frame was kept as uncluttered as possible to add impact to her figure. I added finer detail to the hand mirror later in Photoshop.

IN LAVENDER FIELDS

THESE PORTRAITS ARE FROM A SESSION IN A FIELD OF LAVENDER WHERE I SPENT A SUMMER AFTERNOON WITH A GROUP OF OTHER PHOTOGRAPHERS. ORGANIZED AND STYLED BY MY FRIEND, PHOTOGRAPHER SARAH ANN WRIGHT, WE SHOT THREE MODELS IN THE WIDE OPEN FIELDS, WITH A VARIETY OF VINTAGE OUTFITS AND PROPS.

ALTHOUGH I WAS EXCITED to shoot in a location I'd never used before, there were various challenges to working in the space, the main one being choosing a camera viewpoint. Shooting the model from too low an angle would defeat the purpose of the location as it would blur into a nondescript rural background with a large proportion of sky. The sky itself was white and cloudless on the day, making for an uninspiring backdrop, and a set of portraits I shot with smoke bombs did not look as effective as I had anticipated as the smoke ran off into the white sky, becoming barely noticeable. To really appreciate the setting, a higher angle was needed that would show off the lavender rows rolling upwards to the horizon, filling the frame with purple. However, unable to get any higher than a piggyback from one of the other photographers, I had to think of another way to fill the frame with interest while not obscuring the beauty of the location itself.

In terms of intent, my main goal at the outset was to produce visually pleasing images that had more in common with fashion imagery than conceptual portraits, though I still wanted to produce images with effective visual content beyond straight portrait shots. This proved tricky until I hit upon a visually effective concept.

The model, Little Twiglet, was dressed in a vintage Victorian black and white dress, and since I was shooting her straight on, I decided to play with

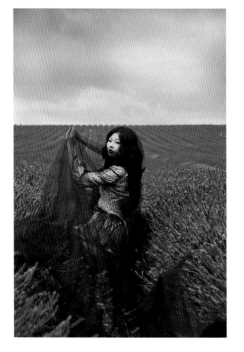

▶ **A BLOT ON THE HORIZON (2011)**
I wanted to blur the boundary between fashion and art in this portrait's creative use of outfit, location, and shape.

◀ **LAVENDER PORTRAIT (2011)**
A closer portrait, in which I delicately incorporated a more dramatic sky from another picture, setting it on a low opacity. It was not selected as the final image because the shape of the fabric and symmetry of the field was not as dynamic and pleasing as in the main image.

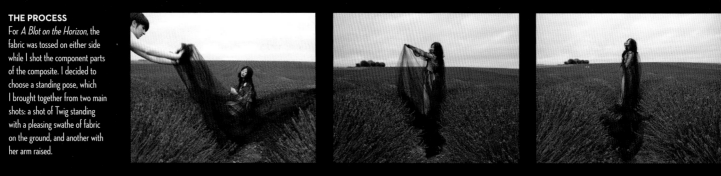

THE PROCESS
For *A Blot on the Horizon*, the fabric was tossed on either side while I shot the component parts of the composite. I decided to choose a standing pose, which I brought together from two main shots: a shot of Twig standing with a pleasing swathe of fabric on the ground, and another with her arm raised.

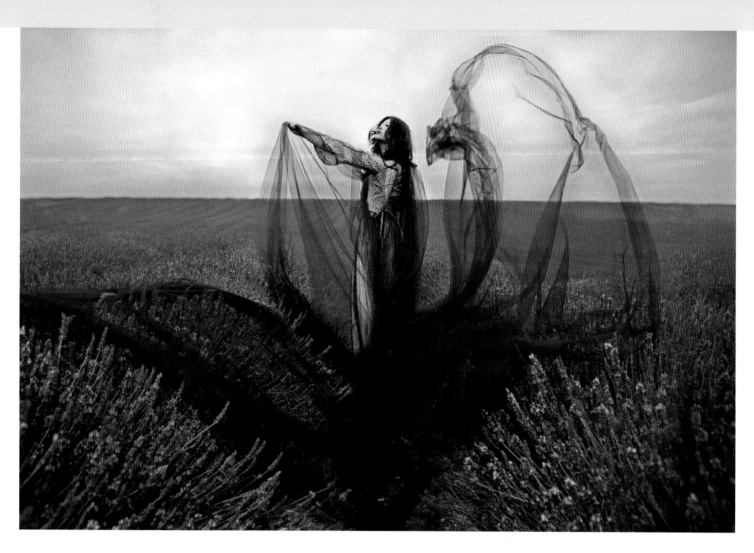

motion. However, the thinness of the rows of lavender was restricting, meaning the model could not move about much within the frame, and also reduced my choice of positions from which to shoot her. Because of this limitation, I decided to use the motion of fabric around Twig's standing figure, as in *A Blot on the Horizon* (opposite). Sarah had brought along a length of black fabric, and I was instantly captivated by its appearance as it spread over the lavender and blew in the wind, its gauze-like quality suggesting a cobweb, a net, or even ink in water. I had only ever shot with white or colored fabric before, but the blackness of this material suited the field well, and stood out against the overcast bright white sky, the dullness of which had swallowed up my paler fabrics.First I posed Twig sitting on the ground in the centre of the frame. I had my friend Hannah toss the fabric around on each side of her so that I could create a composite of the shots to create my own fabric shape later. I also tried some shots of the model standing with the gauze draped along the gap between the lavender, as if it were coming toward the camera. When I got into Photoshop with my selection of images, I decided to merge images from both of the standing and sitting poses. I chose a standing shot, one that had the fabric bunched up and covering up the dull ground between the rows of

lavender, and then composited in raised gauze on the right side, and positioned it lying across the lavender on the left, as if were leaking or trickling into the shot, feeding through into a gaseous-looking heart-shaped formation on the right. I also felt it necessary to tidy up the horizon by cloning out a clump of trees and straightening the whole frame, centering the model at the same time by losing a few pixels from the left edge of the frame.

Once I had the fabric in place and had decided on its final positioning, I worked on overall adjustments. The fabric took on a whole new richness when various Curves color adjustments were applied. However, I kept the Curves adjustments to a minimum and treated the picture carefully as I wanted to retain the delicate, ink-like quality to the black gauze that I had so admired during the shooting. I adjusted Curves to deepen the magenta and red, and to add a moderate punch of contrast to the black fabric, then adjusted this further by increasing the saturation and adding slight vignetting. The image was now complete. I chose a title that would refer to ink without spelling it out, instead using the word "blot" as part of a familiar phrase, illustrating this dramatic rural scene.

ATTACK OF NATURE

SHOT ONE EARLY MORNING IN A NEIGHBORHOOD IN LOS ANGELES, I WANTED TO ENCAPSULATE THE BIZARRE QUALITY TO THE PRESENTATION OF THE APARTMENTS THAT SEEMED SO COMMONPLACE IN LA, AND YET STRUCK ME, A VISITOR, AS UNUSUAL.

I WAS STAYING WITH MY FRIEND, Brooke (a contributor on pages 134–141) who also appears in this image. Having driven down this street with Brooke, I was fascinated by the sight of an apartment block almost engulfed by huge plants crowding around its entrance, with more plants also visible inside. I had bought a prop—a basket of fake ivy—from a charity shop the night before, and it seemed a perfect addition to the scene. I wanted Brooke to be wearing something primarily of one color so that it wouldn't clutter the already detailed surroundings, and I also wanted something that would clash surreally with the environment, so my dressing gown seemed the perfect choice.

I had images from American photographer Gregory Crewdson's *Twilight* series running through my mind: intricate composites set in nocturnal neighborhoods with mystical, dreamy characters within them. The hardest part for me was deciding what to ask Brooke to actually do, and how to frame the shot. I was faced with the age-old puzzle of how to combine location and model for the ideal shot. I was also limited by the context; I didn't want to hang around for too long in the street, or provoke unwanted questions from passersby (or even the police), so I acted quickly to try out a few different poses. I had her sit on the ground with the basket, but this looked too contrived. I then had her move, skip, and jump—but there were two problems with this: it didn't work technically, because the ISO would have had to be degradingly high to retain clarity on her movement, and motion blur was not what I wanted, and also I felt the image needed something different from a whimsical, dancer-like pose. What I wanted was to let the natural absurdity of the scene speak for itself, and so in the end it was just a case of deciding how close to get to Brooke. I tried shots that displayed more of the scene, including the apartments' sign to camera-right, but Brooke seemed drowned in that composition, so I stepped closer, and finally hit upon the composition to the right. I later decided to select the shot where she was looking away wistfully, almost as if she was looking round at the camera, wondering if someone was there: a sleepwalker disturbed.

While I was shooting, I captured as many options as I could, and then during the selection process afterwards I made sense of all of the decisions I've recounted above. I also played around with processing on a few shots before I decided on the final shot. On my chosen images, I played with Curves adjustments until I reached an effect that I felt improved the atmosphere of the shot. I wanted to throw off the darkness of the corners of the image, giving it a slightly "filmic" look. I also wanted to tone down the tungsten hue in the image by adding a slight blue tinge. The final image, subtler in mood than my usual images, took on a similarly quiet, scenic, and bizarre tone similar to that in Crewdson's work.

THE PROCESS

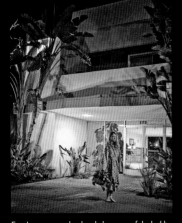

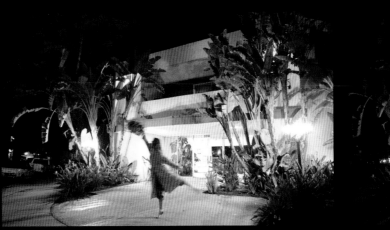

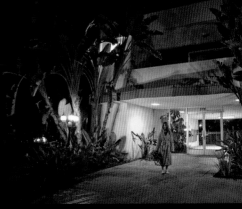

First I experimented with including more of the building. This composition lost intimacy with the model.

Next I tried movement, but it did not work technically (shooting with ambient low-key light only) and also produced too lighthearted a mood.

I tried a wider shot which showed much more of the interesting environment, but I did not feel it was good enough for the final portrait.

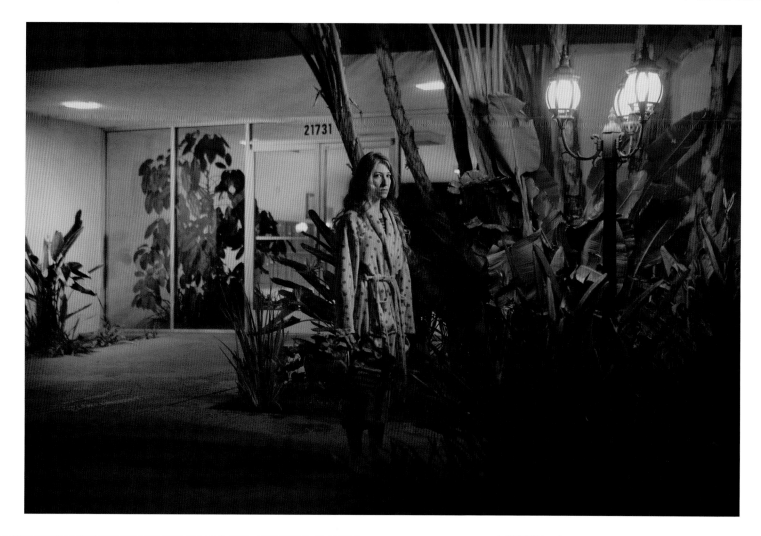

▲ **UNREST (2011)**
I believe the final image conveyed a quietly cinematic tone and achieved an ideal proximity to the subject and the setting.

▼ Original image

I experimented with tilting downwards to show the path leading into the image, but decided it was not so interesting to include.

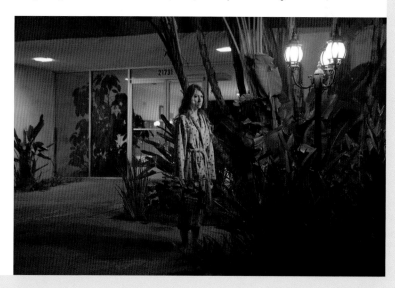

ATTACK OF NATURE

THIS IS A SELF-PORTRAIT SHOT INSIDE AN ABANDONED VIVISECTION LABORATORY, THE SAME LOCATION WHERE I SHOT THE FASHION IMAGES SEEN ON PAGES 66–67.

THIS IMAGE, LIKE *UNREST* ON THE PREVIOUS PAGE, also has a Gregory Crewdson-esque undertone to its bizarre juxtaposition of human and nature. On this shoot I was aided by Matthew. We both wanted to shoot in this green room we came across: I loved the symbolism of nature overcoming artifice in the green moss spreading over the man-made interior, and the scene was just as vividly green in reality as it is appears in the image. The light in the room was heavily diffused by the glass tiles, which made the room very easy to shoot in. Matthew helped to compose the shot, then clicked the shutter. For the final image we auto-bracketed the shots, using Photomatix to merge together three exposures.

I tried a few poses, some of which also included standing nude in corners of the room. It crossed my mind that I might merge together several figures to create a multiplicity scene, although when I got to the post-production stage I felt that would be going overboard. Just like *Unrest* on the previous pages, the context was powerful enough alone. It was almost difficult to bring a human into the scene, to transform it into a "portrait," without cluttering a view that spoke for itself. After reviewing the shots on the LCD screen, I was instantly drawn to the lying nudes. There was something compositionally engaging about the graceful streak of body within an institutional yet unruly interior.

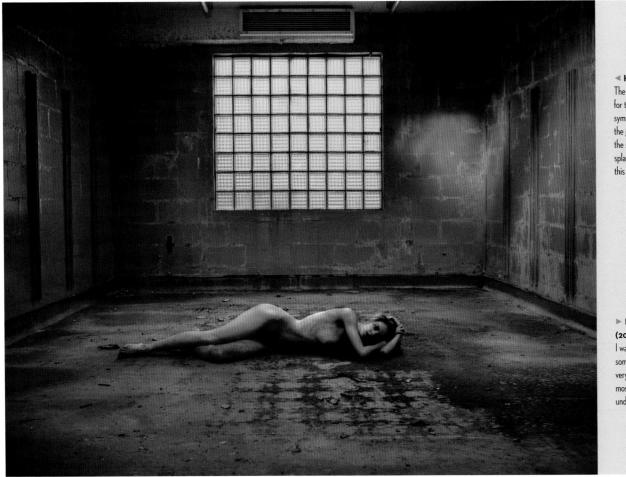

◄ **HALF-LIFE (2011)**
The final composition I chose for the image, keeping the walls symmetrical at the sides, and the glass tiles central. I liked the simplicity of the nude splayed slightly off-center in this strange environment.

► **HALF-LIFE DETAILS (2011)**
I wanted to inject the image with something sinister and surreal, but very subtle. I blended in some moss as if it was growing over the underside of the body.

It reminded me of a shored fish, pulled from its normal environment and left discarded on the floor. In Photoshop, I wanted to heighten the relationship between the moss and my body by cloning some of the moss onto the lower half of myself. I took a sample of it with the Pen tool, feathered it as a new layer, and reduced the opacity, applying a layer mask and erasing gently in areas. I wanted the surreal effect to be very subtle, as if the moss were merely a reflection of the natural growth on the underside of my body, and alluded to this in the title I gave the image: "Half-life"—a scientific term referring to the amount of time it takes for half of the atoms in a substance to decay. This was intended to be part of my *Ecology* series exploring the doomed relationship between human and nature, man-made and natural (more of which can be seen on pages 50–51). Originally when I first regarded this shot, I did not think it had much substance as the pose was very similar to other nudes and partially-clothed images I've done, but through the process of giving the image its post-production treatment and then title, I started to value the image as a final conceptual piece of its own.

THE PROCESS

I tried some poses standing, which in this case did not create as interesting a shape within the frame as when lying down.

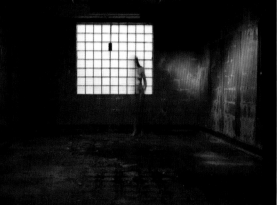

I also tried movement, which had an interesting effect against the glass tiles.

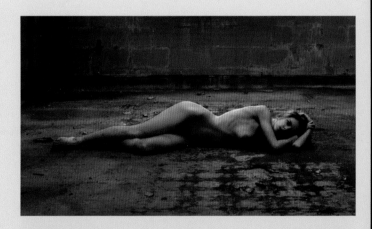

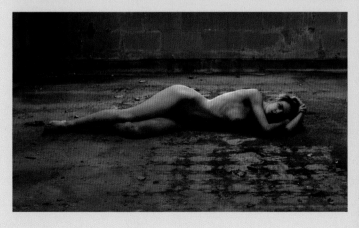

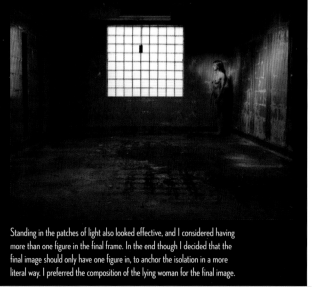

Standing in the patches of light also looked effective, and I considered having more than one figure in the final frame. In the end though I decided that the final image should only have one figure in, to anchor the isolation in a more literal way. I preferred the composition of the lying woman for the final image.

AN AFTERNOON WITH A BURMESE PYTHON

ON MY SHELF WAS A BOOK OF VICTORIAN ART THAT I HAD RECEIVED FROM A FRIEND IN AMERICA. AMONGST ITS MANY PAGES I HAD ADMIRED TWO 19TH CENTURY PAINTINGS IN PARTICULAR, ONE OF WHICH WAS *LILITH* BY JOHN COLLIER, AND THE OTHER *CADMUS AND HARMONIA* BY EVELYN DE MORGAN, BOTH OF WHICH FEATURED NUDE WOMEN AND SNAKES.

ONE DAY I DECIDED to shoot with a snake for myself. After a quick Internet search I found a snakehandler not far from where I lived who owned a 9-foot Burmese python as well as a smaller 5-foot royal python. We set the date to shoot, and all of a sudden there was little time to worry about the fact that I'd never even touched a small garden snake before, let alone had a huge one wrapped around my naked body.

This shoot brought a series of firsts: it was my first time shooting with lighting equipment outdoors, my first time shooting with a snake, and my first time putting together a team for what was essentially a personal shoot, with an extra assistant and the use of a friend's private land. I did my hair and makeup with a diligence I'd never previously bothered with, having considered—but ultimately decided against—consulting a stylist. We shot with a medium-format system that we were not too familiar with, in bright sunlight on a remarkably hot day for the month of April, and to top it off, I wanted to do something unconventional with the snake that would defy all the clichéd images of naked women with snakes that I'd seen when I scoured search engines for reference material. Needless to say, it was ambitious.

This shoot was very much a collaboration with Matthew. Because of the limited time we had with the snakehandler, we had to make sure we shot as efficiently as possible, which meant I had to put a lot of trust in Matthew to work the camera, judge the lighting, and capture my poses. In a sense, I was the model, and he the photographer. However, it would not be entirely accurate to define our roles that way, because even though I was modeling, I also primarily directed the shoot, and controlled the final selection from over 200 shots we took that day, as well as the editing of the chosen images.

Shooting with an animal is not easy: there are shots where I looked right, but the snake did not, and vice versa, and there were also shots that were beautiful, but I did not feel were very intriguing or striking. Putting aside that insecurity, I decided to go with images I did find interesting, regardless of whether they seemed to fulfill my goal of being conceptually challenging. We were shooting with a long lens (75–150mm) on the Phase One 645DF and

P40+ back. The first image I worked on was the image you see opposite: *Snaked*. This was composited from two shots, to provide the depth with the water in the foreground. The shot of me by itself had a luscious quality, but in my opinion had too tight a composition as a final image. Taking the foreground of the scene from another shot where Matthew had zoomed out, I merged them together by extending the canvas on the other shot, warping it as a layer into place, then blending as a layer mask. I cropped it and shaved off any areas of excess, flattened the image, then worked on color enhancements.

▼ **SETTING UP**
I had help from the snake handler throughout the shoot. Getting the constantly moving snake into a good position was rather tricky. The snake was also quite heavy, which meant it was easier to try certain poses when lying down.

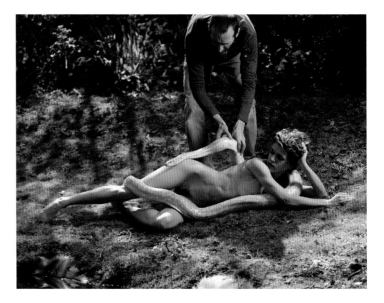

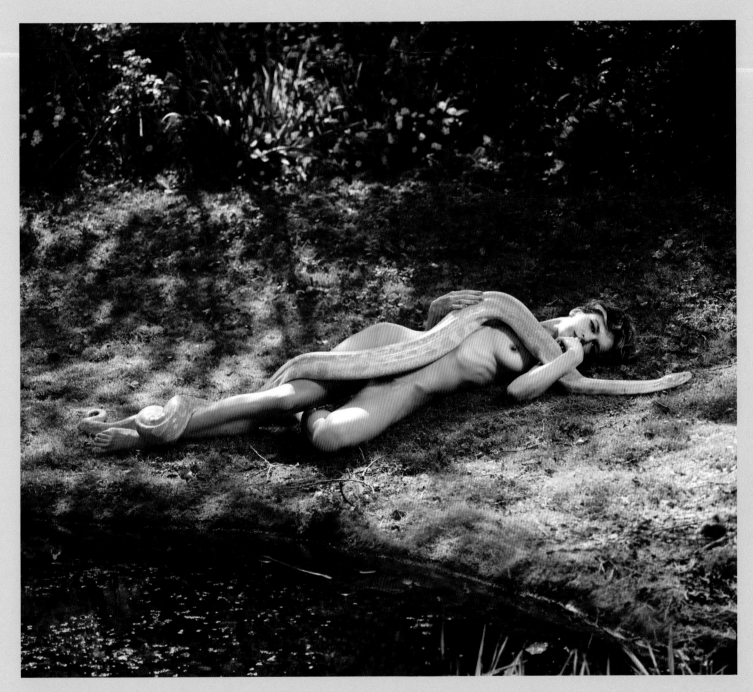

▲ **SNAKED (2011)**
Color and shape are important in this portrait: the positioning
of the body centrally in the image, the snake visible from end
to end, and the color scheme of yellows and reds which were
emphasized in post-production using Curves.

AN AFTERNOON WITH A BURMESE PYTHON

During our shoot, we made use of three key areas of the land we were shooting on. It was crucial that we knew we would not be disturbed, due to the nature of the shoot we were doing. One of the shots was taken under a crooked shelter that threw dappled light down onto my body, filtering out the brightness of the midday sun. I posed with the snake in a manner similar to the poses from the aforementioned paintings, with the frame purposefully portrait-oriented for a full-length body shot.

However, reviewing these shots later at home I realized that the surroundings didn't work so well. The structure around me was impossible to align because it was crooked in several places, so I was dissatisfied with the overall aesthetic. I liked the pose of myself as a subject, but the background made the image overall look murky and uninteresting. I almost gave up, until Matthew contributed a post-production solution. He suggested reshooting the background, and while I instantly recoiled, knowing how tricky it can be to match together two shots taken at different times and places, we nonetheless went out armed with the camera settings of the shot: focal length, aperture, and shutter speed. We found a location in a wood down the road with similarly dappled light to that in the image. I stepped into the shot so the camera could focus on me; then it was set to manual focus, I stepped out, and we shot the scene. We also shot the scene with me standing in place, in case we needed to use the top of my hair to integrate the other shot into the image.

Back at home, I then had to meticulously cut out the figure of myself from the original image, doing so with the pen tool and creating a layer mask. I spent some time placing it into the backdrop of the reshot image, choosing to flip it horizontally, and playing with the Levels and Color Balance as separate layers until it felt integrated. Even after flattening the image (which I did not do until much later, as I wanted to ensure I had zoomed in close at 100 percent, and gone round the whole figure to tidy up loose bits and pieces), I worked on darkening and lightening and playing with color in Curves until the whole image felt right. The hair looked depleted by the end, so I took in a head of hair as a new layer from another shot, reddening it slightly. I added vignetting, and used the Clone Stamp and Patch tools to clean up my skin in areas where I had visible marks (such as spots, goosepimples and, dare I say it, eczema), and added a slight rouge to my cheeks and lips. I also cloned away a flash spot from the snake's skin.

I was pleased with the results that were, I felt, a marriage of classical mood and modernity. In *Double bind*, the snake was upside down, its head between my legs—somewhat a reversal of the snake's position in the paintings I referenced. I felt that this was a neat subversion of the dominance of the snake over the woman's body, giving perhaps a suggestion of empowerment. I liked the fact that I had not used the snake to cover up my breasts in this shot, but had exposed myself in the manner of a real and unashamed nude.

THE PROCESS
Shot against what I realized was a cluttered and undesirable backdrop, the image nevertheless had an interesting dappled light as a result, which I utilized by reshooting the background in an area with thick trees overhead. I then moved the figure across in Photoshop and blended it in, which involved quite a lot of work, but with confidence of the result ahead.

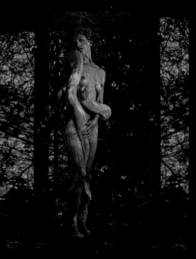

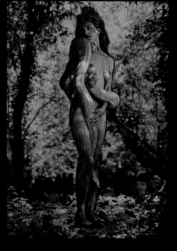

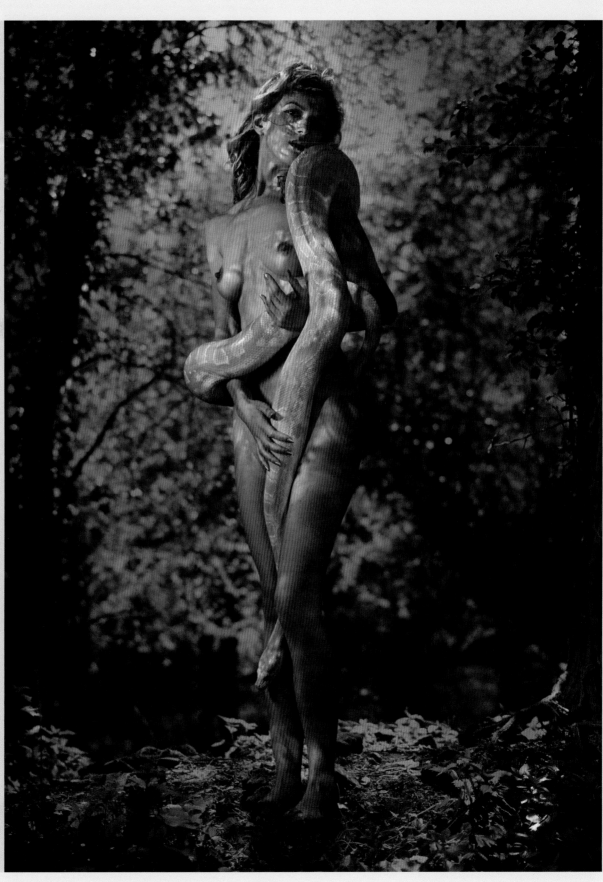

▶ DOUBLE BIND (2011)
The result has an influence from the posing in the 19th century paintings I admired, but delivered with a photographic modernity.

▼ CADMUS AND HARMONIA (1877)
I was partially inspired by Evelyn de Morgan's beautiful 1877 oil painting.

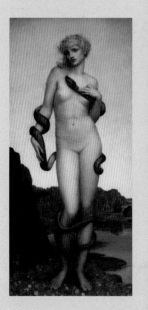

PORTRAITS IN THE MIST

THE MORNING THEY MET THE CLOUDS IS A SELF-PORTRAIT I TOOK
TOGETHER WITH BROOKE SHADEN (A CONTRIBUTOR ON PAGES 134–141),
SHOT IN THE MORNING MIST NEAR THE MOUNTAINS ON THE OUTSKIRTS
OF LA. THE MIST WAS CONTRIBUTIVE TO THE MOOD OF THIS LANDSCAPE-
BASED PICTURE, ADDING A NATURAL AND BEAUTIFUL EFFECT THAT
MADE IT WORTH RISING EARLY ON A COLD NOVEMBER MORNING.

BROOKE AND I WERE BOTH DRESSED in clothing purposefully timeless in its appearance, and we wanted a natural, rural scene to complement the vision we strived for in the images we each produced from the shoot. The band of mist made our figures stand out against the background, and gave the appearance of smoke, or a cloud—hence the title given to the final image.

The mist had given the image an instant natural depth in-camera, but was emphasized even more effectively in post-processing simply by tweaking the Levels to darken and add contrast. The final picture has the subtle hint of an HDR image, but no auto-bracketing took place: this is an example of an image that has had different parts of the frame manipulated in Layers, all from the same exposure. For example, for the sky I brought down the exposure and increased the saturation to the point right before it started to degrade. The orange dash of rising sun through the clouds essentially completed this image for me, crowning the image and leading the eye into the scene with its jagged, vibrant quality, its shape almost suggestive of a thunderbolt.

The image of myself was a somewhat candid moment of feeling the cold (while Brooke fired the shutter), composited with a shot I took of Brooke as she ran back and forth to capture movement in her cloak. I embellished the appearance of the candle inside the lantern by brightening it as if it was really lit. I liked the whimsical quality of Brooke's pose contrasted with my huddled moment of self-comfort; she appears to skip over the field, encouraging her companion to come with her, and looking to the camera like a character in a painting. Brooke's processed image from our shoot went on to win the "Time" category in a competition hosted by Canon and movie director Ron Howard.

Abandoned Spirits is a collaboration with Brooke in which she processed the final result of a shoot we did together the first night we met. We shot on Malibu beach as the sun set, shooting into the darkness with only the lights from the city in the distance. The final image is a 20-second exposure where we used a remote to trigger the shutter and lay still for the duration. There were many soft and out of focus shots, and we kept going until we got "the one." It was a delicate and painterly image even before the processing, but Brooke's editing brought out the mist forming on the sea, and textured the image to exaggerate its timelessness and bring out the white silkiness of our outfits. It had been a cold photoshoot, but an artistically rewarding session, and it was fascinating to collaborate with another artist on such a beautiful yet haunting double portrait.

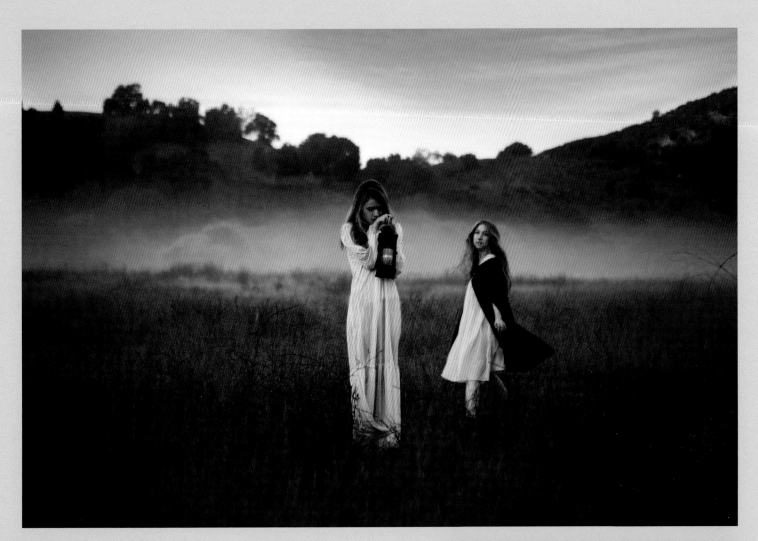

▲ THE MORNING THEY MET THE CLOUDS (2010)
The textures of the field, the mist, the sky, and the trees came out wonderfully with simple color and tonal adjustments. It was an effortlessly photogenic morning.

◄ ABANDONED SPIRITS (2010)
A collaboration with Brooke Shaden, she primarily directed this image and edited the final result. We shot this in Malibu on the day we first met, and it was exhibited at Photo LA only a couple of months later.

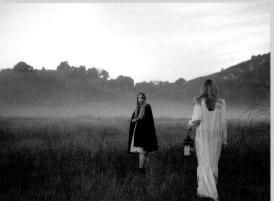

▲ MORNING MIST LOCATION AT DAWN
This was a magical and picture-perfect setting against which to shoot motion-filled portraits. I love the unprocessed look of the location.

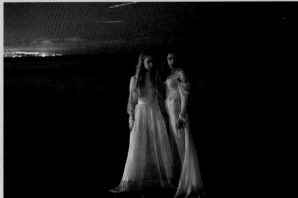

▲ NIGHT BEACH LOCATION AT DUSK
It grew darker and darker on the beach as we shot, making it harder to focus the lens, and necessary to shoot a longer exposure each time.

IN THE GARDEN

IT IS LIBERATING TO TRANSFORM FAMILIAR
SURROUNDINGS INTO A VISUALLY STIMULATING IMAGE
AND TO TRANSCEND THE NORMALITY OF EVERYDAY
APPEARANCE. THE FOLLOWING IMAGES ARE ALL SELF-
PORTRAITS, EACH OF WHICH MAKE USE OF NATURAL
LIGHT, STRONG COLOR, AND THE USE OF AN ANIMAL—
MY CAT—AS A PROP. THE IMAGES ARE ALL RICH IN
DEPTH AND TEXTURE, SHOT IN MY GARDEN DURING THE
SUMMER TO MAKE USE OF THE VIBRANT COLORS OF
NATURE IN ITS FULL BLOOM.

*L*OOPY LUPINUS (OPPOSITE) WAS SHOT on a very bright day, assisted
by Matthew. We wanted to shoot a dynamic and colorful portrait with the
cat (Roxy). We positioned a Photoflex LitePanel on the ground just in front
of me, pointing upwards, giving the marked impression of fill lighting to
counteract the shadows of the bright midday sun. I tried a range of different
positions while holding the cat as I was unsure of the final result, especially
since she kept moving. I posed holding the cat up in the air, with her draped

around my neck, and then over my shoulder while flipping my hair to add
motion to the scene. It was one of the final shots that incorporated some
movement which I liked most from the selection.

On inspecting my chosen image in Photoshop, I realized that the motion
had caused me to fall into one side of the frame, so although I liked the image,
it didn't feel right compositionally. I decided to extend the canvas on one
side, mirroring and duplicating one side of the garden on the other side of
me, to effectively enlarge the space. Adding some retouching to the face also
significantly improved the portrait: cleaning up skin with the Clone Stamp
tool and Dodge tool, brightening and sharpening the eyes, and increasing
the saturation selectively on the lips. I also went into specific parts of the
background with the Pen tool to create selective layers around certain bushes
and flowers, including the "lupinus" plant itself, and to alter the color
balance individually.

It was the crisp and cinematic quality to the image that made it otherwise
attractive to work on, despite its initial compositional challenges. I felt that
the depth and color were strong enough to see it through to completion. The
lens, the quality achieved in the detail by the medium-format sensor, and
the bright, summery environment combined to make a magical, technicolor
scene, and as people remarked afterwards, gave the picture a distinct hint of
Alice in Wonderland.

▶**LOOPY LUPINUS (2011)**
Color, motion, and the presence of the cat contributed toward
an arresting, but lighthearted portrait. I interpreted the image
as a split second in the moment before the character and her
cat run away from something they have seen out of frame.

THE PROCESS
Matthew and I shot this collaboratively using a Phase One
645DF and P40+ back. I posed, then came back to check
the images, adjust the framing, and tweak my next poses. The
shots were taken at a distance using a medium telephoto lens at
150mm, resulting in a delicious natural depth of the final images.

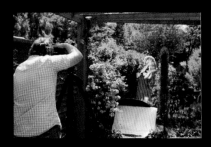

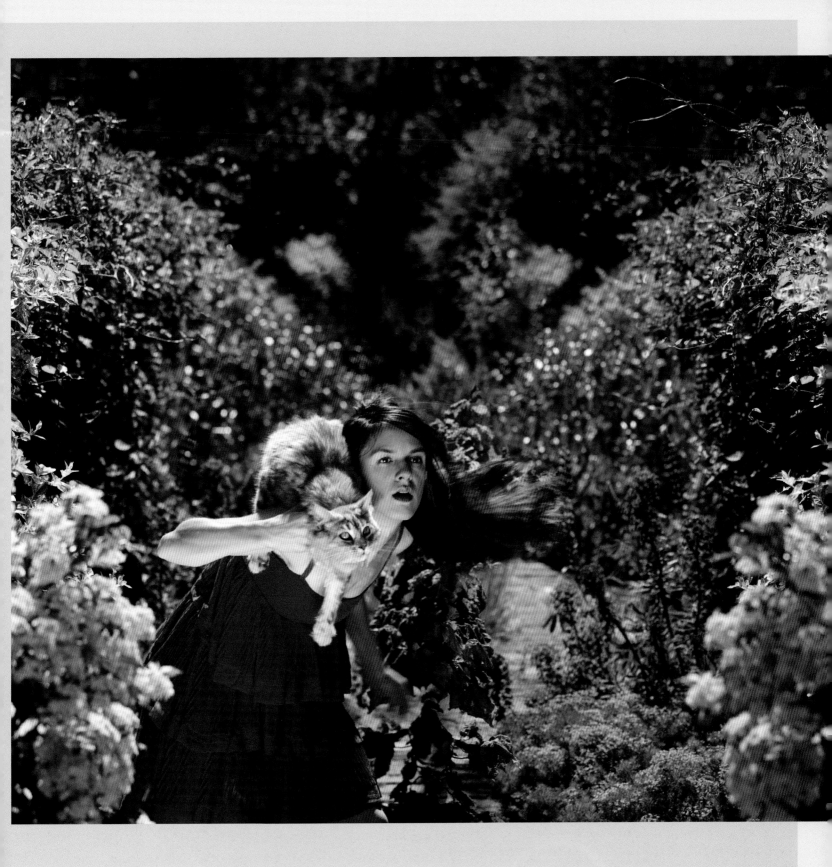

IN THE GARDEN

For *Lobster* (below) I wanted to make use of a fascinating designer's hat I temporarily had in my possession: a particularly artistic object shaped like a lobster or insect. Choosing the peaceful and natural surroundings of my garden as a location, I tried several standing positions which I found difficult to work with, as my head entered the sky in the framing, introducing fence-tops and other garden clutter into the frame. Instead I sat down on the grass, and found I liked the way the folds of the dress toppled over the ground. I shot a series of different pictures and made a decision afterwards, choosing the sitting portrait, feeling drawn to the sprinkling of red buds in the picture and the melancholy expression of the turned head. The cat was added from a shot I'd taken in the same session. Working on adjustments in Curves on this image

helped to create a painterly appearance, and for me went quite a way towards achieving the desired intersection between fine art and fashion.

Incestipede was a bizarre amalgamation of impulse during post-production, inspiration from Guy Bourdin, and also from sculpture. I started out with the intention of simply shooting a nude of myself by the pond in my garden. I had tried different ways of accessorizing this nude image to create a picture with a little more narrative: I had sunk a birdcage into the pond for some of the images, placed a picnic blanket in the water, as well as some imitation roses. Looking over the images, however, I found myself wanting to get rid of the props. They seemed too contrived and confusing with their multitude of possible meanings. I looked through the different poses, and processed the best nude: it was pretty, but nothing more. Seized suddenly by curiosity, I decided to cross a body from one image over another, and then to physically merge them. During the experimentation, in some arrangements I liked the illusion that there was a body underneath or behind me, but when it came to the leg, a quick erase of the layer mask through the top, where it crossed over, made a whole new limb altogether: an alien-like right-angled joint. I spent some time deciding to keep it like this, as this kind of surrealism felt like new and exciting territory, almost reminiscent of the shapes in Henry Moore's work. The top two images show the main components that were fused to make the main body shape. Then I brought in a hand from another image, and took the extra leg from yet another.

I kept the roses, because I felt that the dash of red completed the color palette of the image, and also decided to add in the cat, who had dashed behind me as I shot the images. It added an oddly everyday aspect to the area behind the static main feature, running away from this out-of-this-world installation by the water. I changed the hue of the water to appear bluer, so that it did not appear as nondescript terrain in the foreground. Working on color adjustments in Curves completed the final palette of the image, in particular deepening the purples in the shadows. It was complete, and with the title I chose I wanted to suggest the possibility of there being more than one person in the pile who is yet one and the same: crossing that concept with the visual suggestion of an insect.

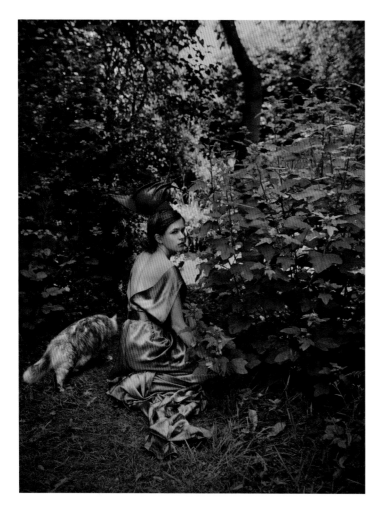

◄ **LOBSTER (2011)**
This was intended as a simple outdoor portrait to show off the bright paletteof the Joanne Fleming dress and Vesna Pesic hat together.

▶ **INCESTIPEDE (2011)**
Arriving at a compositionally pleasing shape was the overriding motivation behind this image. By creating a surreal, alien-like formation of the female body, I took the image beyond that of a typical nude.

THE PROCESS

These two nudes were the sources for my production of the final piece. I liked them individually but felt they lacked something creatively. I married them together to create a surreal form not quite human, spending a great deal of time repositioning the layers to make sure they found their right place in the piece.

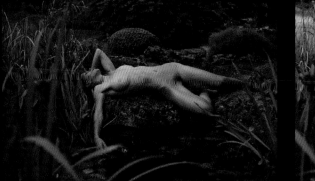

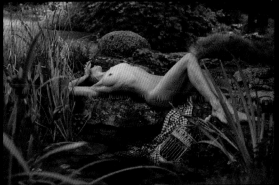

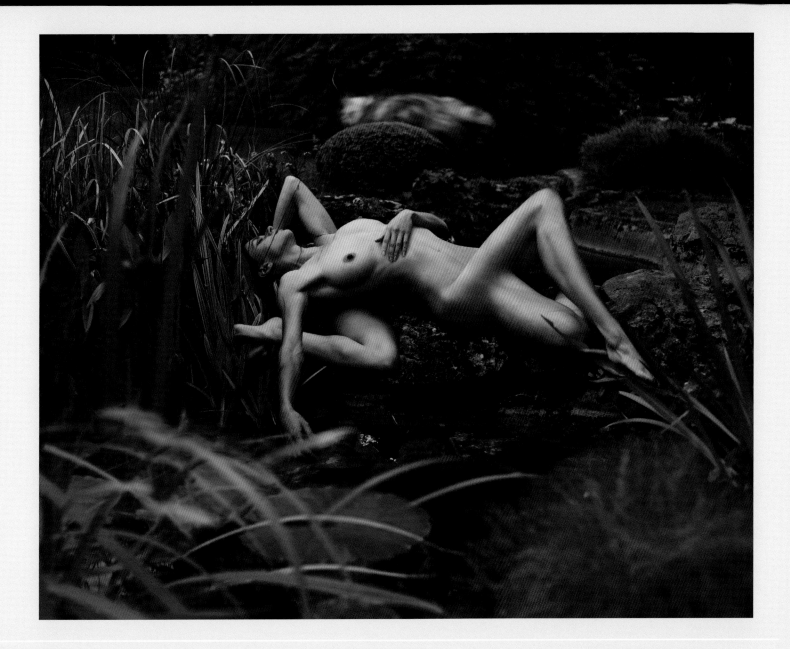

STARK WINTER PORTRAITS

SHOOTING IN THE WINTER MIGHT SEEM
UNDESIRABLE, BUT THERE ARE ACTUALLY SEVERAL
GREAT ADVANTAGES TO IT. I HAVE FOUND MYSELF
PRODUCING A WHOLE SERIES OF IMAGES
IN THE AUTUMN AND WINTER WHICH COULD NOT
HAVE BEEN SHOT WITH THE SAME MOOD AND
ATMOSPHERE IN THE SPRING OR SUMMER.

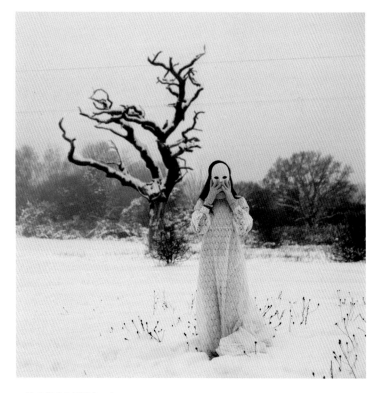

▲ **BLANK CANVAS (2011)**
This is one of the most anonymous self-
portraits I have created. It was inspired by
the blankness of the winter scene, and a
mask I picked up from a crafts shop.

THAT DIFFERENCE IS ABUNDANTLY CLEAR FOR an image like
Blank Canvas, a picture of me shot collaboratively with Matthew. The
white of the snow parallels the white of my dress and mask, and the stark
shape of the distressed tree (which fell down only two weeks later) form an
image that would be very different in tone had it been shot surrounded by
green grass and spring blossoms.

The features of winter that make it wonderful for creative portraiture
include the blank canvas of snow, the textures of leafless trees and detail of
naked brown ferns, but it is also the lighting that makes the season so excellent
for photography. Soft, diffused light which makes shooting portraiture—and
especially nude portraits—more effective. All of these aspects of winter
shooting characterize the next few pages.

Getting up at sunrise to catch that first soft light is easier in winter, when
the sun can rise as late as 07.30am. Also, at sunset one has more chance of mist
developing, without which the long exposure of the tail-lights in *Heatstroke*
(opposite) would not have been so atmospheric.

Although both of the images on these two pages do not appear to be
photographic trickery, they are actually both composites of a kind. In *Blank
Canvas*, I took the tree from one shot into another, combining it with the shot
of the figure. I first decided it was a stronger image when cropped square, and
removed the wasted space to one side. I then hesitated over whether the shot
would look better with the tree in view, thinking it was an interesting image
both with and without it, eventually deciding on the tree version because of
its overall striking aesthetic. Moving the tree from one picture to the other,
even though the shots were mismatched in terms of scale and angle, wasn't
particularly difficult because the background was white and featureless, and it
was easy to blend from one image to the other. I was pleased with the final
composition, even though I also thought it worked without the tree.

Heatstroke had a little more to it. Out shooting with Matthew, I positioned
the camera to shoot myself about an hour before the sun set, posing by a small
stump of a tree. I had the notion of being nude, apart from my faux-fur coat,
so that it would appear in isolation for what it symbolizes—namely human
self-indulgence and exploitation of other living creatures. I tried several poses.
Later we shot other images after the sun had nearly gone, including some long
exposures of car headlights and tail lights coming through the mist over the
nearby road. In post-production at home later that night, the portraits of
myself looked too vacuous, and the long exposures too vacant. I decided to
fuse them together and get what I ultimately wanted: the human element I'd
originally sought for, but with a much more powerful and meaningful context
that I did not foresee.

▼ **HEATSTROKE (2011)**
This is one of my most topical portraits, albeit shot with the subtlety and ambiguity I always desire. It launched a whole series of new images whereby the surrealism was evident, but in new ways, without including levitation or overt visual tricks.

GOLDEN HOUR
BY THE SEA

THE IMAGES ON THESE PAGES REPRESENT THE
BEAUTIFUL LIGHT ONE CAN ACHIEVE AT THE TWO
OPPOSING, YET SIMILAR, ENDS OF THE DAY: SUNRISE
AND SUNSET. THE KIND OF LIGHT AVAILABLE DURING
THE "GOLDEN HOUR" CAN DECORATE A PERSON WITH
A SOFT ORANGE GLOW AS IN *SILENT SIREN*, OR
PRESENT A MAGNIFICENT MURAL OF COLOR
IN THE SKY, AS IN *MOORED*.

BOTH OF THESE IMAGES were shot as part of a series, or at least a phase
of interest, in the theme of dystopia: of presenting fallen figures alongside
decay and debris. The following and previous pages show further images in
this series, which I came to later title *Ecology*. *Silent Siren* was shot one early
morning in Malibu during a trip to California in the winter of 2011. I was
interested in shooting a figure partly out of the frame, in this case model
Katie Johnson, as if she just happened to be there, washed up like flotsam. I
placed plastic water bottles into the seaweed around her, which I purposefully
brought along with the intent of connoting the notion of plastic waste in
the sea. Although I felt that this theme was perhaps too forced in terms of
my prop-placing, I loved the conviction with which Katie had posed, bravely
in the chilly brisk morning lying on the beach, and the pin-sharp beauty of
her profile and golden hair seemingly merging in with the seaweed, like a
mermaid. I felt as if the model's performance saved the shot. The choice of
composition was very important here. Just like with *Unrest* on pages 34–35,
I had many choices of shot which showed more of the model and more of
the scene. I decided to choose this crop which, although it truncated her
body, kept a more stable composition, and created the sense that she was
interrupting the picture, rather than the sole intended focus.

Moored was shot in Dungeness, a famously rundown seaside town on the
coast of Kent in England. I brought along a vintage 60s-style raincoat with me
to suit the seaside location, and had the idea of doing something dystopian
and slightly disturbing with the rotting boats along the beach. We tried
various images where I was hanging out of the boat. For this image, I
composed the shot and posed while Matthew took three auto-bracketed
exposures of the scene—two stops either side of the main exposure—as the

sun was setting. We only had a little time before the sun would disappear
completely, so we worked quickly and got as many shots as we could. I like my
pose in this shot and how the sun is peeping just over the edge of the boat. I
processed the image using Photomatix to bring together the three exposures
(right) which resulted in the tonemapped image (opposite). I did further work
in Photoshop by working with the original Raw files as layer masks over the
tonemapped image, as I wanted to heighten the drama of the sky while leaving
the bottom half low-key and moodier. By producing an HDR image, I was able
to get the fine detail of the broken windows in the boat, where the camera
would normally have to overexpose the shot in order to make the figure visible
in the same frame.

◄ **SILENT SIREN (2011)**
Taken with a focal length of 24mm, this portrait encapsulates a lot of the environment while also rendering fine detail in Katie's facial features. The particular angle was all-important to gain that balance.

▼ **MOORED (2011)**
By waiting until sunset, the beauty and decay of this location became wonderfully apparent. Placing an anonymous human element into the image crosses a landscape shot over into the realm of portraiture.

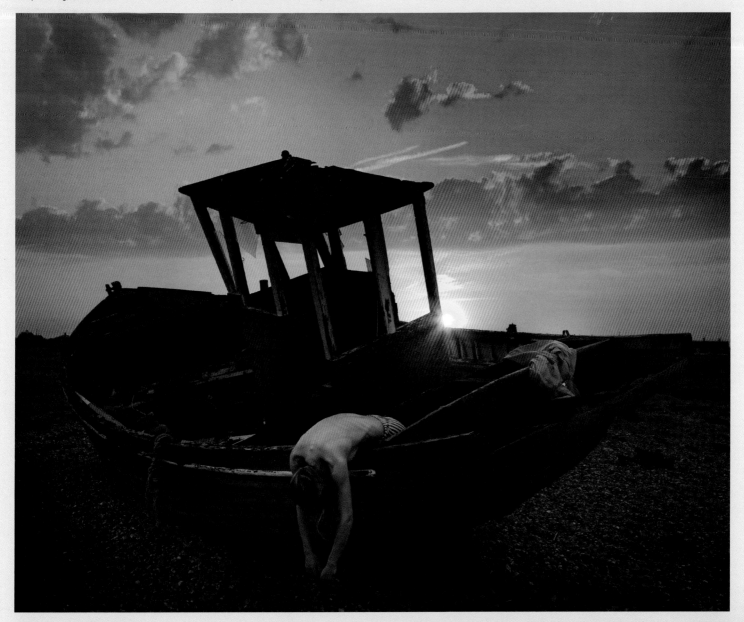

THE PROCESS
The three exposures taken for *Moored* before the final image was merged in Photomatix, and then tweaked with color adjustments and also cropped slightly in Photoshop.

NATURE AND WASTE

THE IMAGES ON THESE PAGES SHOW HOW NATURE HAS BECOME AN ENCOMPASSING THEME IN MY FINE-ART WORK. HERE I INCORPORATE STRANGE PROPS, INCLUDING ACTUAL ITEMS OF WASTE AND DEBRIS, INTO MY IMAGES.

I HAD WANTED to do this for a while before I first tried it. I wanted to place contrapuntal objects into my self-portraits that would jar the viewer slightly, but I found that it was quite hard to do so without the prop looking like an unwanted contrived component. I had a revelation with *Gyre Falls*, which I shot in a wood in Los Angeles in the early morning, where I set up the shot, stripped bare, and had a friend click the shutter. I felt rather ridiculous wrapping the plastic wrap around myself, and I couldn't see exactly what the shot looked like until I went back to check and shoot some further shots. The idea of using the wrap in this way was to make it resemble a stream of water pouring down onto me, symbolic of the way in which man-made materials are outweighing natural resources—and in particular, the abundance of plastic and its presence in the sea. I wanted it to look as if water was turning into plastic. However, I did not want the topical aspect of my intent to be overbearing; my main goal was to achieve a beautiful picture, because for me that is how a more profound layer of meaning is achieved. I wanted the possible meanings to be suggestive, not definitive; it is only in a book like this that I would think it appropriate to go into detail about the thought processes behind my work.

The strip of images below shows an overview of my process. First I took test shots, where I got an idea of how the plastic wrap looked on-camera, and how the light was working. Whether it's a self-portrait or not, this stage is important for getting a sense of direction. I then started to form my pose in the frame and lowered the camera slightly. It was once I started to lie back that I achieved the right perspective on my body—a crucial aspect of posing a nude portrait. I chose the final image for the particular pose and strain of the arm, the plastic slightly obscuring the face, and the shape of the material. I added to the plastic wrap by taking a sample from another shot, to make it seem like the plastic was dripping from my body, forming rivulets falling on the ground. I also decided to crop the top off—it was important to me to keep the line of plastic, as if it was a waterfall, but I considered the very top of the branch to be unnecessary. I also added more plastic to the section of the image just above the hand, and afterwards applied a Curves adjustment to the whole image, tweaking the colors to how I wanted them, simply working by eye.

I was pleased with the resulting image, considering I'd framed myself blindly. I liked the way in which the shape of the plastic also suggested a soul rising from the body—another level of meaning that anchored the overall reference to human mortality. I also found it interesting that my outstretched pose was not dissimilar to that of the main figure in Michelangelo's *The Creation of Adam* (c 1511). This intertextuality, relating the image to art history, and yet with the image being a photograph with a prop from our "modern" world, gave what could have been a simple nude self-portrait much more depth. To title the image, I looked for a word that referred to the ocean and subtly alluded to its pollution, and chose "gyre," to represent the polluted vortexes in the sea. "Falls" had a double meaning, echoing a disaster within the natural world as well as the human demise, and also sounding like the image was named after a waterfall.

▶ **GYRE FALLS (2011)**
A self-portrait nude where the simple use of an everyday material, plastic wrap, becomes a potent symbol and metaphor.

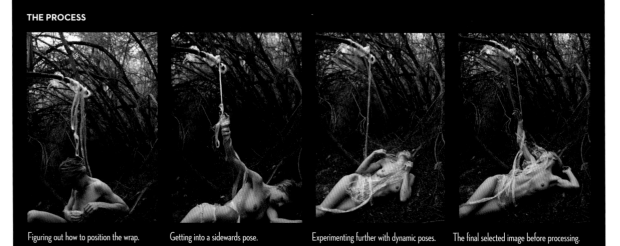

THE PROCESS

Figuring out how to position the wrap.　　Getting into a sidewards pose.　　Experimenting further with dynamic poses.　　The final selected image before processing.

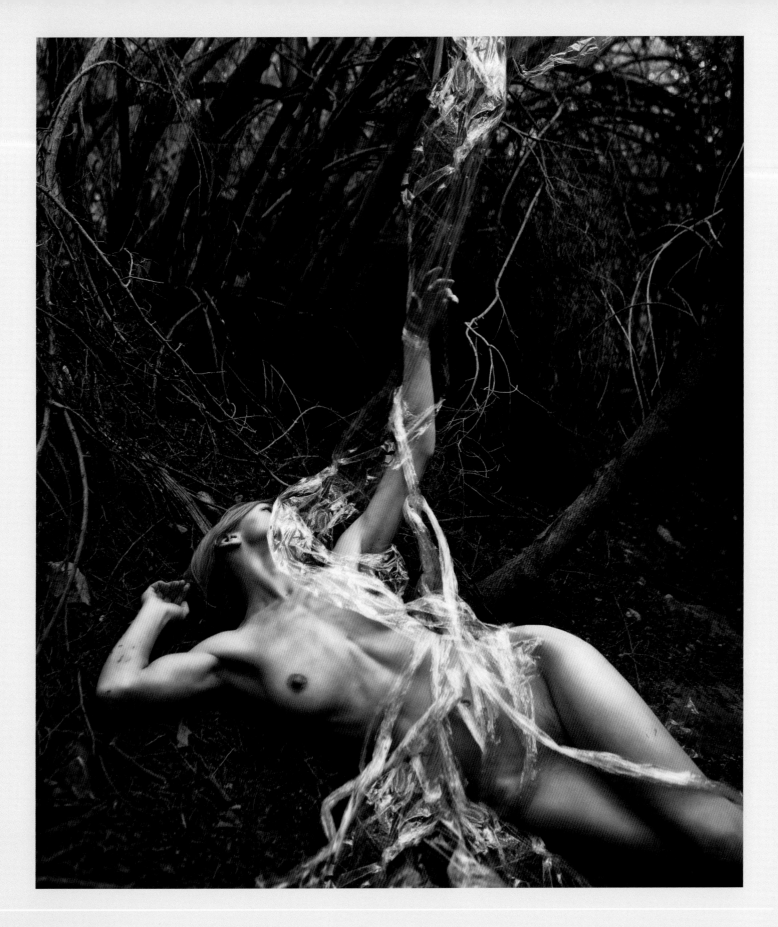

CHAPTER 3
URBAN PORTRAITS

I SHOOT IN AN URBAN SPACE WHEN I CRAVE EDGE, AUTHENTICITY,
A SENSE OF THE REAL BRICK-BUILT WORLD WE LIVE IN: WITH ALL ITS
ACCOMPANIMENTS OF DUST, GRIT, AND ROT. URBAN SPACES AND OBJECTS
OFTEN CONVEY CHARACTER AND A NOTION OF TIME IN A MANNER
THAT NATURAL SCENES CANNOT.

THE LANDSCAPE OF THE CITY, AND OBJECTS associated with the city, can convey deeper messages about the world we live in—and in a portrait—the role of the human element within it.

Urban locations often pose more practical challenges than shooting in nature, but the times when I have been able to shoot in an abandoned building or in a street full of character have rewarded me in ways that cannot be beaten by the most photogenic natural vista. The theme of decay runs in abundance throughout this chapter. A building in disrepair can be somehow more interesting than a functioning one, and the textures in such environments can have great impact on a creative portrait. Disused satellite dishes in the midst of the Lincolnshire countryside emanate a curious charge that transforms an otherwise tranquil rural scene, while a rundown street becomes a bizarre backdrop for a magnificently dressed model.

As my fine-art work often places dystopian objects within a natural scene, urban scenes can take on an apocalyptic semblance alone. When a scene is more loaded with meaning, it can take more care to place the human element in a way that does not clutter or overwhelm the scene. Simple juxtaposition becomes a key feature of urban shoots, including the abandoned locations such as the mental asylum or derelict children's ward. The standing subject is enough, appearing surreally and starkly alone. In other images in this chapter, the subject is jumping, hanging, or even levitating, becoming a form in their own right; perhaps as moribund as a car shell, or jumping with energy, as tall as a building against grey skies and puddles.

▶ **RETREADING (2011)**
On first spying these tires, I would rather have shot a nude portrait, but this was not possible in the location. Instead, I used a clinging red dress that had almost tire-like grooves in its material, and the result I believe turned out better than a nude would have done. I was inspired by Guy Bourdin's images where women's legs and feet enter the frame of an image in unusual and candid ways.

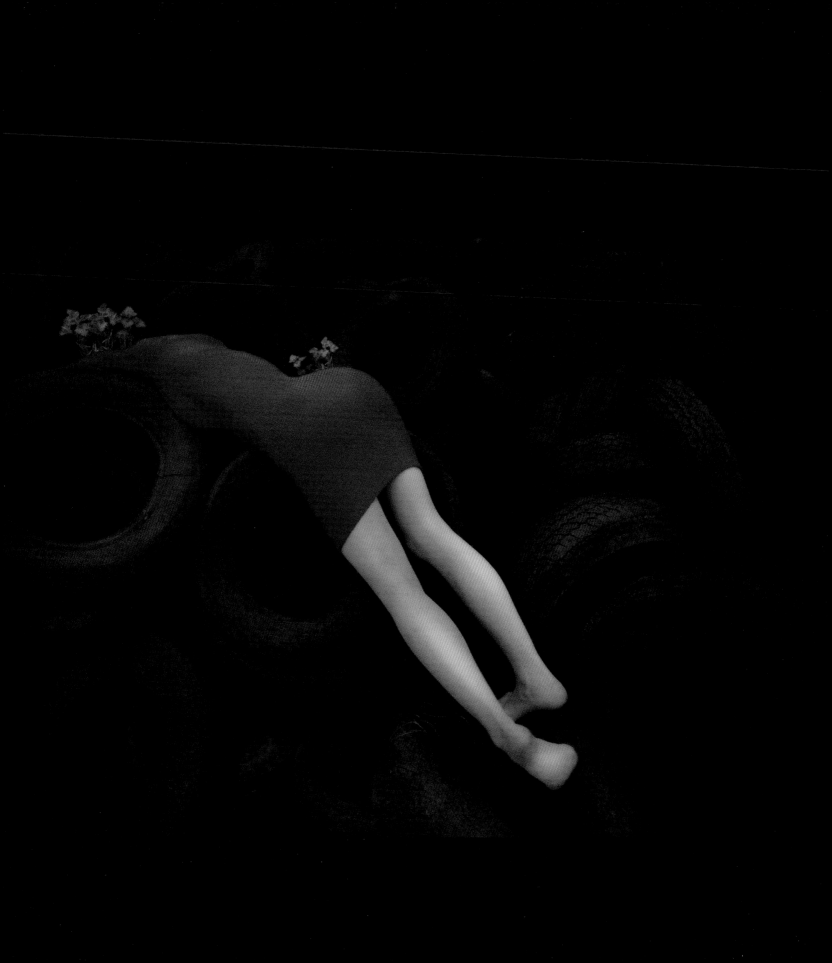

SHOOTING TIM IN AN ABANDONED HOSPITAL

PHOTOGRAPHING TIM ANDREWS WAS A UNIQUE EXPERIENCE
FOR ME, PARTLY BECAUSE I HAVE NOT OFTEN USED MEN AS MODELS,
BUT ALSO BECAUSE OF HIS CIRCUMSTANCES. HE HAD ALREADY BEEN
PHOTOGRAPHED BY OVER A HUNDRED OTHER PHOTOGRAPHERS
INCLUDING RANKIN AND JILLIAN EDELSTEIN, AS PART OF AN ONGOING
PROJECT IN WHICH TIM PLAYED THE ROLE OF A MODEL OR MUSE.
THE PROJECT PRESENTED MULTIFARIOUS REPRESENTATIONS
OF TIM BY A DIVERSE MIX OF ARTISTS.

TIM'S LIFE CHANGED when he was diagnosed with Parkinson's disease. He retired from his job as a lawyer and started to embrace a different lifestyle, one that has offered up a whole new creative freedom. Tim approached me by email telling me about the project, inviting me to shoot him, and we met to discuss what had attracted him to my work. I decided I wanted to employ trickery and movement in his shots, as well as a celebratory sense of this man having fun and fulfilment in retirement despite the situation with his illness. First, I wanted a great location, and luckily enough the one I managed to get access to was perfect for the juxtapositions I wanted to achieve.

The location, an abandoned children's hospital, was one I had noticed while out in East London. With a bit of research I found out how to access the location. There were various areas I wanted to shoot in with Tim, including a room with a still-functioning operating theatre lamp, and an old children's ward. We also shot in desolate blue wards and a dark basement.

Having been used to shooting female models, I thought it would be a challenge to shoot Tim, as there wouldn't be the typically feminine poses, swishing gowns, and red lips that adorn much of my own work. In fact, it turned out to be one of my most enjoyable shoots ever. Thrilled at being in the abandoned location to start with, I felt instantly inspired by the derelict surroundings, the textures of the peeling paint and the discarded objects, and the way the children's hospital setting provided interplay between the fact of a serious medical condition and the childlike rebirth of Tim's creativity.

◄ BLUE WARD (2010)
This floor of the hospital had the best natural light, and made an ideal setting for some relaxed portraits with the background thrown out of focus. Tim added an edge to the shot when he swung his cane over his shoulder, and I also liked how this action brought his hands into the frame.

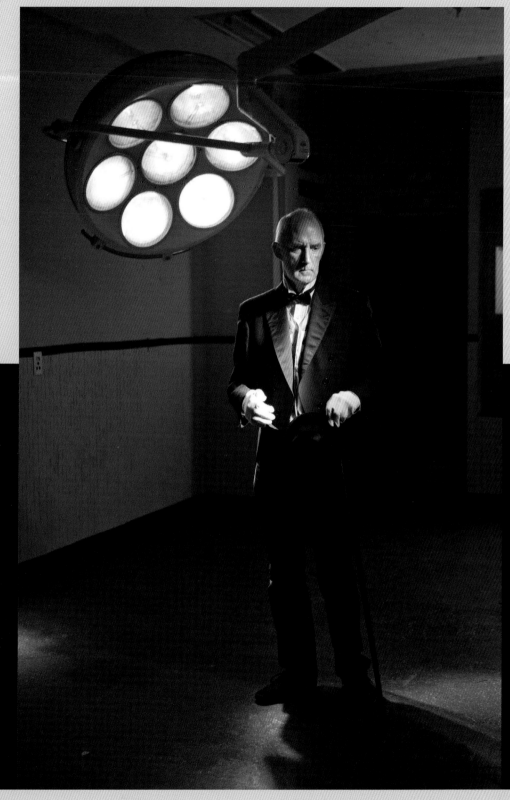

◄ AD LIB (2010)

We started in the room with the operating light, which was a tricky place to shoot because of the high-contrast lighting coupled with the brightness of the lamp. I positioned my camera on a tripod and auto-bracketed the shots so that I could blend more detail into the background of the portraits. I loved the symbolism of the operating lamp as a stage spotlight, with Tim "performing" below it, in a quirky choice of outfit. However, I also wanted to try something with visual trickery and multiple figures. The main image that went on to be featured in Tim's collection fulfilled these ambitions, and is displayed on the next page.

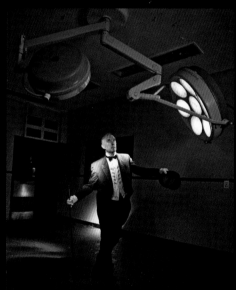

▲ THEATER (2010)

This was a perfect juxtaposition using one of the best features of the abandoned hospital: the working operating theater lights. I tried several poses and this was my favorite.

SHOOTING TIM IN AN ABANDONED HOSPITAL

The most memorable room we shot in during our collaboration was a room that appeared to have once been a children's dormitory, and had a mural on the wall that read "Every Day is a Holiday." Coincidentally a very apt statement in the light of Tim's retirement, I immediately wanted to incorporate it into a shot.

Shooting in abandoned places can be tricky when it comes to lighting, and I have often used HDR which involves shooting several exposures of the same shot and merging them together to achieve a diverse luminance in a high-contrast lighting situation. Here, however, because I had gained permission to use the premises, I felt relaxed enough to be able to set up my tripod and attach my external flash to a light stand and umbrella to experiment with using artificial light on Tim. Testing the flash, I saw that the effect the light had on the trees of the mural was instantly fascinating—but more so when the flash and umbrella were kept in the frame. They seemed to become elements that tied in with Tim's story, as if referencing the performative aspect of his photographic projects. I decided to keep the light stand in shot and have Tim pose in his suit and top hat beside it, then look behind him as if he were gesturing to another clone of himself. By keeping the camera static I could then shoot Tim as the clone, this time nude, holding out his hand as though reaching to his leading partner. I intended to put both poses together in post-production, though the transformation of his size was a spontaneous decision I made in Photoshop.

My first step was to cut out the second shot of Tim to be moved to the main image. I had kept the camera in the same place between shots, so the pieces merged without trouble, but whenever I bring parts of more than one image together it is not just the technical boxes that need to be ticked. The components need to gel well, and part of the alchemy of photography is not knowing whether an image will truly work as a whole until the editing stage. I had a few shots of the left-hand Tim looking up, and some looking down. I preferred a shot of him looking down, but this meant his eyeline did not meet that of the second Tim when left at full size. So, quite by accident when I was scaling the second Tim, I saw that the gaze met if I simply made the second Tim smaller. I am not usually keen on tampering with scale, but on this occasion I was drawn to it.

Further work I did to the image involved deepening the greens and darks in Curves, cropping the image so that there was less blank space on top and bottom, and cloning out a seam in the wallpaper I found distracting in this particular polished image.

Every Day is a Holiday was exhibited as part of Tim's "Over the Hill" exhibition, at Guernsey Photography Festival and Impact Art Fair in London in 2011, and also in an exhibition in Berlin. It was also featured in UK newspaper *The Guardian* weekend supplement and BBC2's Culture Show as part of a feature on Tim.

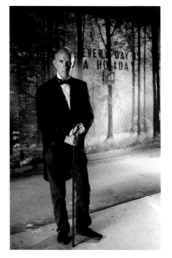

▲ **WITH CANE (2010)**
A more formal portrait of Tim standing in the same room with the mural.

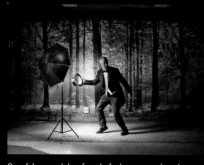

THE PROCESS

One of the original shots from the final composite, where the actual framing is apparent. Because of the style of the room and wallpaper, the top and bottom were redundant parts of the frame that I cropped away, making the final image widescreen-style.

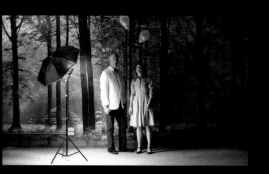

BEHIND THE SCENES
Tim and I take a shot together, with the balloons I also brought along and inflated as props to compliment the surrealism of the setup.

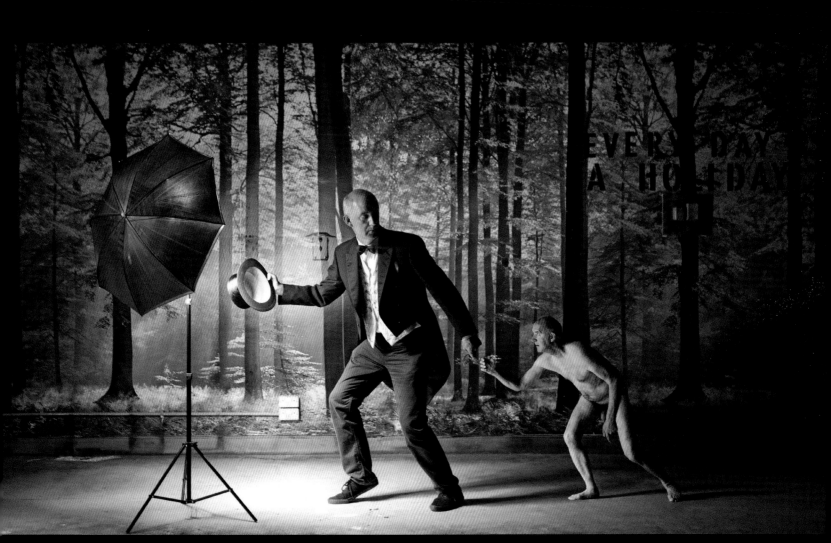

▲ EVERY DAY IS A HOLIDAY (2010)
The main piece from the shoot with Tim, and the favorite for both of us. I feel it chimes with my style of multiplicity and surrealism while also hinting at several key aspects to the psychology behind Tim's whole photographic project.

FULL OF GRACE

WHAT SEPARATES A PORTRAIT (EVEN A "CREATIVE PORTRAIT") FROM A TYPICAL FASHION IMAGE IS THE NOTION OF A HUMAN ELEMENT. FASHION IMAGES ARE PICTURES OF CLOTHING THAT HAPPEN TO CONTAIN PEOPLE, WHILE PORTRAITS ARE PICTURES OF PEOPLE WHOSE CLOTHES OR ADORNMENTS ARE USUALLY IMMATERIAL. IN A FASHION IMAGE, THE SUBJECT IS A MODEL; A PORTRAIT IS USUALLY OF A REAL PERSON, WHETHER OR NOT THEY ARE PLAYING THEMSELVES AS THEIR ROLE.

THESE IMAGES of model Grace Gray can certainly be categorized as fashion—but also as portraiture. The focus on her physiognomy, her connection with the camera, and the distinct representation of her personality all play a part in an image story that is not just about the dress she is wearing. These shots were taken at a prop house in London, on an original Victorian street that ran right though the middle of the location.

I enjoyed shooting with Grace who posed vivaciously for the camera. Her costume was wonderful for its texture and glow in the final images, and her face, hair, and makeup had a pin-up quality that was perfectly complemented by post-processing. I shot Grace with natural lighting, but used a huge reflector (a Photoflex "LitePanel") camera right, which made a big difference in bouncing back the overhead sun to fill in the shadows.

▼ ▶ **FULL OF GRACE (2011)**
I shot these images of Grace with a Phase One 645DF medium-format camera and natural lighting.

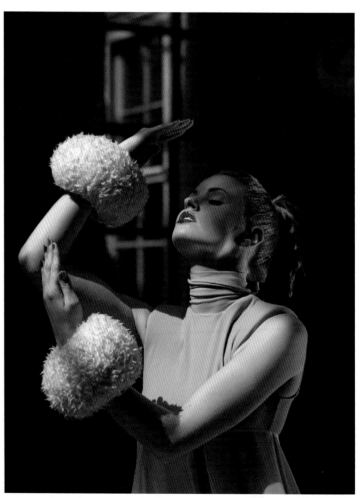

BEHIND THE SCENES

During the shoot, what made these images work was Grace's character and the way she expressed herself performatively for the camera. In processing, what polished the images was the use of the Curves adjustments in Photoshop to lift the dark shadows of the images, deepen the blues and greens, and make the reds and yellows "pop" by contrast. I also manually increased the saturation of the reds, and took the Clone Stamp and Patch tool to clean up areas of blemish on the skin, sharpened the eyes, and made the lips redder by selecting around them and increasing their saturation. The whites of the dress also benefited from a subtle Diffuse Glow, ensuring I did not blow out any highlights on the "poodle puffs," the dress, or the skin.

Even though the adjustments in Photoshop were relatively subtle and did not change anything compositionally about the photograph, the changes made the images a lot more interesting in my opinion. They lifted the image from "a shot in-camera" to a polished image: painterly, yet still full of detail.

▼ **GRACE (2011)**
Curves adjustments in Photoshop, subtle airbrushing, and a Diffuse Glow all added to the pristine, painterly aesthetic of these portraits of Grace.

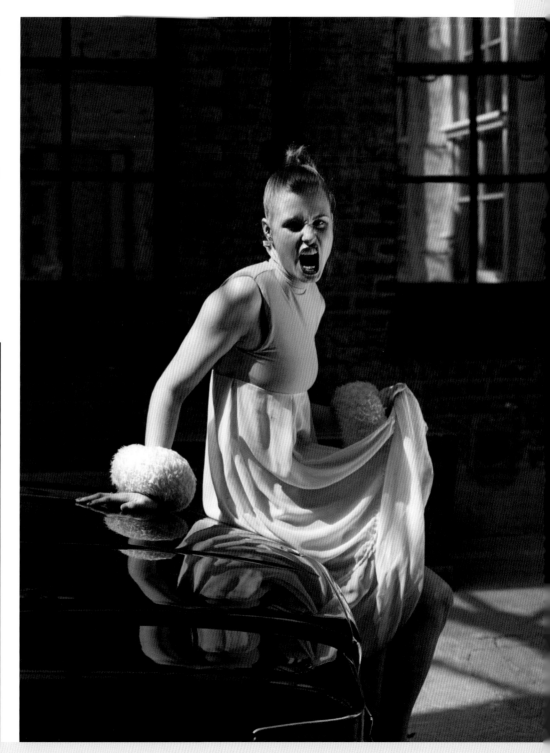

THE PROCESS

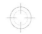

IN A GARAGE IN LA

THE TWO PORTRAITS ON THE FOLLOWING FOUR PAGES WERE SHOT INSIDE A SMALL BUT
ATMOSPHERIC BUILDERS' WAREHOUSE IN DOWNTOWN LOS ANGELES, USING NATURAL LIGHT
FROM A SKYLIGHT IN THE BUILDING. IN BOTH I EMPLOYED TRICK COMPOSITION TO ACHIEVE
A SURREAL, FANTASTICAL RESULT. SHOT DURING WORKSHOPS, THEY DEMONSTRATE THE
SIMPLICITY OF THE TECHNIQUES USED, AS WELL AS THE IMPORTANCE OF BOTH A GOOD
ANGLE AND POST-PROCESSING TO ENHANCE AND DE-CLUTTER THE ENVIRONMENT.

A T FIRST GLANCE *Body Repairs* is striking for the ominous questions it raises as to the subject's state and the implied narrative. The model hangs from a chain in seeming discomfort, neither absolutely alive or definitely dead, and with no obvious clue as to how she got there. The image's surrealism lies in its subtle use of manipulation: the woman's position is not necessarily impossible, but is definitely uncomfortable. A strategic placing of props in the original setup, and post-production to remove the aid, has resulted in an image that effectively conveys a sense of the surreal without a blatant focus on the mechanics involved.

The original shots to the right show how the assistant, Sean, held a chain up into the air while the other end was wrapped around the model Katie. Lying back on a stool, she had great flexibility and was able to wrap herself back down the other side and hang her head on the floor. I took another shot of the scene without Katie or the stool, which I layered into the composite afterwards, and removed the stool and assistant.

The objective was easy to achieve in terms of having Katie appear to be hanging. The hardest part was making the image look effective and interesting contextually and aesthetically. Having shot this image in dark surroundings, but wanting to retain the exposure on the model, I reopened the same image in Camera Raw and worked on a separate file for the background, overexposing it, then de-noising, increasing vibrancy and layering it into the shot. By masking it exclusively over the background, it gave a painterly quality to the scene behind Katie without affecting the quality of the foreground. I also took an extra piece of hair from another shot to make it seem as though her curls surrounded her head fully, filling in the gap in the middle. I boosted the impact of the image overall by adjusting colors in Curves, adding vignetting, and cropping the image to leave out some of the distractions on the left. I enhanced the red of Katie's lips and brought the missing shadow back into the image.

I loved watching my influences come alive in this somewhat unexpected edit. The rushed shoot and the mistakes I'd made during the shots, such as not changing my lens to manual focus for the empty shot of the scene, made the editing challenging. I worked carefully to match the shots and improve the overall scene, blurring out the boxes in the background and adding a final stroke of dodging to the model's legs to give the final image a kind of illustrational, comic-book appeal.

THE PROCESS
I could see that the shape of the model's form in the main posing shot was striking enough to work with, and the darkness around her made for a fairly easy edit.

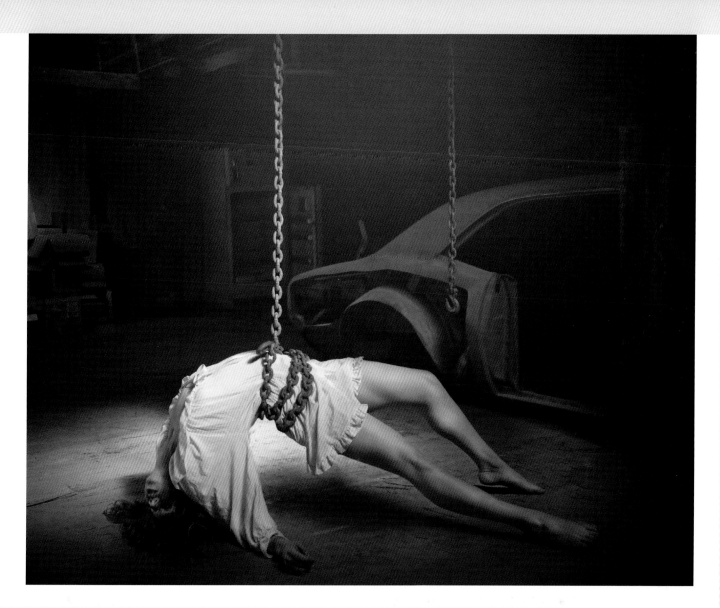

▲ BODY REPAIRS (2010)

This portrait was inspired by horror films and fashion photography. I was able to create it due to the physical flexibility of the model and the help of an assistant. It was then made real through careful post-production.

LOCATION

Although this was not the most difficult location I've ever shot in, I found myself thinking long and hard about how to best incorporate the awkward props, such as the car, especially when it was not feasible to move it.

IN A GARAGE IN LA

Riding the Rug was shot in the same location as *Body Repairs*—this time with model Olivia. For this image I wanted to shoot a levitation portrait with the subject appearing to ride a magic carpet (or in this case, a rug from the local supermarket). The concept was incredibly easy to execute. I simply positioned the rug on top of a black, thin-legged stool, which became all but a black line to edit out in post-production. The key to making this image effective was to shoot from a low angle to create the impression that Olivia was moving upwards, as well as having a believable sense of force and action ripple through the rug by making her pose dynamic. For the main image of Olivia's face and shoulders, I had her move on cue while I fired the shutter, flicking her hair in the same moment. It was also important that I shot another image of her leg curled around the fold of the rug, as if saddled on a horse, and clutching the corner. In post, it was fairly easy to blend folds of the rug into one another from different images.

I'd actually shot this particular set of images without intending this to be my final piece. It was more of a test for the concept, but as it turned out, I preferred it to the remake. As a result, I spent more time deciding on exactly how to have the framing in the final image. There was significant clutter in the background that I'd have otherwise moved if I'd known I was shooting the final image, so I had to lose this in Photoshop by drastically darkening the image to reduce the clutter in the background, leaving only the rafters visible. I wanted to crop some of the image at the top and bottom, but without losing the sense of height between Olivia and the floor, nor the sense of height from her figure to the rafters above. I kept enough context at the bottom of the frame to allow for the insinuation of the space beneath her. In terms of a shadow, I realized it would have been inappropriate for her actual positioning, and that the diffused light would have been unnoticeable anyway on such a textured floor.

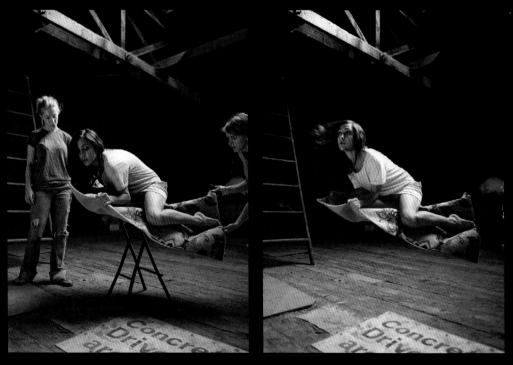

THE PROCESS
The hardest part of producing this image wasn't the "levitation" aspect itself, but rather the choices made in angle, framing, and processing the picture to improve those qualities. I wanted to keep enough of the surroundings to give the image a context, but keep the focus on the girl herself. I find such a conflict common across portrait photography.

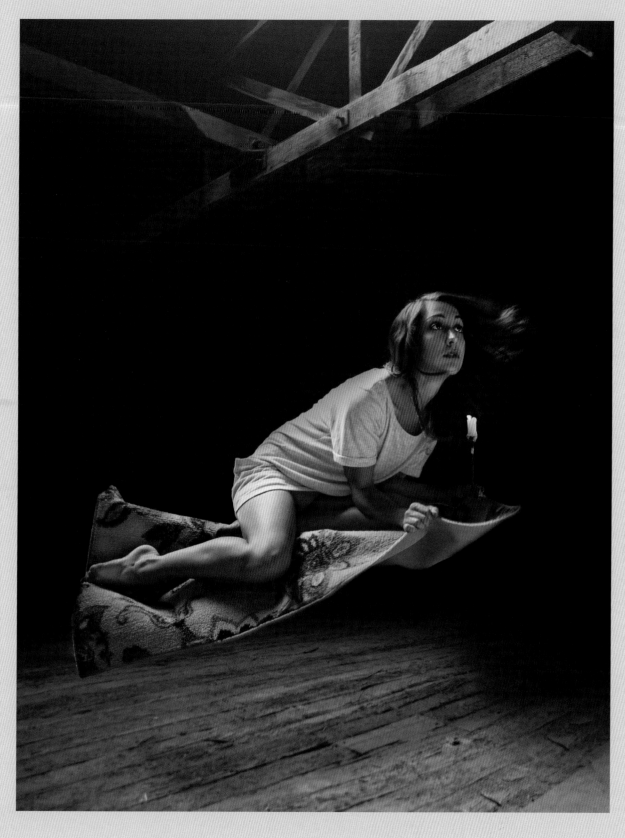

◄ **RIDING THE RUG**
(2010)
Inspired by the imagery in children's fantasy stories, this image was so much more effective when I shot Olivia wearing a T-shirt and underwear, as opposed to when I tried to replicate the shot in a flowing dress which obscured the shape of her rug-riding form.

A LABORATORY EXPERIMENT

THIS WAS A FASHION STORY I CREATED ON MY OWN INITIATIVE USING THE CLOTHING OF THE DESIGNER ARA JO, WHOSE PIECES I HAD BORROWED MAINLY FOR A WORKSHOP EVENT. I HAD A DIGITAL MEDIUM-FORMAT SYSTEM TEMPORARILY IN MY POSSESSION THAT I WANTED TO MAKE GOOD USE OF IN THE TIME I HAD. I HIRED A MODEL, A STYLIST TO DO MAKEUP AND HAIR, AND PLANNED TO SHOOT AT AN ABANDONED VIVISECTION LAB. MATTHEW AND I HAD GONE TO SCOUT AND CHECK THE LOCATION THE DAY BEFORE WHEN WE SHOT *HALF-LIFE* (PAGES 36–37).

ALTHOUGH THERE WAS no pressure to directly serve a commissioning client on this shoot, the challenge of being able to work unnoticed in an abandoned location itself created a pressurized environment. We soon settled down and were able to photograph everything we wanted in a total of three outfits, shooting for 30–40 minutes in each. As the model was being styled, Matthew and I chose the first shooting spot and got the lighting setup ready. I am accustomed to using natural light, and normally for a self-portrait in this kind of environment I'd use HDR techniques to capture the range of light coming through the windows and cracks. I've also often used motion blur for ghostly effects, as seen in *Her Fleeting Imprint* on page 78. However, on this occasion I decided to use lighting equipment because the goal was to produce competent fashion portraits where the hair, makeup, and outfits were professionally lit. I also wanted to be practical and keep the lighting equipment minimal, and brought just one TritonFlash kit.

With the first look prepared, we started shooting in the green room where I'd shot the *Half-life* self-portrait. It was the most difficult session, mainly because everyone was warming up: I was trying to think of ideas, the model was just getting comfortable in the environment, and the lighting was unflattering as I had it faced almost directly onto Sam, resulting in a flat look—it wasn't really doing much for the clothing.

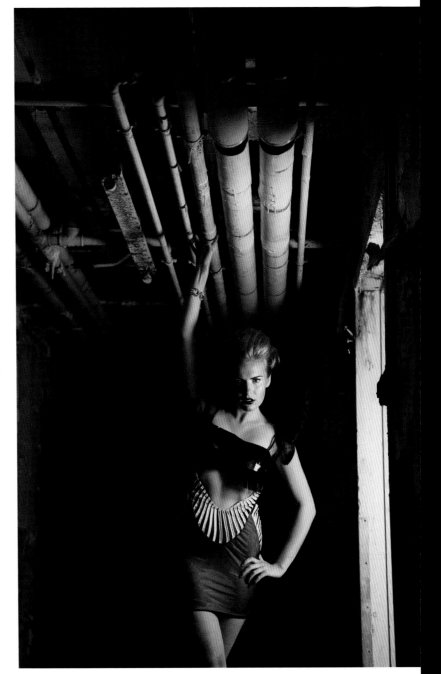

▲ **CONDUIT (2011)**
This was my favorite shot of the day, which I feel captured Sam's confidence brilliantly. I also liked the subtle mirroring of her dress in the environment surrounding her. For the entire shoot I used a Phase One medium-format system with one studio flash kit.

As I shot, I began to move the light further round to one side, so that it was coming across the model in what is called a split-lighting technique. I started to see that this was making the shots a lot more effective. The moment where I felt everything came together was when Sam stood out into the hallway, keeping the flash inside the room she'd just come out from, I shot from the hallway in front of her, triggering the flash through the wall. Sam posed coolly and effortlessly, raising an arm up to the interesting exposed pipes up above her. The flash lit her from the same direction as the natural light coming from the room which gave her just enough illumination without being overbearing—and essentially made a catch-light in her eyes that completed these low-key shots—much like *Conduit* on page 66. The split-lighting technique made her appear taller and more defined due to the way in which it cast the light over one side of her face and body. Her look and manner reminded me of a Hitchcock blonde, and the black-and-white conversion went aptly with that mood.

Following this session, we managed to shoot a good deal of images in a variety of rooms using the other garments and a headpiece. It was a full day of shooting and I had a lot to work through which I batch-processed using Capture One for an easy workflow. I put together the final images as a fashion story with text and credits to the team.

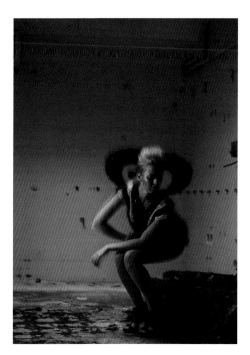

◄ BURNT OUT (2011)
This is one of the less conventional images of the shoot in a technical sense; I could see it being used in a fashion story, especially with the room around the subject that would allow for typography. This was shot without flash as Sam pretended to sit down, making for a jagged and interesting blur.

▼ BLUE (2011)
Shot with the flash to one side of the model within the room. The image looked a lot more effective after some simple post-production: a simple straightening of lines and enhancing the blue of the walls.

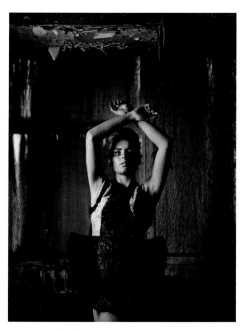

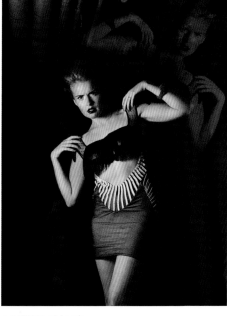

▲ HAZARD (2011)
I loved how the fiery red burnt window seemed to complement the smokey eyes of her makeup. I kept in the ceiling to show the detail of its dilapidation, the look of which is a strong incentive to shoot in locations like these.

▲ IN THE LAB (2011)
I experimented with the images in post-production in strange but simple ways. I wanted to incorporate the lure of the model's gaze in monochrome without desaturating the entire picture.

MARIA IN HACKNEY

THIS WAS A FAIRLY INFORMAL SHOOT THAT TOOK PLACE IN HACKNEY, EAST LONDON. A FRIEND AND MAKEUP ARTIST ANIA GASTOL WANTED SOME NEW PORTRAITS TO BROADEN HER PORTFOLIO, AND CAME TO ME WITH THE IDEA OF SHOOTING A STYLED MODEL AGAINST MUNDANE INNER-CITY BACKDROPS. SHE PUT A TEAM IN PLACE, CONSULTING A HAIRSTYLIST AND COSTUME DESIGNER.

A T THE TIME, I was intrigued by the prospect of an urban shoot, having been inspired by the photographs of Chris Dorley-Brown, a London-based street photographer. His work, very different from my own and which often does not feature people, nevertheless had a strange influence on me throughout the shoot that followed.

We started off on Hackney Marshes, where I shot model Maria against the block of flats looming in the distance, which I felt was an interesting feature against an otherwise natural landscape. Though I felt the pressure to get conventional fashion images for everyone's portfolio, throughout the shoot I also felt driven to rebel against the idea of beautiful portraits and many times I posed Maria straight on to the camera, encouraging her to shift from her instinctive figure-flattering tilt, and gaze directly at camera, chin down. I snapped numerous candid pictures of her, many of which turned out to be my favorites: shots where she was looking away, or just getting into position. I incorporated props I had brought along with me, which included balloons, and also a pot of bubbles which Lenka the costume designer blew into the frame. This added a subtly surreal element, with moments where Lenka would peek into the side of the frame, with just her hand visible, or her face as she blew the bubbles. One of my favorite shots was a frame with half of Lenka peering in, which is featured opposite. The manner in which she was cropped off the edge of the shot was unconventional for me—my usual urge is to fill the frame with the subject. I liked that the image revealed something about the mechanics of the context, and that while Maria was posing, Lenka became almost a second model.

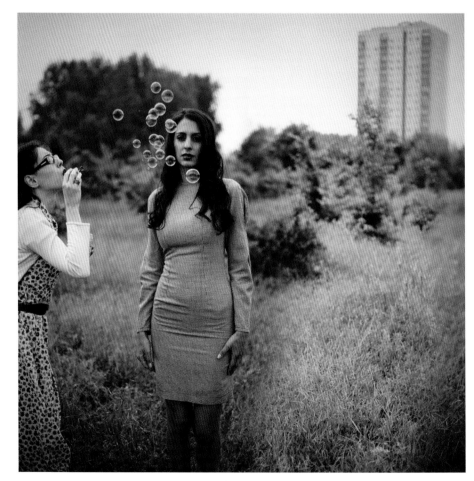

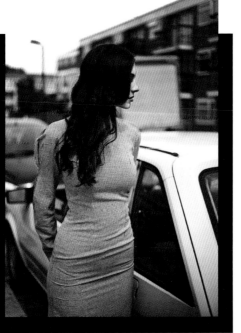

MONOCHROME (2010)
What I liked about this candid portrait was the definition and light on Maria's profile. It drew her out from the cluttered background, which I felt looked particularly striking in monochrome.

The next part of the shoot was an impromptu session by an old Austin Maestro parked just outside the flat where we were returning to have our lunch break. On a whim I asked Maria to stop, wanting to shoot something in the street as part of the urban-themed session. My favorites included an image of Maria with her face raised to half a frame of sky (below), which almost leads the viewer's gaze and attention away from the street scene itself, into the thoughts of the woman and the wind through her hair. I used a 50mm 1.4 lens for this session that helped to blur out the distractions behind her. The harsh direct sunlight of the June day made things a little difficult as I was not even using a reflector, so I tried to do creative things with Maria's poses to distract from the undesirability of a standard, face-on portrait. I had her lean over, look up, and gaze into the distance. Throughout this shoot I was interested in the shape of her form against the urban shapes on the street, from buses to vans, puddles to tower blocks.

◄ **ON THE MARSHES (2010)**
This is a semi-candid portrait of model Maria interrupted by costume designer Lenka blowing bubbles. The unexpected "at ease" quality made it one of my favorite images from this shoot.

► **DIPTYCH (2010)**
I found it very interesting to pair together images of Maria from the different sessions, invoking narrative by way of juxtaposition. It was a particularly good technique to use for those images that I felt were beautiful, but not quite complete in themselves, offering only fragments of potential meaning or narrative.

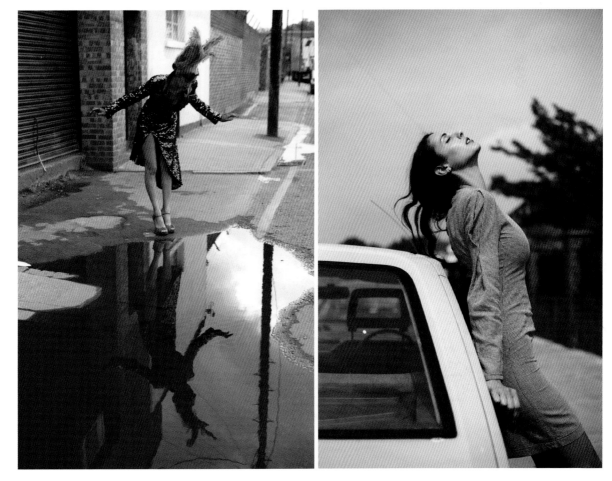

MARIA IN HACKNEY

Halfway through the day's shoot with Maria, we had a costume change into something rather more extravagant: a sparkling sequined cabaret dress complete with feathered cap, and headed to the streets around Hackney Wick. We shot outside a derelict pub with brilliantly colored graffiti all over its outer walls, which clashed fantastically with the costume and making for a startling juxtaposition. I shot so many images that I was bewildered with choice by the end, and somewhat confused at what the intention of this session was for me as the photographer. I shot many images that were satisfactory as sublime, posed beauty shots, but I also wanted something a bit different: maybe a scene that invoked sadness or irony. I made Maria turn away from the camera and I also shot some self-reflexive images of her looking at passers-by, and shyly at the camera in between takes.

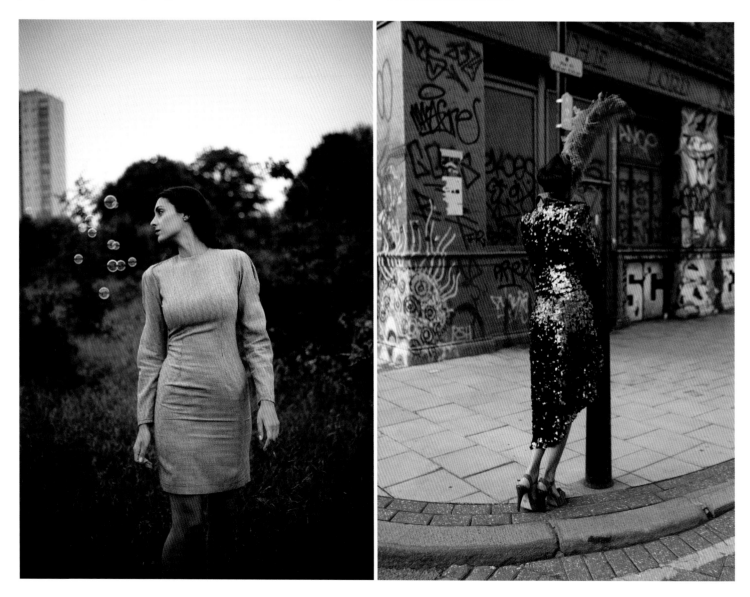

◄ **AVERTED GAZE (2010)**
I feel this is one of the strongest juxtapositions I made with the diptyches. I liked Maria's turned-away pose in each, and the questions about her identity and situation that it provokes.

▼ **ON THE STREET (2010)**
Another from the last street session.

▼ **TURNED AWAY (2010)**
An unusual configuration and placing of shapes made this choice of portrait interesting to me: the turned away figure, with the curve of her spine continued by the line of the tower block.

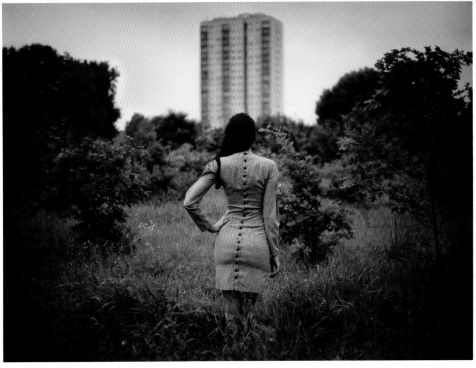

This was my first real time working with a full styling team, and it was certainly new for me to have the input of other artists on the shoot. I felt that the results weren't strictly conventional fashion images, but something a little quieter and experimental. It was really in the selection process where I made sense of all the images by choosing some of the posed shots and some of the in-between takes and bringing them together as diptyches, and also pairing some with shots from the other sessions of the day.

In that respect, this whole shoot was a slow-burner for me. I liked the images the more I looked at them over the months that followed. I shared some of the portraits online but did not feel fully confident initially as to their "genre"; what they really were, and for whom. I sent them to the team for

their portfolios and they each had their favorites from the day. It took me a while to realize that the shoot's multi-faceted nature was a good thing, and that the choice and presentation of the images was the key to any end meaning.

It was primarily a lesson for me on the importance of candidness in a shoot, the importance of afterthought, and to allow even the most seemingly irrelevant inspirations to take a welcome place in one's photographic approach—Chris Dorley-Brown even complimented the images when I put them online! It also preceded the lessons I began to learn on lighting: the marked difference in shooting at certain times of the day, and the value of finding unexpected places to shoot during an otherwise preplanned session.

BY THE SATELLITE DISHES

THESE IMAGES WERE SHOT FOR A BAND CALLED VISIONS OF TREES. THE BAND AND THEIR AGENCY WANTED INTERESTING PUBLICITY PHOTOS THAT WOULD UTILIZE A QUIRKY LOCATION AND ALSO INCORPORATE SOME OF THE TECHNIQUES THEY HAD SEEN IN MY OWN WORK: THE MULTIPLICITY AND LEVITATION-STYLE IMAGES.

WE BEGAN BY SOURCING the ideal location by looking online. It came down to abandoned locations, one of which was a set of disused satellite dishes in Lincolnshire, north-east England. Abandoned locations in general are frequently used in fashion and music shoots, but this one had an appeal as something a bit different as we'd never seen them used elsewhere. Conveniently, I was holidaying with family in the same area of Lincolnshire shortly before the shoot, which gave me the chance to scout the location before the whole team travelled up from London to a location that (as far as we knew) might no longer exist. I took some test shots of the dishes and thought about how I would use them.

Once organized and confirmed, the whole team travelled up and arrived the night before the shoot, so we could rise early the next morning and shoot as the sun came up. It was bitterly cold as Matthew and I stood by the dishes waiting for the others, who arrived just as the sun was breaking the horizon, so I moved straight into shooting relatively simple portraits of the band, including some of Joni and Sara standing by the dishes, bathed in the soft, golden light of sunrise. One aim of the day was to get some straightforward portraits that could be used alongside more contextual ones. The best time for close-up portraits was just as the sun rose, as it inevitably became difficult to shoot effective images of their faces once the sun got higher and made harsher shadows. I saved most of my more complex, contextual scenes for midday onwards.

A challenge was in being able to capture the scale of the dishes alongside the intimate feel of a portrait. However, even if this wasn't achievable in one shot, it was achieved across several shots: presented as a diptych or even just a group. We shot with only natural light, using a reflector to fill the shadows.

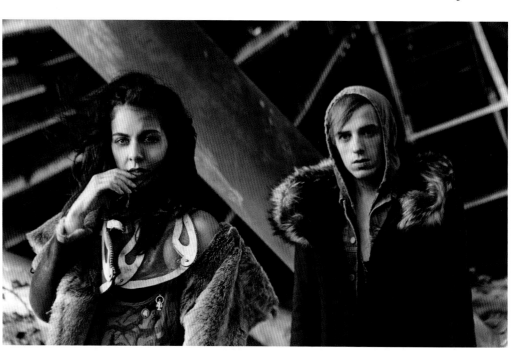

◀ **CLOSE-UP (2010)**
This was chosen by the band; one of the closest portraits from the session. It took a different, more anonymous viewpoint of the location but still highlighted a detail of the interesting structure behind them.

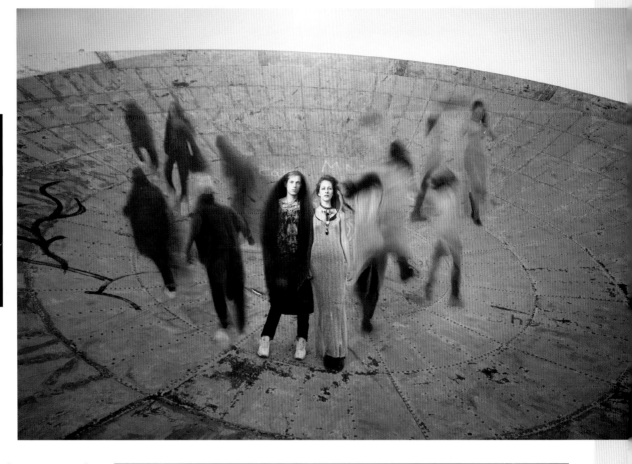

► **THEIR FLEETING IMPRINT (2010)**
Taking direct inspiration from one of my own self-portraits, *Her Fleeting Imprint*, seen on page 78, this was done by using multiple slow exposures composited together in Photoshop, with the central figures illuminated with a gold reflector.

Their Fleeting Imprint is a multiplicity image I made of Joni and Sara, directly inspired by a self-portrait of mine that they liked. They wanted the same ethereal mood, which I created by having them run round the dish and shooting multiple pictures of them with my camera locked down on the tripod. I purposefully chose a shutter speed to capture motion blur in the shots. To shoot the central two figures, I had Matthew stand in to assist, holding the gold side of a reflector toward them. The dish they were standing on was in shadow at this point, with the sun coming up behind it, so bouncing the light back into their faces effectively illuminated them against the dark dish, and gave the illusion there was a light standing right next to them. I simply composited out Matthew and the reflector in Photoshop by taking a clean shot of the scene and layering it over the first. Of course, I had to continue to ensure my camera did not move between shots in order to ensure they would match.

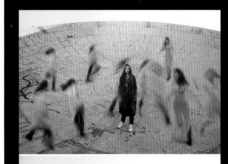

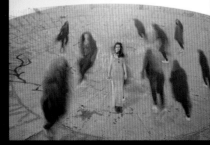

RUN-AROUND
I had Joni run around Sara and vice versa, and created composites of each of them circling the other. It was from these composites that I plucked the figures to make the final double composite, but I also kept this one as its own separate montage.

STAND-IN
Matthew achieving the illumination on the subjects with the gold side of the reflector.

BY THE SATELLITE DISHES

HERE ARE FURTHER SURREAL PORTRAITS I CREATED
DURING THIS COMMISSION, WHICH BOTH DEPENDED
UPON CAREFUL SHOOTING AND COMPOSITING IN
ORDER TO WORK EFFECTIVELY. THE SHOT OF JONI
AND SARA APPEARING TO JUMP OFF THE SIDE OF
THE DISH WAS A SHOT THAT LOOKS QUITE SIMPLE,
BUT WAS A LITTLE TRICKY TO EXECUTE.

MY LEVITATION-STYLE shots are usually created by supporting the subject with a stool or prop that is then masked out with a shot of the empty scene. To use this technique, the subject cannot move around in the frame, and must stay where they are being shot. For this image, I did it a little differently. I shot the pair simply standing safely within the dish, Joni holding on to Sara, while Sara jumped into the air. In post-production, I needed to move them across the frame, essentially cutting them from the image, placing them onto a blank scene, and shifting them along. The trickiest part was putting back the long shadows the midday sun had cast behind them, especially when the shadow had to move with them, and grow longer. I had to delete and recreate the entire shadow for this to look convincing, and made a selection with my pen tool, feathered it, and then darkened it in Levels.

The image opposite was the main signature result from the shoot, and being an intricate multiplicity composite, it was the most complex to create. I shot a mid-shot of them up close to the camera, and then filled the frame behind with them to create a surreal busy image of multiple figures moving further into the distance. In principle, shooting a multiplicity image is quite easy—I just had to mount my camera on my tripod, and position Joni and Sara in different parts of the frame.

THE PROCESS
The original shot of the pair jumping, which was then transposed onto a clean shot of the background. The fiddly work was in tweaking details in order to complete the image: adding the midday shadow, replacing the ground area on the bottom right corner to appear cleaner to the eye, and also adding an extra lick of hair to Sara's head to complete the overall aesthetic.

◄ **ON THE EDGE (2010)**
Overall, I wanted an image that was clean, bold, and surprising, giving a sense of the height of the dish but without losing the finer elements of the band's expressions and the details of their outfits.

However, in this particular case there were two complications. One was that there were so many figures I wanted to place together that there became to be a lot of blending work. Some figures had slightly mismatched focus or exposure, and had to be tweaked, and I added layer masks to all of them so I could erase inevitable edges that appeared around them. A second complication was that I wanted to achieve the perfect placement of figures, an arrangement which only became apparent once in post-production. This meant moving a figure to a different spot to the one it was shot in, having to transform it correctly and making its depth of field appear accurate by blurring it. I had even more figures than the number that are seen in the final image,

as I wanted to experiment with lots of different options that I later eliminated. My file in Photoshop had at least twenty separate layers, which became mind-boggling. I was pleased with the result, which out of all the pictures, showed the most detail of the interesting location while also allowing us to be close to the subjects.

▼ **SIGNALS (2010)**
The background for this shot was processed separately as a tonemapped HDR image in Photomatix. The cloning work then took place in Photoshop. I wanted a busy, bizarre image that incorporated both the location and the band's presence at its fullest.

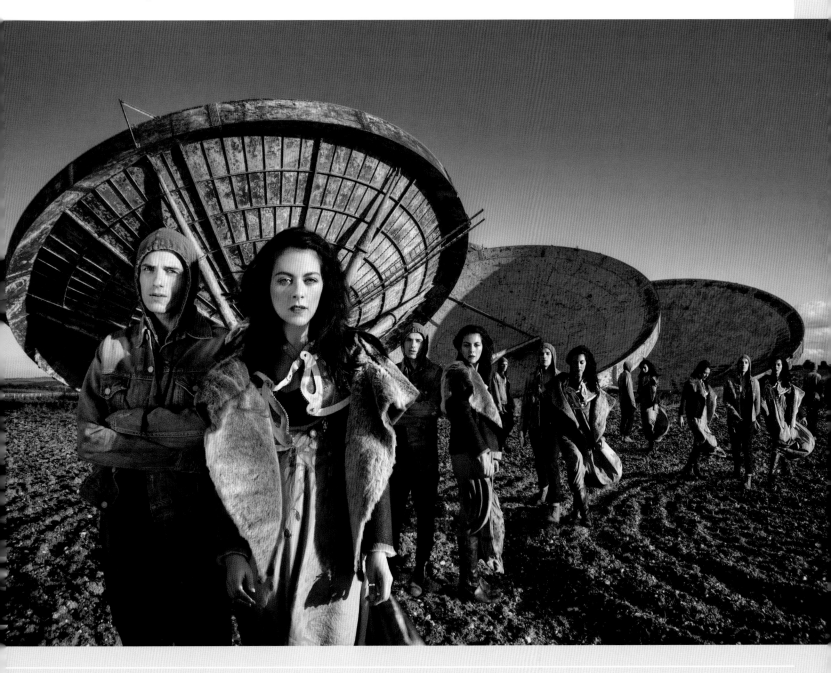

A CITY ROOFTOP

HERE WAS AN OPPORTUNITY TO USE THE ROOF OF A STUDIO DURING A WORKSHOP I WAS HOSTING IN LONDON. THERE WAS LIMITED TIME IN WHICH TO SHOOT, AND I HAD TO DEMONSTRATE A CERTAIN LEVITATION-BASED AESTHETIC TO THE OTHER PHOTOGRAPHERS.

RATHER THAN SHOOTING indoors, my sights were set on shooting outside: I was more attracted to the distant outline of the city banks and the downtrodden East London street below as seen from the rooftop. It was cold and dreary, and I began to feel half guilty for having led the group—and our model Mette clothed in a thin silk dress—out into the brisk breeze up top.

When it came to shooting, I had Mette balance on a bar stool with the aim of making her appear to be floating horizontally, and also, when sitting up, to look as though she was hovering. My intention was then to remove the stool in Photoshop by using a blank image of the scene. Back inside the studio, the shooting continued as a group using the natural light coming from the skylight of the studio. In the last moments before lunchtime, I shot some portraits of Mette under the skylight. The downward direction of the light darkened the background, automatically cutting out the clutter of the studio. On a whim, I had Mette put on my big fur coat, gave her a lantern prop, and directed her to jump in the air, where I caught her movement.

When it came to going through my pictures during the editing process, I was disappointed by the images I had shot of Mette up on the roof; they looked awkward, or just a little bland, and while they did represent a safe option that easily demonstrated the levitation technique, I decided to take a risk and experiment instead with the images I'd shot of Mette indoors. A moment of madness saw me roughly cut out my favorite picture of Mette jumping and place it onto an empty rooftop scene, curious to see if they would go together. The perspective, angle, and lighting did seem to correspond: having been taken in roughly the same time period and with the same overhead diffused lighting—albeit with one floor between them—they matched. With a new confidence, I carefully cut out the image of Mette as a new layer, refined the edges with a layer mask, and arranged it properly into the scene. It was still a levitation image of a sort, but with the model loftily

jumping as if in slow motion. It was not the kind of approach I would normally take, as it would have been preferable to actually shoot her *in situ* and avoid the risk that came with the substitution of the environment. After all, there seemed to be no other rooftop image that worked with the shot of Mette, only the one from a certain angle that I chose. It was a blind experiment that paid off, and it was the spontaneity and unpredictability that I enjoyed about the experience and that I was learning to embrace in my photography.

The choice of scaling was the most important factor in making the shots work together. I positioned Mette over the puddle so that I could add a subtle, inverted reflection of her foot into the water, in an attempt to effectively anchor her into her new environment and strengthen the illusion. I added extra details to enhance the mood of the image: most prominently the light from the lantern. I would have been happy to leave the lantern unlit, but the opportunity was there to brighten up the bulb with a false orb and inject a mysticism into the scene. I did this simply with a pale yellow soft-edged paintbrush at a low opacity on a new layer.

Curves adjustments worked a treat in this image with so many pale textures to enhance, from the white silk of her dress to the graffiti on the wall. A subtle white diffuse glow brought out an ethereal glow over the entire image: to the clouds, the ground, the dress, the fur, and the hair. Finally I enhanced details of Mette's face with a tiny bit of airbrushing and saturation of the lips to subtly warm up the slightly sallow darkness there. The workshop had demonstrated (to me, and hopefully to the participants) much more than the mechanics of compositing a levitation image: it had revealed the inherent unpredictability of photography, and the rewards of embracing it and using it as an opportunity to grow as an artist.

▼ RISING IN THE EAST (2011)

Taken in East London with model Mette Tonnesson. I shot Mette inside the studio under the skylight and composited it with the outdoor image. Both images were shot with the diffused light of the overcast day, creating synergy between the two.

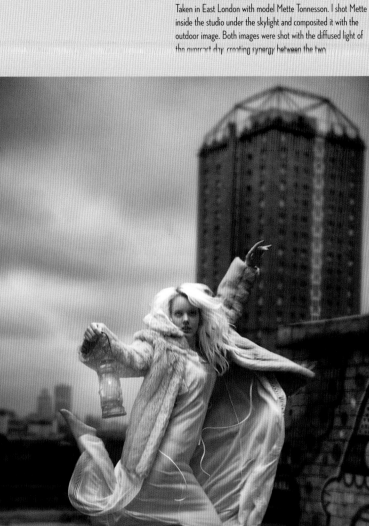

THE PROCESS

ON THE ROOF

I originally posed Mette in a long white dress on top of a stool with the original intention of producing an image where she would be surreally hovering.

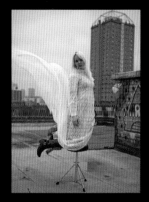

UNDER THE SKYLIGHT

Having the model jump into the air produced such a dramatic change in the shape made by her coat, limbs, and hair.

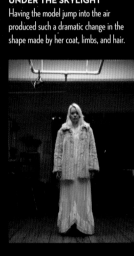

PROCESSING

I tried out the editing experiment in the short time I had, putting together a rough cutout before I decided to proceed with the intricate operation of compositing for real.

THE ROOF

The final image was made up of three exposures for the HDR scene of the roof, with the figure of Mette placed on top. This was how the roof looked in a single exposure.

SELF-PORTRAITS USING ABANDONED LOCATIONS

HER FLEETING IMPRINT WAS SHOT IN HELLINGLY LUNATIC ASYLUM IN SUSSEX DURING THE LAST MONTHS IN WHICH THE DERELICT HOSPITAL BUILDINGS STILL STOOD. IT WAS MY FIRST TRIP TO SUCH AN ATMOSPHERIC ABANDONED LOCATION, AND THE ADRENALIN RUSH WAS IMMENSE.

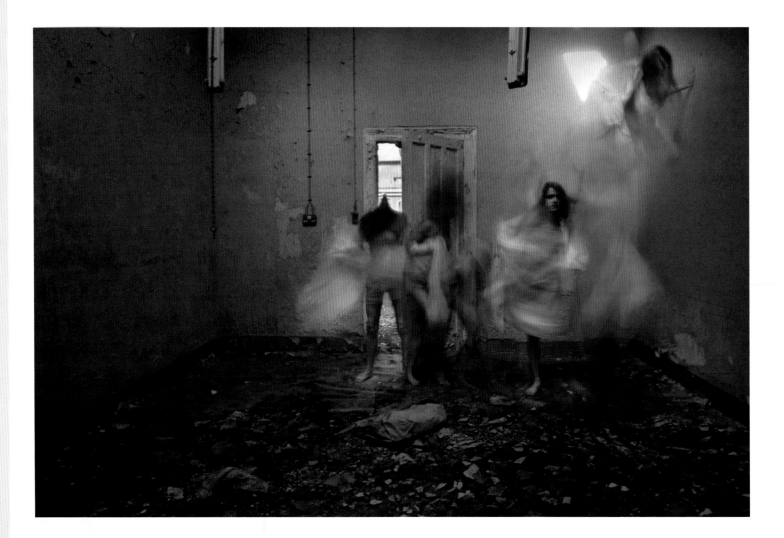

I T WAS THE BEGINNING of a series of trips Matthew and I took to different derelict places during which we shot together, collaboratively, and the resulting pictures became our *Abandoned* series, which I have exhibited and had published.

While researching the location, we'd seen pictures of a particular blue-toned room we hoped to find, so were delighted to stumble across that exact location in the rambling grounds. We set up the scene so it would show the wide span of the room as I wanted to create a flurry of shapes that I could put together as a multiplicity composite to fill out the space. Keeping the shutter speed purposefully low to capture motion blur, I moved around, waving my arms while Matthew fired the shutter.

Going through the images afterwards, there were many arresting poses: almost too many to choose from. The hardest task was to select a range that could be used to create a composite that also kept the delicate blur of the original shots intact so that I didn't cut through the soft edges surrounding the raw imprint of each figure. I was sure I wanted to use a certain shot that showed my figure in the doorway with an eerie "pinhead" against the light. Another key figure was one where I was half-facing the camera that had a twisted body and a little more detail in the face than the others.

I decided this would be the central figure of a stream of movement, as if frozen for a split second in the eye of the viewer. I completed the path of the ghostly figures by placing one on the wall as if it was trying to escape, perhaps crawling toward the window implied by the shaft of light on the wall behind. In technical terms the composition was easy to put together because of the seamlessness of the edges surrounding the blurred figures.

In terms of concept, I felt as though I had set about this image with a subconscious intention. I was representing an imprint of the self with a sense of frenetic movement within the final frame: almost like a static mini-movie. It was only when I afterwards read about the history of the mental asylum that I realized my image had more relevance than I'd known due to the terrible lives of the patients within the walls and the terror they had endured. Such narratives of despair are often exaggerated through rumor or gossip, but it turned out that my portrayal of a female figure within the room was not as melodramatic as it might seem: a bizarre image I otherwise might simply have classed as a dramatic artistic portrayal of a fictional character. This image gave the series a bit more of a dialogue and some historical context that I had never felt qualified to be able to portray in my work before.

The Scribble Room was produced in a moment of personal association with the wall of the children's hospital I'd previously encountered during a shoot with Tim Andrews (pages 56–59). Simple and intentionally crude in composition, I posed small and cowering next to a giant, surreal paint splatter that reminded me of my own childhood and of the extremity of my emotions as a child. It did not feel appropriate to do anything more with the scene. As impressive as the room was, it could only be taken at face value as its vastness was baffling; for me, this drowned out any potential there may have been to try to compete with it. For all my previous self-portraits in abandoned places I was barefoot in gowns, but here I wore shorts and heeled shoes which created a surreal element, and raises the question of why the person (or child) is huddled in the corner.

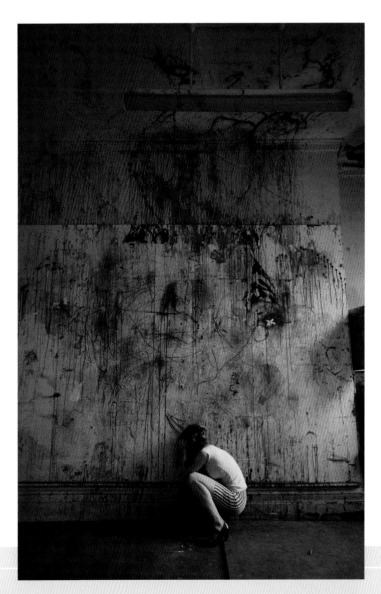

◀ **HER FLEETING IMPRINT (2009)**
The idea of a ghostly "imprint" was inspired by the mood of the eerie, deserted location itself, and the history that dripped and peeled from the walls.

▶ **THE SCRIBBLE ROOM (2010)**
This was shot during a visit to an abandoned hospital in London with Tim Andrews. I composed the shot and had Tim click the shutter for me while I posed.

CHAPTER 4
INTERIORS

THIS CHAPTER WAS ORIGINALLY INTENDED TO COVER ALL THOSE
PORTRAITS THAT DO NOT FIT INTO THE PREVIOUS CHAPTERS: ALL SHOT
INDOORS IN A VARIETY OF INTERIOR CONTEXTS. HOWEVER, THE COLLECTION
HAS COME TO STAND FOR MUCH MORE THAN MERE MISFITS. THE INTERIORS
COVERED IN THIS CHAPTER STAND FOR ALL OF THE SHOOTS THAT TAKE
PLACE INDOORS, WHERE THE BULK OF MODERN LIFE TAKES PLACE.

WITHOUT THE VAST possibilities of outdoor space, the area used could be as confined as a blank studio wall or blacked-out room—thus this chapter highlights how the imagination can be needed more than usual for a truly creative indoor portrait. This chapter also uses location as theme: from a bedroom in London to a kitchen in Paris; from a seaside theatre auditorium, to an old Victorian three-storey house around which I took a series of surreal portraits of models dressed in ball gowns.

The regular interior is what I started out with as a photographer; I started by shooting a lot of my self-portraits in my own living space. I have rarely used studios and am used to my subjects (whether myself or another model) posing in an inhabited space amongst furniture and props— sometimes adorning the frame with surrealism, and sometimes lighting the space dramatically so that darkness and anonymity enfolds them. The fashion portraits in this chapter range from simple brooding poses through to the quirky and uncanny; they are artistic images that use surprising details to make the viewer look twice.

This chapter has more illusionism than the others: at least three of the stories can be considered overtly surreal photography, and it is no accident that I have used these kinds of techniques to help enrich an otherwise basic interior that was uninspiring in itself. From my collaboration with Rossina Bossio to the portraits of my workshop models appearing to hover and fly in their studio settings, this chapter strives to go beyond the "everyday" aspect of the interior.

▶ TUB (V) (2011)
A portrait with the soul of a painting, shot simply with natural light, a low angle, and a simple composition in a rustic setting. More from this shoot can be seen on pages 84–85.

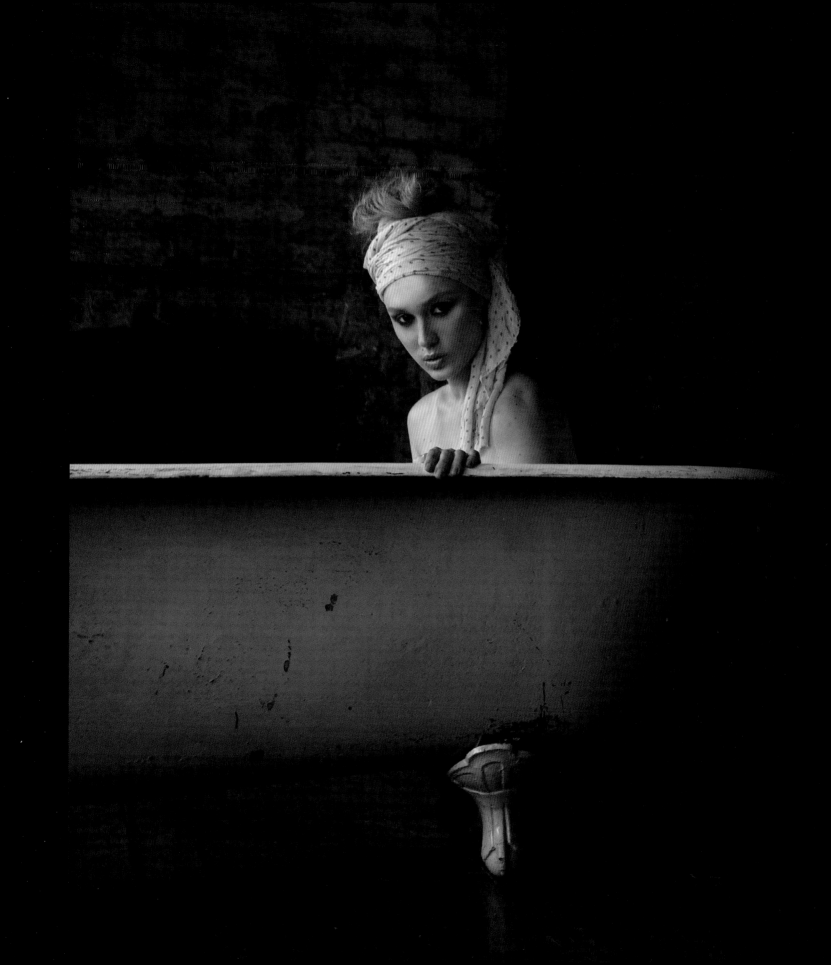

IN A BEDROOM IN LONDON

WHEN MAKING A SELF-PORTRAIT, I'VE ALWAYS SAID THAT
SPONTANEITY CAN, AND SHOULD, SEEP INTO THE PROCESS IN ORDER
TO COUNTERACT THE BLINDNESS OF ARTISTIC VISION THAT CAN
OCCUR WHEN YOU ARE ON BOTH SIDES OF THE LENS.

THIS SELF-PORTRAIT IS A TESTAMENT to that notion, and encapsulates the wonderful organic nature of the process of creating a portrait: embracing something you didn't quite expect. It is an excellent example of unconventional framing and cropping to elicit a candid, almost accidental quality.

An Exercise in Emotional Detachment was an idea I'd had for a portrait title before an image ever existed. I was open to a variety of potential contexts in which the image could be shot, but I knew it would be a self-portrait. The final image, as seen opposite, was shot in a friend's bedroom where I was staying during a time that was somewhat daunting and lonely for me. Having not made a self-portrait for a while, I was eager to shoot intimate close-up portraits of myself, a type of image I hadn't really explored before. However, I knew I wanted to do something that wasn't quite so close to my own self; I wanted to perform another character, and so decided to use a cigarette. I do not smoke, but it was a prop that I felt could add an interesting angle to the shot, both in terms of the visual effect of the smoke, and the emotions I could convey while blowing it out. I felt that this was the perfect way to execute the theme of emotional detachment and fit the title I'd had in mind. I took many different shots with the lit cigarette, triggering the shutter with my remote. The smoke inevitably took on a life of its own as I took the shots, moving around the images in different ways.

Looking through the images, an image with a neat cloud of smoke perfectly obscuring all of my facial features but my lips intrigued me the most. It fit the title perfectly: you could not see my face; I became anonymous, detached, and unidentifiable, while the smoke became a symbol of the smokescreen I wanted to convey.

▼ **MAKING CHOICES**
I loved the quality of natural light from the window and the more natural, candid self that I captured. However, most of the smoking portraits I took were too literal for my intended purpose, which is why I chose a more abstract portrait from the session.

THE PROCESS
The original shot from camera, and then the image after applying a style in Capture One, which transformed the blue of the wall into a deep emerald green.

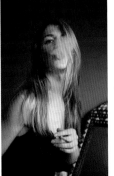 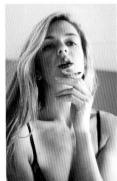 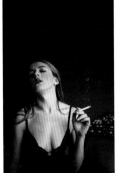

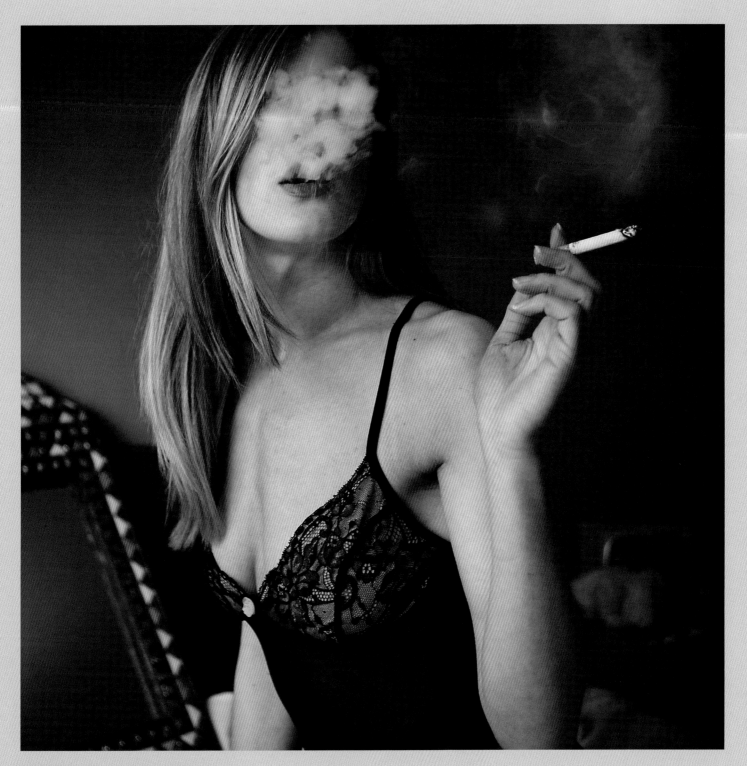

▲ **AN EXERCISE IN EMOTIONAL DETACHMENT (2010)**
I loved the elements that chimed in the chosen image, but being a self-portrait, it wasn't
easy to control them within the desired frame. It was the cropping and composition
afterwards that largely contributed to the final presentation conveying my original intent.

IN A VICTORIAN BATHTUB

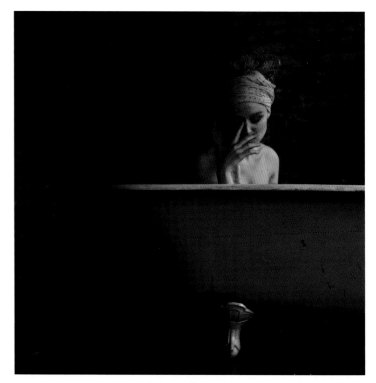

THESE PORTRAITS DEMONSTRATE HOW A FASHION SHOOT EVOLVED INTO SOMETHING MORE INTIMATE AND PORTRAIT-LED. SHOOTING IN A ROOM IN AN OLD VICTORIAN WAREHOUSE IN LONDON, I WANTED TO MAKE USE OF THE QUAINT PROPS THAT SURROUNDED US—AMONG THEM AN OLD TIN BATHTUB.

O N STARTING TO SHOOT, I found that the outfit the model was wearing—a pink spotted dress—did not go very well with the surroundings. Due to the time constraints of this session it was not feasible to change, nor would it have been appropriate to try nude or semi-nude shots. Deciding to use the bathtub, and constricted by the time we had allocated in the location, I wanted to quickly shoot an implied nude, a portrait of somebody apparently taking a bath. She dropped the dress past her shoulders and I shot from an angle low enough to hide the top of the garment. The styling of her hair with the headscarf, together with the low-key ambience that used only natural light coming from the adjacent window, reminded me immediately of the painting *Girl with a Pearl Earring* (1665) by Dutch painter Johannes Vermeer. In the painting, the girl wears a bright headscarf amidst the darkness of an anonymous interior: here, the blonde of Ayla's hair coming from the scarf in my portrait recalled the yellow scarf falling from the girl's head in the Vermeer painting. I took some shots of Ayla looking straight at the camera, asking her to put a hand on the rim of the tub to add a little more of her presence to the composition, as the tub was filling a lot of the frame. I then asked her to put her hand across her face, and look weary and tired. I wanted to capture a portrait that was a little more mystical, a portrait that suggested a narrative beyond that of a simple fashion portrait.

In post-processing, it was interesting to see how subtle changes developed the mood I'd captured in-camera (see before and after below). I slightly darkened the images in Levels, used color enhancements in Curves to slightly throw off the blacks of the shadows, and then experimented with the red and green curves to create a brown tonal texture to the image. I then subtly airbrushed the skin and enhanced the color of the lips by drawing round them and adjusting the reds in Hue and Saturation. I also sharpened up the eyes. Another from this session is seen at the beginning of this chapter on page 81,

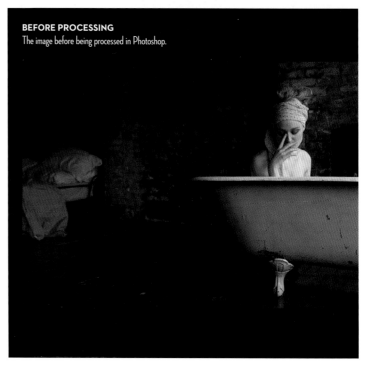

BEFORE PROCESSING
The image before being processed in Photoshop.

Model Ayla Selamoglu. This was shot with a Canon 5D Mk II, focal length of 42mm, f/4, shutter speed 1/40 sec, and lit with natural lighting only.

This was an HDR shot where three exposures of the scene were put together to display a greater amount of detail. It was surprising to get such clarity on Ayla's face between the shots, but she had kept so very still while I photographed her that it merged together perfectly.

which I chose to flip horizontally to differentiate it from the other images I processed from this session.

Below is a wide shot also from this session that encapsulates the whole scene as well as the full length of the tub. To create this image I shot three exposures and merged them as a HDR image in Photomatix, capturing the range of luminance across the scene and the fine detail in the wall and floor. I also cloned out a plug fitting and wire to make the floor area appear cleaner.

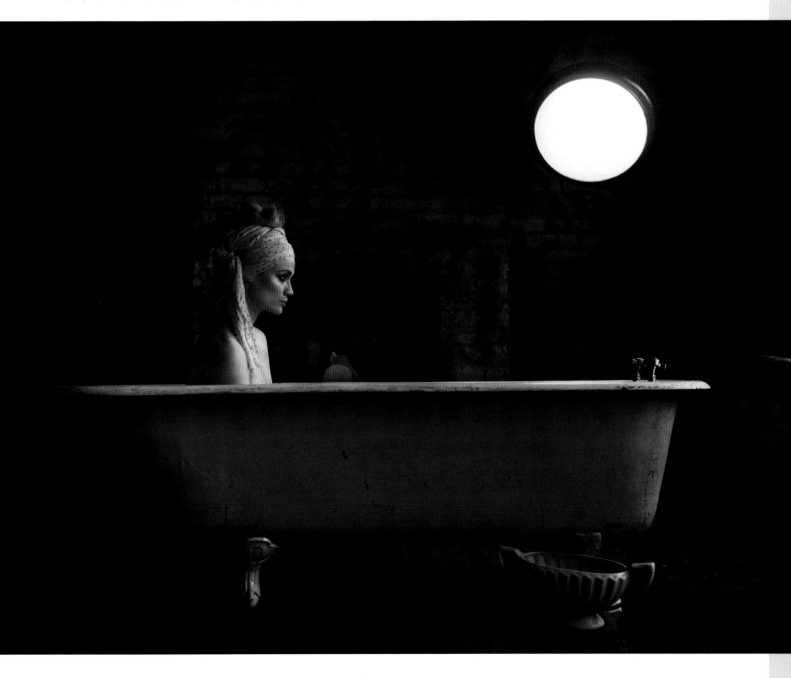

TRICKS IN A HAUNTED THEATRE

THE NEXT FEW PAGES ARE DEVOTED TO VARIOUS PORTRAITS I SHOT IN THE ROYAL HIPPODROME THEATRE IN EASTBOURNE, SUSSEX. I DISCOVERED THE LOCATION WHEN I WAS SEEKING NEW AND INTERESTING VENUES IN WHICH TO HOST MY WORKSHOPS WHERE I WAS DEMONSTRATING A RANGE OF TECHNIQUES TO A NUMBER OF ATTENDEES.

THE THEATRE was quite an interesting location to work in because of the obvious tension between new and old: while it had a functioning auditorium and front-of-house, the backstage rooms were decaying or in disrepair, with one in particular very similar to a room one might find in an abandoned building. This was a distinct advantage as I wanted to emphasize to my workshops how both areas of the building could be used to different creative effect.

Performing the Past was shot in the aforementioned "abandoned room," a challengingly small space in which to work (see images of the room below right). It had two interesting crumbling and colorful walls with a big window in between them, which inevitably meant we had a difficult high-contrast lighting situation to deal with.

For the portrait to be effective, I wanted to get down to a low angle and capture our model, Bella Grace, against the wall. I needed to get close enough to omit the distracting window as well as the door on her other side, but crucially, still be far away enough to give room for context. I wanted to incorporate an extra prop into the frame, an old piece of theatre seating which also needed compositional "breathing space," so I positioned Bella in front of it in dressed in an elaborate green dress and holding a mask. I arranged rubble around her, including some light bulbs I found in a corner of the room, feeling that these simple embellishments helped create a plausible story within an otherwise contrived scene.

By using multiple props that all suggested a theatrical theme, a narrative began to form. The dilapidated setting gave me the idea for the title, that this was a portrait of a character "performing the past"—a vision or memory of an actor amongst the relics of the stage. I also thought carefully about how to pose the model. I wanted a dynamic feel, so I asked Bella to flip her hair while I took numerous shots. This movement made the image more interesting than simply having her sit statically, but I also wanted her face to be in focus amidst her falling hair. There was something still a bit dull about the image as it was straight from the camera, so in the processing I wanted to incorporate more of a sense of movement in some way. The main process I applied was to create feathered layers around the floor and to lighten them in the RGB curve which created the illusion of dust or mist around Bella, as if there was a breeze that caused her hair to move. I then adjusted the colors in Curves to embolden the tones, to add a distinctive blue tinge to the image, and also sharpened her eyes and slightly enhanced the red of her lips.

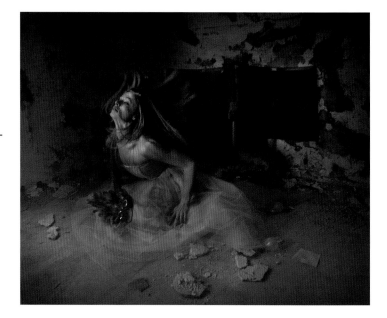

LIMITATIONS OF THE SPACE
The size of the room was small, and the natural lighting was difficult, which made it necessary to think carefully about composition and light metering.

Suspended, shot on the stage, is an example of how I have used two important techniques: the trick of levitation, and also that of stitching together a panorama. I wanted to produce an image that was dramatic, slightly ominous, and similar in technique to *Body Repairs* (pages 62–63), to show how simple levitation tricks could be.

The levitation element was easy enough to accomplish. I had Bella lie across a stool, then took a shot without the model or stool, which I layered over the first shot to create the illusion that Bella was supported only by the rope. The hardest part was to ensure the image worked aesthetically and appeared convincing, so I concentrated on the finer details: I made sure that the person holding the rope kept it as taut as possible (nevertheless I still had to transform it, rotate it to straighten it, and stretch it in Photoshop). I also asked Bella to arch her back as much as possible. Another tricky element was dealing with the shadows after I had erased around the stool in Photoshop to reveal the background beneath it. I did this by copying over a sample of shadow from one side, feathering it, and bringing it over to fill the gap.

When I shot the images, after I had the levitation part in the bag, I tilted my camera to include more of the auditorium in the image. Although I wanted the intimate proximity to Bella in order to see the interesting details of her face and form suspended in the air, I also wanted some context that I could choose to use, or not use, at a later date. It was important to me to have options. Another aspect to this image that might not be obvious, is that I made use of two different exposures to capture the detail of both the seating and the stage. It was beyond a camera's ability to render the correct exposure for both the auditorium and the brightly lit stage spotlight without underexposing or overexposing one or the other, so I shot an exposure that was suitable for each element and then combined them. I masked these around Bella and made sure there was a gentle gradation between the two.

I added a subtle lens flare (placing it onto a new layer of less than 50 percent opacity) in the top left corner, to add to the light that was emanating from the lighting box in the theatre. I slightly airbrushed Bella's face, arm, and shoulder with the Clone Stamp tool, and reddened her lips a little. I also added a Curves adjustment to deepen the contrast and the red tones of the image.

◄ **PERFORMING THE PAST (2010)**
The placing of props, use of motion, and angle of the shot all contribute to the final composition of this dynamic portrait.

▼ **SUSPENDED (2011)**
This was shot with a Canon 5D MK II, with a 24–70mm lens. I used the benefits of auto-bracketing to gain the extra dynamic range, and also tilted to one side for another shot, to create a slightly panoramic view.

THE PROCESS
Here are the shots that were used as part of the composite: the shot of Bella on the stool, the "blank" shot without her, and the panoramic tilt to the left.

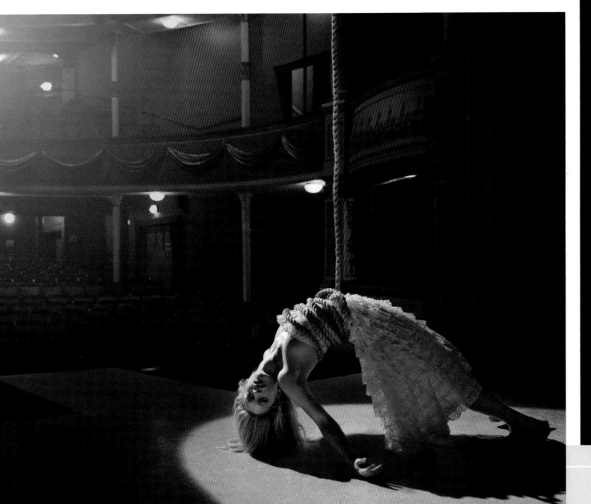

TRICKS IN A
HAUNTED THEATRE

The image *Stagecraft* (opposite), was shot with two models, and was created in a manner very similar to that of *Suspended* (on the previous page). I had the models Holly and Bella sit atop two rather insecure fibreglass pillars, with four assistants steadying the columns at the base. By having the assistants keep their heads down, I could ensure that the area around the models' feet and skirts would not be obscured and it would also make it simple to paste a section of clean background over the assistants once I had taken an empty shot

of the freestanding pillars. Of course, I had to make sure I had not moved the camera at all between these shots. In summary, to create this image I split the composition into two parts: the top half and bottom half of the models, and also for ease of processing ensured that the people not intended to be in the final composition were confined to the bottom half of the shot.

After these pictures had been taken, I tilted my camera (still on the tripod) to the right and took more of the auditorium, auto-bracketing the shots in-camera using my AEB mode. This took three exposures, two stops either side of my settings.

In Photoshop I first worked on the trick element, then performed a Photomerge to bring the image together with its extended scene. I did significant post-processing work to the image to make it as vibrant and colorful as the final version appears: the smoke was taken from another image which I placed on the layer blending mode "lighten," masking and blending it, and placing it around the auditorium. I also made the spotlights in Photoshop by marking paths with the Pen tool and altering the Color Balance differently for each one, then "boosting" the whole image with color adjustments in Curves and adding some vignetting. The whole image was intended to be over-the-top— a playful, slightly saccharine scene that transformed what looked on the day like a dull dark theatre, into something exciting and exquisite. I did not plan the image for this result; there was a lot of spontaneity in the process that made it all the more intriguing to unfold.

For *Act Drop*, I wanted to shoot a simple, colorful, and dynamic trick image with my model Ruby True. I was attracted to making the red curtain part of her portrait, and felt that doing a trick image would be a great way to combine this element of the setting together with a dynamic pose from Ruby. The shot was a fairly simple shot to create, and allowed curtain and person to come together in close proximity in a striking pose. To get the shots I needed, I had Ruby stand on a stool and stick one leg after the other into the air so I could capture them both, trying hard to view the shots as though I were already in Photoshop and aligning the layers, making sure there was space for one foot to come out of the other end of her dress. I then took another shot of her top half so she could deliver a striking pose and shake out her hair while standing safely on the stool. I shot a blank shot without model or stool, and then a couple of brighter exposures to capture the detail of the comparatively dark chairs behind her. I incorporated this detail subtly in order to give the whole scene a delicious consistency in color and tone.

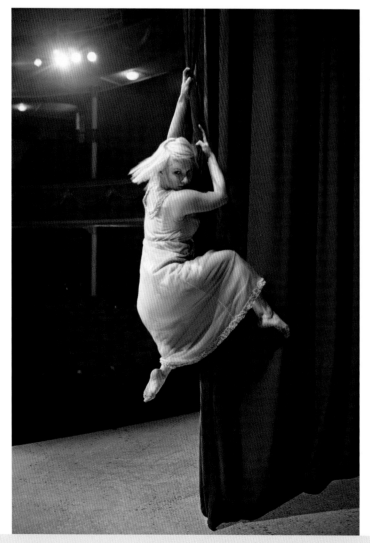

◄ **ACT DROP (2011)**
Color was very important in this image, and working on saturating the colors in post-production was an essential step in polishing the aesthetic quality.

THE PROCESS
To make Ruby appear as though she was clinging from the curtain I had her alternate her movements across three images, and then shot the scene without her in it.

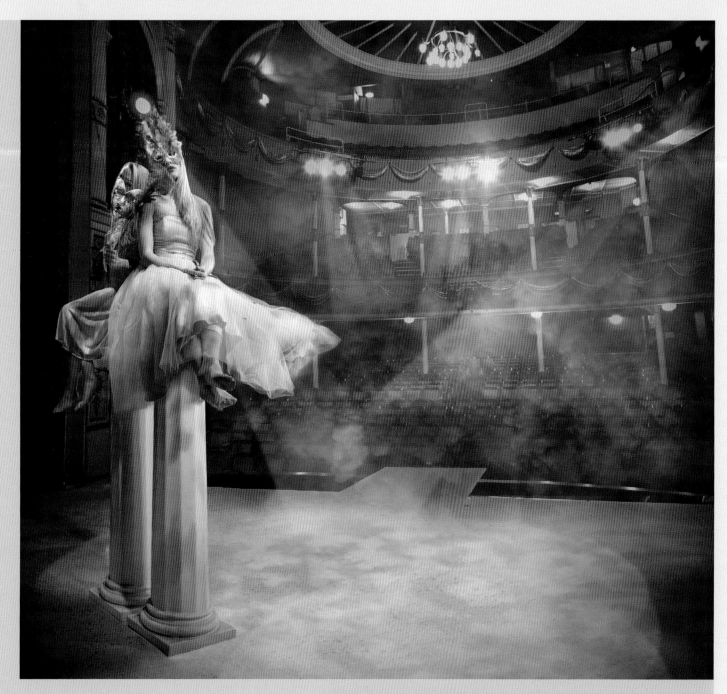

▲ STAGECRAFT (2011)
The models' discomfort meant I had to work quickly, and also meant that I had to have support from assistants who appeared in-frame, and were later edited out.

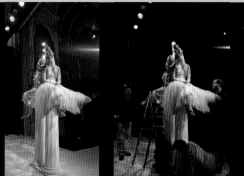

THE PROCESS
The original shot (hugely different from the outcome) and the achievement of the first all-important stage: making the models appear self-supported upon the pillars.

TRICKS IN A HAUNTED THEATRE

THE SPECTATORS

The Spectators is a composite I shot in the seats of the theatre. I love to make my compositions as simple and striking as possible. I wanted to get in close to the seats by erecting my tripod at a high angle, but at a height that meant I could see Bella's face without feeling as though I was looking at her from above. I also chose an angle that was tilted slightly to one side so that the chairs would move across the frame slightly diagonally, giving depth to the image without turning the portrait into a profile shot. All of these choices were made relatively instinctively and I only actually realized their importance when I tried to shoot another image in the seats during a later workshop, which didn't work as well.

The technique used to create the multiple figures was very straightforward: I had Bella sit in each seat in turn while I kept my camera locked down on the tripod, and chose camera settings that allowed for motion blur in-shot so that her facial features and limbs would be distorted. I do not generally like to fake blur in the post-production: I try to make a decision on the spot about whether to achieve it in-camera.

I found the post-production stage to be fiddly because I had so many choices from which to make a selection of ideal figures. When I make a multiplicity composite, it is not the novelty of having multiple figures that I thrive on: the key for me is in creating an interesting shape within the frame. It is about achieving the right placement to form a particular line and motion between one figure and the next. In this case, because of the blurred ghostly poses, I wanted to achieve a pleasing flow between the figures so they would show depth and shape as the viewer's eye moves across.

I had numerous shots to work with, so I started by placing a range of these into one composite and selecting the ones I most liked, but also making sure I had an option for each of the different seats and positions. Some of the figures could be moved from one seat to another, which added further choice. Once I had a range of figures, I thought about hiding the visibility of one layer and then another, to work out the final selection and positioning.

I settled for four figures in the end, considering that any more seemed overcrowded. Another important change was to make the chairs stretch away into infinity to eliminate the clutter at the back of the theatre. I did this simply by using the Clone Stamp tool to carry on the lines of chairs to the edges of the frame.

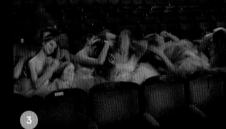

1 - 2 I had Bella move her body and hair for in-camera motion blur. This achieved the immediate ghost-like effect I wanted.

3 With lots of options, I placed different figures of Bella into the master composite before deciding on a combination.

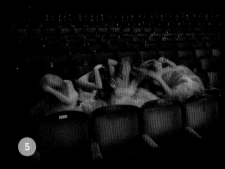

4 I decided on a final series of four figures of Bella which created the shape that I wanted, a line of figures with depth and variation.

5 I worked on tweaking the composition by extending the seats into the distance and then making Curves adjustments to achieve the final image seen opposite.

As with all my images, especially constructed trick composites, I made sure I saved it as a PSD file with all the layers intact in case I wanted to go back to it later. After I had flattened the image, I saved it as a separate file (a TIFF) and worked on the overall color adjustments. I could see that because the colors in the picture were quite pale and light that the image was a good candidate for some tonal adjustments, so I used the Curves and Color Balance tools to deepen the tones and amplify the color scheme of black and red. I also decided to enhance the color of the dresses by drawing a selection around them and adjusting slightly in Hue and Saturation, making them slightly bluer. Finally, I added vignetting by using Lens Correction to subtly draw the focus of the scene towards the subject.

▼ **THE SPECTATORS (2010)**
I made Bella into an eerie series of ethereal "spectators" by use of a simple multiplicity technique, but I also made sure I chose an effective camera-angle and height, bringing together an ideal combination of shots taken.

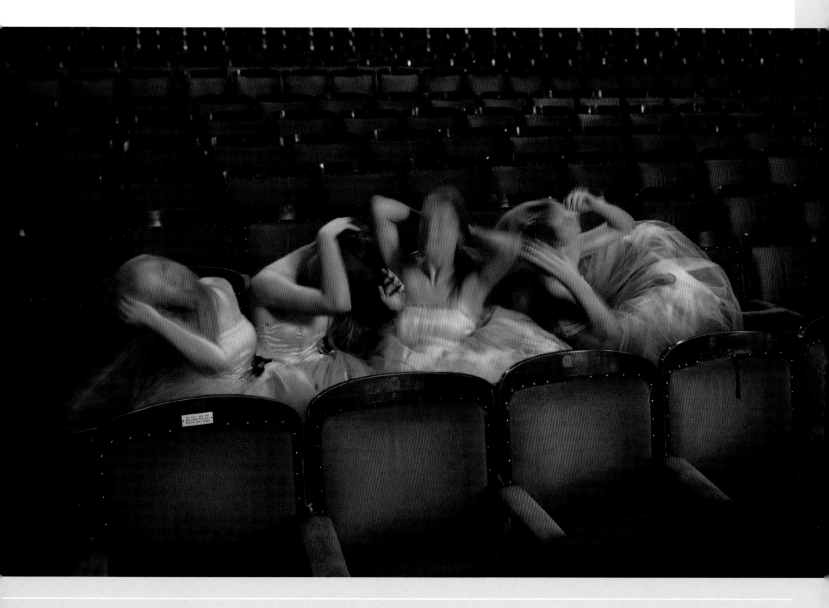

THE BLACKOUT ROOM

THE INTENTION BEHIND THESE IMAGES WAS TO DELIVER A PORTRAIT THAT WAS DARK IN MOOD AS WELL AS IN TERMS OF LIGHTING KEY. BOTH MODELS IN THESE FASHION PORTRAITS, WHICH WERE SHOT IN BLACKED-OUT ROOMS WITH FLASH OR CONSTANT LIGHTING, USED FACIAL EXPRESSIONS AND BODY POSES TO CREATE A BROODING CHARACTER PORTRAIT IN A DRAMATIC ATMOSPHERE.

SHOOTING THE RAVEN IMAGES was one of my first experiences with using flash lighting for fashion portraits. Shooting in a room with no natural light, I wanted to give a sense of the background so that the image had depth without showing too much of the surrounding clutter, particularly the large bed to one side of the room. I was shooting model Andria: tall, elegant, and confident with using her body to create long, sculptural shapes. Her facial expressions were also defined and powerful, and I wanted to utilize these visual strengths along with the atmosphere of the room, which reminded me of the darker stories of Edgar Allan Poe. I mentioned this inspiration to Andria and asked her to give me a few different angular shapes within the limitations of the dress's movement, as it needed to stay in line with her thrust-out chest.

I wanted to incorporate enough depth to draw Andria out from the background. This was achieved via the side positioning of the flash (see process shot on the opposite page) and also by choosing a high focal length on my 24–70mm zoom lens—particularly on the closest shot I did of Andria which was 64mm and brought her into an intimate proximity to the camera close enough to see the details of her makeup, outfit, and jewellery. The same lens allowed me to zoom back out to shoot wider shots that showed the full length of her outfit.

The Photoshop adjustments I made to these images played an important role in developing the mood of the story I put together. I wanted to further enhance the feeling of depth by adding a lens flare to some of the images (choosing the "105mm prime" which has the simplest and cleanest flare action) on a new layer, coming from the brightest corner of the image,

and then reducing the opacity. This increased the sense of space and "dust" around Andria. Taking care not to blow out the delicate highlights, I also increased the contrast and blue tones with Curves adjustments, which dramatically emboldened the contrast of her body against the light. I also did quite a bit of airbrushing on the skin to make it look intentionally flawless—as if the model were a doll, porcelain-skinned and slightly unnerving—but also to make the images competent as a conventional fashion story.

Hook was taken in another blacked-out area of the same building, also with the intention of making a character-led, brooding portrait along the same lines as the Poe-inspired shots of Andria. For this shoot, I used constant lighting positioned on one side to produce a dramatic contrast of light over the model Sophia, putting one side of her body into significant shadow, but angled so that the whole of her rigid "overcoat"—as well as her obscured eye— gleamed. I chose this image from a fairly wide variety of images I shot of Sophia, some with her holding a candlestick, some posing on a swingchair, and also some images of her in dancerly motion. I liked the simplicity of this static portrait and its straight-eye contact. I felt it needed very little processing, simply a subtle reduction in color temperature and gentle enhancements on the brightness of the left eye and the red of the lips. I liked how the outfit was symmetrical and well-presented, and the casual folding of the dress between the model's fingers could imply that she was about to rip it.

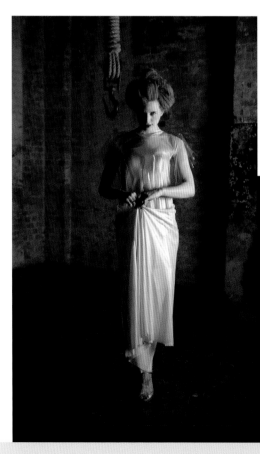

◄ **HOOK (2011)**
The design by Stephanie Grace Foy featured a rigid plastic shell around the dress, which restricted movement to a static stance, and set the pose for this portrait.

COMPOSITION
I wanted to find the right framing to engage with the model's expressive physiognomy without losing the context of the background or providing an awkward crop of half of her body. The act of joining her hands made the framing of my final shot work.

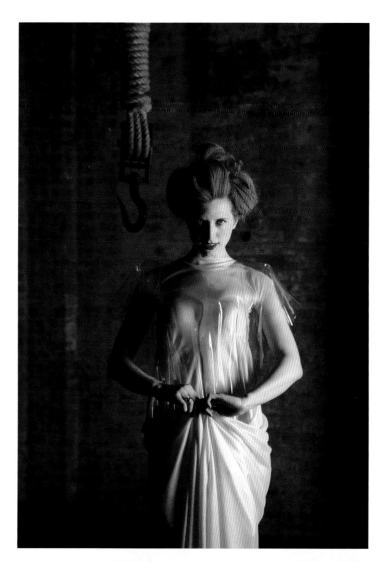

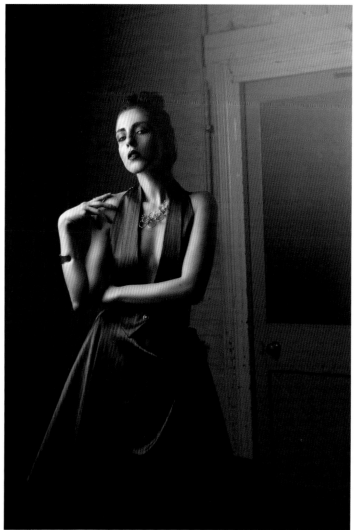

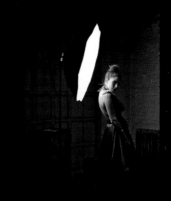

FLASH
The simple lighting set-up for Andria, one Elinchrom flash head in a large octodome softbox.

▲ RAVEN (2011)
Because I had several images from this shoot session that I worked on, I found it easy to first go through the images in a Raw workflow program, Capture One, adding batch styles and then outputting into Photoshop.

◄ DIPTYCH (2011)
I presented the sequence of images of Andria as diptyches, which provided an interesting flow of shapes and more of a sense of a story than limiting the result to one single image.

A KITCHEN IN PARIS:
WITH ROSSINA BOSSIO

THESE IMAGES ARE COLLABORATIONS WITH ROSSINA BOSSIO, A FELLOW SELF-PORTRAITIST WITH WHOM I TOOK JOINT SELF-PORTRAITS ONE SPRING IN PARIS. WE SHOT A TOTAL OF FOUR PORTRAITS DURING OUR TIME TOGETHER, SOME OF WHICH WERE INSPIRED BY PAINTERS: IN PARTICULAR BY BALTHUS, AND A FAMOUS PAINTING *GABRIELLE D'ESTREES AND ONE OF HER SISTERS*, (1594) BY AN ANONYMOUS ARTIST.

A KITCHEN IN PARIS

All the final images created with Rossina had a predominantly post-modernist intent to them, with psychoanalysis being a key influence in the references made to gender roles in the titles and images themselves.

In order to shoot the images effectively, we shot each other separately, as we had the opportunity to direct each other to pose for our respective shots and then bring them together in post-production. This way of working was also partially due to the fact that we did not have a remote control that worked with the camera we were using, a Phase One 645DF. So that the compositing would be fairly straightforward, we made sure we kept the camera still between shots and to take note of where each person was in the frame. For *Pathetic Phallacy*, inspired by the writings of Sigmund Freud, we wanted to create an image that was amusing and satirical, and shopped for a range of phallic vegetables. We tried a variety of poses where we chopped and interacted with the vegetables, and later worked together in Photoshop to select the two poses we thought worked best together.

Tough Toys for Tough Boys was shot in the small nursery area of the apartment. Surrounded by relics of childhood and struck by the gendered nature of children's toys, we set about producing a slightly satirical image where we lay across the boy's car mat, as grown women, playing with cars. The image was purposefully voyeuristic, with the camera placed in the doorway, framing the image with blurred doorframe. To clarify the image's parodic nature, we named it with an abbreviated version of a title of a book by Will Self.

▼ **PATHETIC PHALLACY (2009)**
It was a tight space to shoot in, so we made sure we framed the scene carefully so that the space behind us would be identifiable as a kitchen.

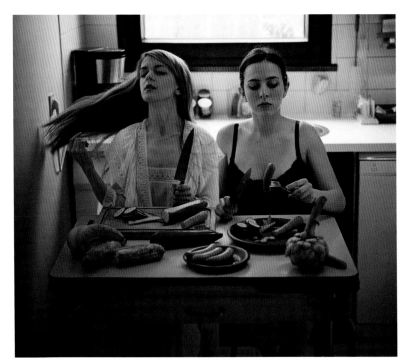

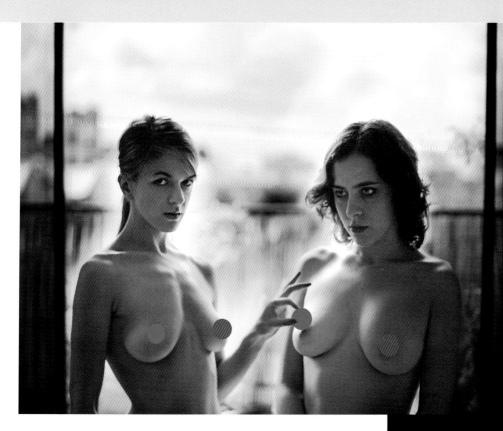

▼ **TOUGH TOYS FOR TOUGH BOYS (2009)**
We took advantage of the props at hand in the apartment we stayed in (thanks to Julie Seguinier) and took inspiration from them for the concepts in our images.

BOOBY TRAPS (2009)
This was inspired by a classical painting, but delivered with a humorously ironic and modern twist. I shot a darker exposure of the background so I could incorporate detail into the outside space behind us.

For *Booby Traps* we set out to produce a nude image with both of us posed in a manner similar to that seen in the 16th-century painting *Gabrielle d'Estrees and One of Her Sisters*, which Rossina had suggested we reference when we had first researched for visual sources to inspire our collaboration. However, it was only in post-production that we started to build upon the image originally shot as a plain nude. This version of the image became specially relevant to photo-sharing website Flickr, with the intention of subtly mocking its censoring of female breasts. I added "pasties" in the shape and color of Flickr's dots (pink and blue), and made my hand interact with one as though placing it onto Rossina. I then thought of the pun for the title. Rossina also made other versions of the image with the same concept of the breasts being covered or censored.

A KITCHEN IN PARIS: WITH ROSSINA BOSSIO

THE ARTISTS' SKETCH

The Artists' Sketch is my favorite piece from my collaboration with Rossina, as it took a painterly influence and transformed it into a multimedia outcome. We did not necessarily plan for the semi-drawn result of the final image. We shot it as separate images and brought together the poses in Photoshop. The idea of Rossina drawing upon the table and myself hiding under it was inspired by a painting by Balthus, as were the poses: the slightly aggressive stance of Rossina versus my passivity and feminine self-adoration below. The cat was taken from another photograph and added in post-production.

Rossina and I took it in turns to process the images, at each stage feeling as though the image needed something more to make it interesting. I was disappointed that the ambience of the room was not so effective originally: it was flat and dull, and I was also dissatisfied with the depth and the focus on the actual subjects, which was slightly soft. We hit upon the idea of making the image less tangibly a photograph. Rossina, who is also a painter, sketched the scene and scanned it into her computer. Placing it over the image in Photoshop, I used a layer mask to erase parts of the drawing to reveal the photo underneath. The image became something original and refreshing, an experiment that blurred the lines of the two artistic disciplines.

THE PROCESS

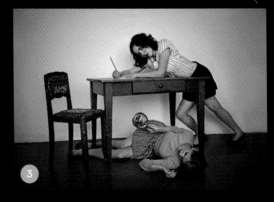

4 I played with adding wallpaper texture to the scene, painstakingly erasing through a layer mask so everything would appear in front of the wallpaper. I also added a cat to the chair. This was from a picture of my cat taken at home, but the result looked somewhat flat and false. At this stage I felt the image was overprocessed and still didn't look quite right.

1–2 Mounting the camera onto a tripod, Rossina and I shot each other in our respective parts of the frame. We tried different positions from the ones seen in the final image, and made sure that the furniture stayed in the same place so that we could potentially use any of the poses together with the same image.

3 Having agreed on the choice of poses, I worked them into a composite in Photoshop. Tidying up the image by cropping out the door, I also played with Color Balance across sections of the image to make it more interesting than the bland look of the original scene. I still felt it lacked something.

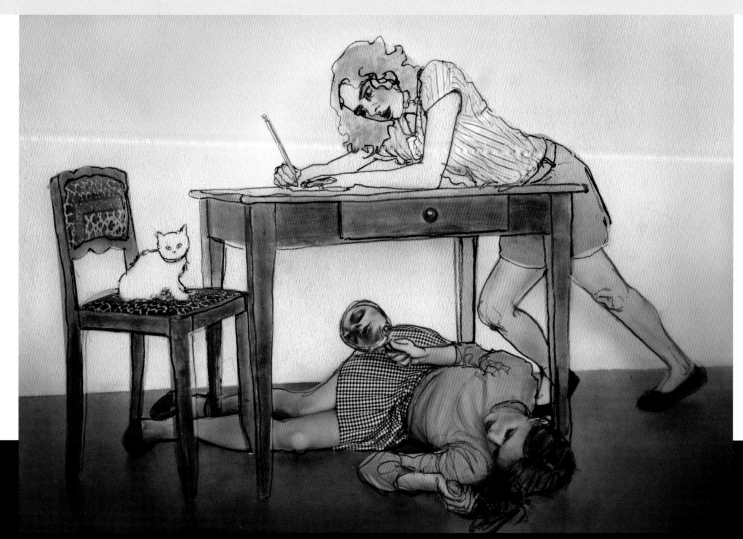

5-6 Inspired by Rossina's drawing, I played around with different ways of partially exposing it as a layer mask on top of the photo. First I tried to keep the effect of the drawing to one corner or one specific half of the image, but this missed out the lovely detail of Rossina's drawing in other parts of the image. I decided to keep the drawing at around 50 percent opacity at the lower half, and have it gradually become a full drawing at the top, by Rossina's head. This way the image became mostly drawing-based, with an element of photographic realism. It also meant that the cat became entirely a sketch, making what began as a rather stilted fictional addition into a more creative, self-reflexively fictional element.

THE ARTISTS' SKETCH (2009)
The final piece became a collaboration between Rossina and I, and soon after we sold a limited edition print of the piece.

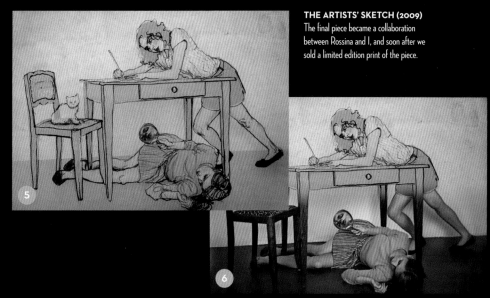

SURREAL PORTRAITS IN BALL GOWNS

THE PORTRAITS ON THE FOLLOWING PAGES WERE TAKEN DURING A SESSION I HELD IN A THREE-STOREY TOWNHOUSE IN LONDON THAT WAS FULL OF CHARACTER. I WANTED TO PHOTOGRAPH THE MODELS, OUTFITS, AND LOCATIONS TOGETHER IN A WAY THAT WOULD NOT ONLY MAKE BEAUTIFUL POTENTIAL FASHION IMAGES, BUT ALSO HAVE AN EXTRA ELEMENT OF NARRATIVE AND SURREALISM TO THEM

THE PROCESS
I took three shots of each scene that I later merged together in Photomatix. It was inevitably shaky around the profile so I remasked this area in Photoshop and then worked on overall color enhancements.

▶ **MEMENTO (2011)**
The props of the location, the dress, the lighting and the look of the model all came together to communicate a believable narrative and a sense of warmth and nostalgia.

THE INTERESTING THING about all the portraits over the next few pages is that their surreal element was not necessarily ironed out beforehand. The pictures, for me, were a touch experimental in terms of their post-production direction. They represent a true embracing of the growth of an image's concept from shoot to edit.

For *Memento* and *Memento Mori*, I was shooting in the morning with model Sammy on the top floor of the house with sunlight streaming through the window onto a table and picture frame. It was both the light and the props that drew me to pose Sammy in this corner. I had her crouch down so she was close enough to the props for a relatively intimate composition, and so the viewer would be able to see the child's face in the picture frame. I also tried some shots further away so that I could photograph her full-length figure, including the end of her dress tailing over the floor.

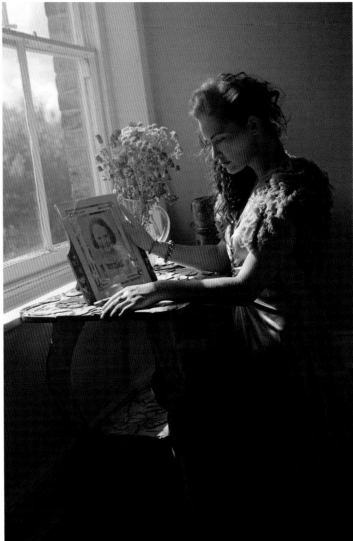

I directed Sammy to look at the frame with her hand upon it as if reminiscing about a character from the past. At the time I thought the concept was perhaps somewhat trite, but the wilted flowers added that extra adornment to the scene and the props came together in a way that made sense. I was mainly focused on achieving interestingly lit images that showed the beauty of her appearance, the light, and the outfit she was wearing. Instead of using a fill light to tackle the difficult lighting situation, I chose to auto-bracket the shots for an HDR image. I processed the exposures in Photomatix to generate an HDR image, followed by further processing in Photoshop. For *Memento*, I added color adjustments in Curves, and increased the contrast in places where the HDR rendering had left it rather soft.

For *Memento*, I was happy with the image as a sublime, aesthetically pleasing portrait of a character gazing at what could be a picture of her child, with the overall image itself processed in the manner of a tinted postcard.

In the wider shot, I wanted to do further editing to add a surreal twist. The blank space of the wall begged for something more. I knew the answer was somewhere already within the image. I decided to copy the child's features from the photo frame onto the wall, liquefying the features to give an evil expression: turning the eyebrows downwards in the middle, and twisting the mouth into a snarl. I brought the opacity of this layer right down and then scaled and warped it to fit the space. I also added a dash of light across the middle so the face appeared to form from the window beams. There was now a face upon the wall, subtly but eerily present, appearing at the side of a woman yet to notice it. I enhanced the contrast of warm tones on the left side by the window versus the cooler tones on the right side, and deepened the ominous shadows on the floor and the sky outside the window. The clouds now clustered darkly with the beginnings of a thunderstorm showing a kind of pathetic fallacy, where the elements conspire against the main character.

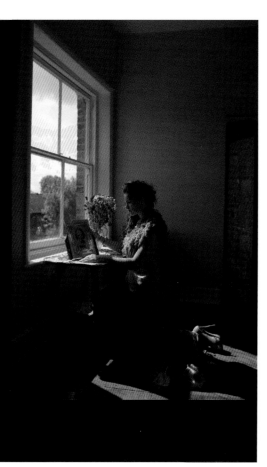

SHOOTING SPACE
The room was restrictive for the kind of wide shot I wanted, so I improved the composition in Photoshop. A critical part of starting work on the original shot was to straighten up the room and clone out the doorway on the right.

▶ **MEMENTO MORI (2011)**
I entitled this darker image *Memento Mori*, playing on the title of the other image, but keeping a twisted continuation, as if giving a reminder of one's mortality where the child in the picture is actually the woman herself, growing older all the time.

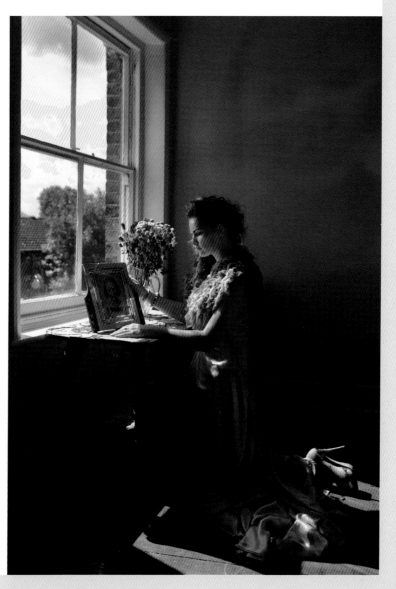

SURREAL PORTRAITS IN BALL GOWNS

I knew from my first trip to this location that I wanted to shoot in a particular corridor that featured the staircase and old map of the British Isles. The corridor was quite dark and had no natural light, so I had to compromise by shooting the model Janelle close to the doorway, and by positioning a constant light pointing in from outside to enhance the light coming in. I shot a stream of images of the model standing in the doorway, moving around the skirts of her white dress. Janelle was also a dancer, so her poses suited the elegant style I wanted to communicate.

I didn't feel quite satisfied with the series of relatively normal portraits I was producing and wanted to do something a little different. I contemplated trying a levitation-themed image, but I had no stool at hand, and the angle from which I was shooting Janelle would not make for an arresting levitation image. From where I stood on the stairs, her legs were foreshortened, and the long skirt obscured them so levitating legs would go unnoticed or at least look feebly depicted. Instead, I decided to make an image where it would appear as though her skirts were lifting and blowing without her intervention, as if a phantom gust of wind was rushing through her legs, or as though the gown was dancing by itself. I did not have a tripod to hand for this shoot, but I kept my camera as still as possible while I directed Janelle to lift one side of her dress then the other, and to lift her arms and pose the top half of her body. In Photoshop I brought these three aspects together by cutting around each side of the raised skirt from each respective shot, shaving away the edges where her hands appeared, and placing them onto the master composite in which her hands were raised. It did not matter if there was slight movement between the images, because the white material was easily matched and could be warped and reshaped to match the surrounding area. It was important in this respect to shoot with an outfit that did not have a pattern.

To make the overall image more effective, I applied a Curves color adjustment and also airbrushed Janelle's face, sharpening the eyes that had pleasantly caught the catchlight of the constant light. I also added a very subtle Lens Flare on a lower opacity layer to the area where the light was entering from the doorway. The title was intended to suggest that the woman was being moved by something intangible, and with the map behind her, alluded to the idea of wanderlust: that something was making the character want to escape or explore the world beyond her home.

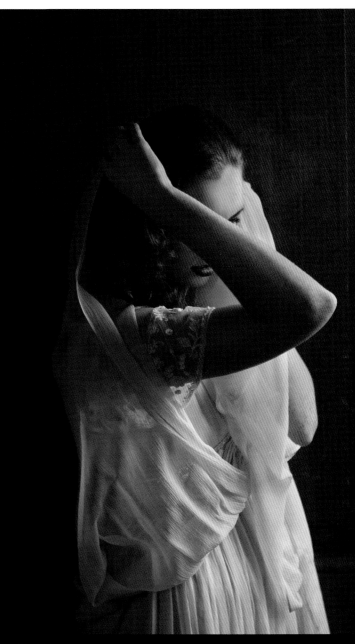

▲ **VESTAL (2011)**
I liked the mystique created when Janelle pulled the veil over her head, and shot numerous versions of this portrait. Referencing the ancient Roman religious aspect in the title, I chose to process this unconventional, faceless image.

THE PROCESS

CORRIDOR
The space in which I shot Janelle was fairly tight and I wanted to include the map behind her without including too much of the other clutter on the wall around it.

THE LIGHT
I positioned a StarLite QL (a Photoflex constant light) outside the door to enhance the natural light from that direction.

▶ **SOMETHING MOVED HER (2011)**
A gently wistful portrait that I feel delivered the ideal pose, lighting, and angle I could have achieved in this situation.

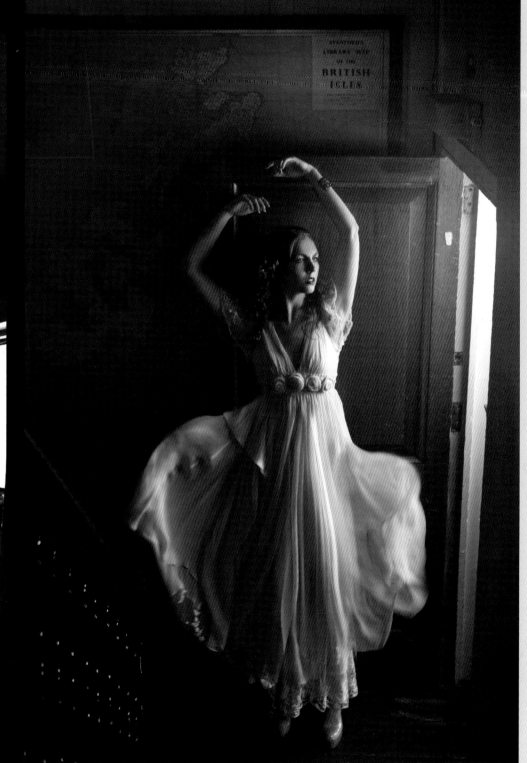

SURREAL PORTRAITS IN BALL GOWNS

She Became Drawn In was formed from what was originally an outtake or candid shot. I had first positioned the model Chrystaline onto the chair, swapping it with what had been a more modern-looking seat. I liked the diffused windowpanes behind her and also the quirky orange wardrobe, however, I found it very difficult to work these elements into a portrait. The wardrobe stood on a slant against the uneven wall and floor, and I could not think of an effective way to pose the model with the wardrobe other than to make her appear to walk out of it, which I'd already done on a previous shoot and found somewhat clichéd. So I settled for taking portraits of her sitting in the chair. At the time I did not think anything of them.

Experimenting in post-production, I brightened a particular picture that had Chrystaline facing away from the camera, when she turned to look at the wardrobe I'd commented on. I found myself liking the vibrancy and texture of the dress in the image, the mystery added to the picture by not seeing her face, and the peripheral inclusion of the quirky wardrobe. As a picture alone, however, it wasn't enough. I liked the idea of a "portrait interrupted" but the facelessness didn't lead anywhere without the presence of another aspect to the image. I wanted there to be an object to her gaze, one that I could not have necessarily added during the physical shoot.

I looked through other images of Chrystaline I'd taken in the same room. Amidst my attempts at creating portraits on the spot, I had posed her standing poker-straight by a lamp, which I did not find substantial enough as a stand-alone portrait. I decided to cut loosely around her figure, along with the lamp, and move it into the other image. After contemplating placing her next to the wardrobe and discovering there wasn't enough space to accommodate it in the frame, I had the idea of transposing the figure on top of the wardrobe, as though it was a painting on its surface. I experimented with the positioning, perspective, and opacity, and tried different layer blending modes to create the appearance of a drawing or painting and to reduce its photographic realness. I settled on using Pin Light mode, but also applied other artistic filters to give it an etched appearance. I then decided to add another figure to the front of the wardrobe, so selected another image of Chrystaline from the standing portraits and matched it to the brighter area on the front. I chose a title that alluded to the idea of the character being part of the art on the furniture.

▲ **SHE BECAME DRAWN IN (2011)**
I wanted the viewer to follow the model's gaze toward an element of the scene that might go unnoticed at first. I wanted to make them look twice, and prompt the question, "which came first?"

THE PROCESS
A photo I shot of the model by a lamp, which I did not consider interesting enough for a final image, but came to be used as a quirky part of a surreal composite, seemingly painted onto the side of the wardrobe.

A true embracing of spontaneity occurred during the edit of *Common Creatures*. At the time of shooting I was drawn to the bright colors of the walls and radiator, the enigmatic empty birdcage, and the bizarre painting by an unknown amateur hand that depicted familiar creatures in a simplistic fashion. At first I decided to try an image with motion, and my assistant lifted and flicked Sammy's dress on cue, so that it would appear to be flaring out from behind her while she gazed into the birdcage, which I'd decided would be hovering in the air. In the edit this concept didn't work, or bored me somewhat. What I found more interesting were the images of the assistant holding Sammy's gown and the candid between-takes. Sammy herself took on the attitude of a bird with a male hand holding the tail of her dress, peering into a cage that I filled with fictional birds (from a photo I'd taken of another painting in the same room). I noticed there was a space in the painting into which I inserted a profile of Sammy, changing the opacity, and layer blending

mode, and tweaking Color Balance and Levels until she resembled one of the painting's "common creatures." I decided on an overall crop to split the man down the middle to obscure his face, making him anonymous and placing the focus onto the bewildered girl in the middle. I enjoyed the series of surprises I experienced in editing this unconventional portrait, and I developed it from an initial candid shot into a surreal scene inspired by a range of sources I kept in mind including Martin Parr, Guy Bourdin, and Magritte. It took me a long while to decide on a title: I wanted something provocative, but not didactic or obvious. I was torn between using a phrase relating to the word "bird" and its use in British slang for a woman, and also considered the connotations of cages: feathers, pets, and keepers. However, ultimately I decided that the title should not just refer to birds, but should encompass all the "common creatures" within the painting on the wall.

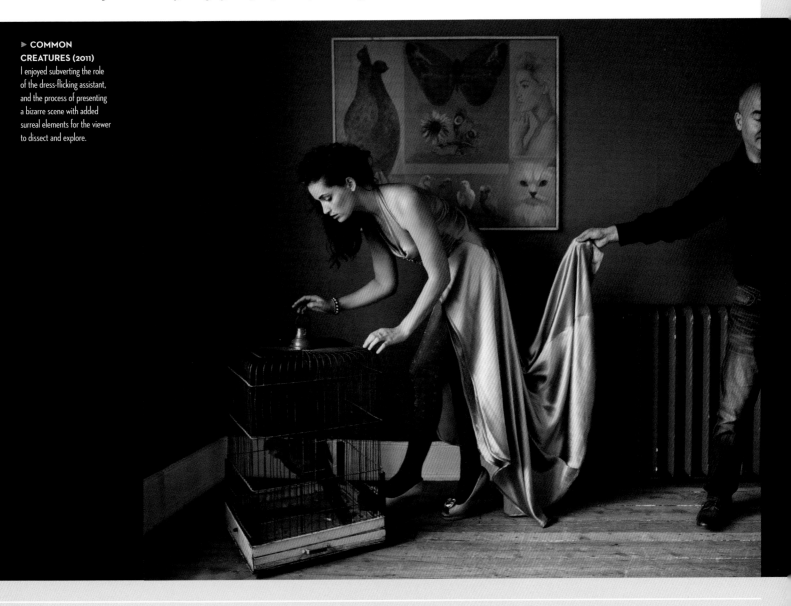

▶ **COMMON CREATURES (2011)**
I enjoyed subverting the role of the dress-flicking assistant, and the process of presenting a bizarre scene with added surreal elements for the viewer to dissect and explore.

AGAINST A BLANK WALL: TRICK IMAGES

THESE ARE PORTRAITS IN WHICH THE SUBJECT IS APPARENTLY HOVERING OR FALLING: PORTRAITS THAT MAKE USE OF SURREALISM IN A CREATIVE WAY, THAT CAN CONNOTE ANXIETY, DREAMINESS, OR EXCITEMENT. SHOT AGAINST A BLANK WALL OR STUDIO BACKDROP, THESE PORTRAITS USE PROPS AND SETTINGS TO MAKE AN OTHERWISE UNINTERESTING ENVIRONMENT INTO A FUNCTIONING ELEMENT OF A CREATIVE AND STIMULATING PORTRAIT. FOR EACH PORTRAIT I USED A CAREFULLY POSITIONED CHAIR OR SOME PHYSICAL ASSISTANCE TO SHOOT A SERIES OF IMAGES WHICH WERE THEN PUT TOGETHER AS A COMPOSITE IN PHOTOSHOP TO MAKE THE ILLUSION COME TO LIFE.

CATSUP (OPPOSITE PAGE) WAS SHOT IN MY BEDROOM using the blank white environment of the bed and wall, and using only the available natural and ambient light. I used my bedroom lamp, positioned at the bottom left corner of the frame, to light the scene. This proved to be a little tricky in terms the number of resulting shadows that I had to perform my compositing on, but it helped to clean up the image by increasing the brightness in Levels and Curves and desaturating the image slightly.

My intention was to create a simple levitation-style pose above my bed, which I achieved by first posing the top half of my body as I wanted it, and then my lower half. I brought both pieces of my body together in Photoshop, and after some careful cleaning up of the wall and matching the contrast and brightness in each component part, I found myself with a completed levitation image. However, I found that the overall composition was a little uninteresting: dead-ended, in terms of providing a full experience for the eye and some kind of extra stimulation for its narrative. I had the sudden idea to incorporate a prop, my cat BB, into the image. Taking a shot of BB against a white rug, I cut roughly around his black outline, moved it into the main image, and set the layer to the Darken blending mode. This instantly made the edges invisible, saving a lot of work that would have required erasing meticulously around the outline of his fur. I applied a layer mask to take away any excess, then reshaped him slightly by using the Warp tool to manipulate him into the undulating position I wanted. I added a shadow, as well as a longer tail with a more effective shape from another image, making sure the curve made by his body swept in the opposite direction to the curve made by

my legs. It was this piece of tail that completed the composition for me, the crowning detail that made the whole frame come alive. Similarly, I felt that the slight shadow that I added to the skirt behind BB's tail drastically improved the image, due to the depth added by this tiny but important detail. The image was no longer flat. More than that, it was now more interesting in terms of narrative. Coming down more on the side of amusing rather than profoundly conceptual, I gave it a lighthearted title to match. *Catsup* became a memorable portrait of myself and my cat holed up together in my overpriced bedroom in London, taking part in a sublime oblivious reverie.

▶ **THE SMOTHERING (2008)**
My most popular and recognized levitation-style self-portrait, *The Smothering* has been widely exhibited in the UK and US, published in books and magazines, and is the highest selling limited-edition print out of all of my work.

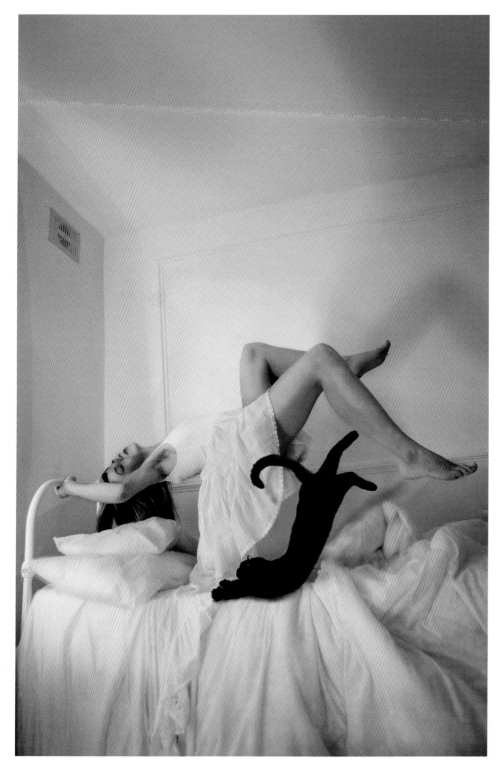

▲ **CATSUP (2010)**
A levitation self-portrait shot with ambient light and a desk lamp. I used a chair to achieve the height for the effect of this trick image.

THE PROCESS
Images from the process of creating *Catsup*. The top and bottom half were shot separately so I could pose for each with the most conviction within the uncomfortable circumstances. The addition of the cat made things more interesting.

AGAINST A BLANK WALL: TRICK IMAGES

Hover Craft was created during my first workshop in London. I had previously created levitation images like *Catsup* with the subject floating horizontally, and for *Hover Craft* I liked the idea of the model sitting upright, flinging her limbs forward in an almost threatening demeanor. Inspired by the *In Between* series by artist Julia Fullerton-Batten and also by Stephen Spielberg's *Poltergeist*, I laid out a sofabed in the studio. By avoiding using a studio backdrop, I let the background of the window and wall become part of the scene in which I wanted to present an otherworldly illusion of a blonde-haired girl floating in her bedroom.

In order to make this illusion work, I had the model, Mette, sit on a chair on top of the bed and alternately raise each leg. The aspect that first attracted me to this shot was the way in which Mette's hair was being blown around by the high-power fan in front of her, so I made sure that I photographed her with her face close to the fan so her hair splayed out dramatically. I also made sure I shot the scene without the model or the chair in it, and kept the camera locked down on the tripod throughout all of these shots.

In post-production, I took the four crucial shots I needed: the two legs, the head with the blowing hair, and a clear shot without the chair so that I could easily edit out the parts I didn't want. I'd had the chair covered with a white sheet which made for a swift and efficient edit because of the overall whiteness of the whole scene. Transferring the head and hair was tricky because a distinct seam emerged between the two body positions, but I was able to make the image work by taking a sample of the dress from another shot and using it to merge the two positions. After I had positioned the body parts, I worked on the background to make it whiter, which included cloning out distractions on the wall (one disadvantage to using the natural setting of a cluttered studio). I decided to add a shadow to enhance the notion that Mette was hovering above the bed, because at this point she appeared to lack context floating in mid-air.

The process for *Flying Solo* was similar to *Hover Craft*, but for this composite I had the model, Sofia, lie on her stomach over a chair. An assistant held the empty frame around her head while she flicked her hair backwards and posed for the top half of the image. Keeping my camera in the same position, I had an assistant lift her legs from the back while wrapped in a white sheet: this made them much easier to edit out. Upon post-processing this image in Photoshop, the main issue I dealt with was making the overly white context more interesting. It did not look like an effective levitation piece once I'd cleaned up the image and cropped out the untidiness on the floor in front of Sofia. This was due to the fact that there was no longer a proper floor, and therefore no obvious relationship to the height at which the model was seemingly suspended. I solved this by marking the appearance of wall and floor by creating a line for the corner of the wall and editing in the image of a skirting board. I changed the color balance of the area below the line to create the subtle appearance of a painted or carpeted floor. Final adjustments involved airbrushing Sofia's face and reddening her lips, and adding more detail to the bow around her waist from another image where it seemed fuller. The final image was suggestive of a real environment without its banality: slightly unreal, with a picture-postcard appearance that I found aesthetically satisfying.

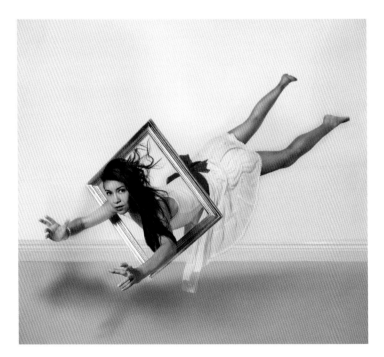

▶ **FLYING SOLO (2010)**
This portrait with model Sofia had the advantage of a controlled lighting environment and clean studio backdrop to achieve a fairly easy edit, but the disadvantage lay in the fact I needed to try harder to make the whole image interesting creatively, and give it an artificially-constructed context.

► **HOVER CRAFT (2010)**
This was one of the first times I used a controlled lighting setup. I shot with a large softbox in a studio, but accessorized it to reflect a more natural scene by incorporating the window and a couch I made up like a bed with a sheet and pillow.

THE PROCESS
The shots of Mette's legs (right) that I used as part of the composite. After this, I shot Mette leaning forward towards the fan to have her hair blown out dramatically for the headshot (below).

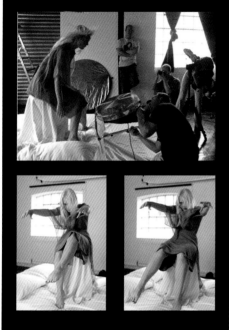

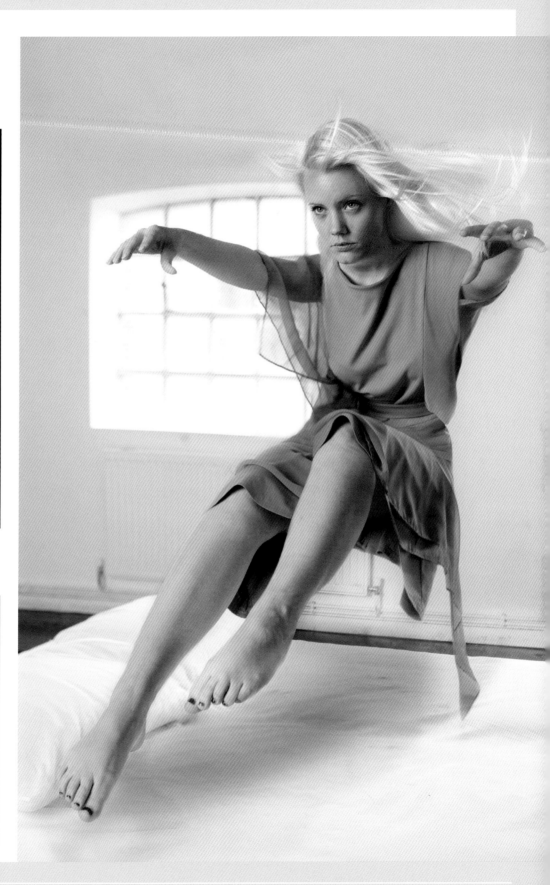

SOFIA (2010)
Behind the scenes.

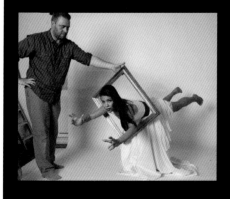

CHAPTER 5
ARTIST SHOWCASE

LOOKING AT THE WORK OF OTHER PEOPLE CAN OFTEN BE BAFFLING
FOR ARTISTS: HOW FAR DO WE GO IN SEEKING INSPIRATION FROM OTHERS,
WHILE AT THE SAME TIME MAINTAINING A PROTECTIVE MEMBRANE AROUND
OUR OWN WORK? THERE HAVE BEEN MOMENTS WHEN I HAVE FELT AS THOUGH
THE EXISTENCE OF OTHER PEOPLE CREATING ART IMPOSES LIMITATIONS ON
MY AIMS AND PREVENTS ANYTHING I DO FROM BEING ORIGINAL. LIKEWISE
THERE HAVE ALSO BEEN TIMES WHEN I REALIZED MY WORK COULD NOT
EXIST WITHOUT THE WORK OF OTHER ARTISTS: I WOULD INSTANTLY LOSE
BELIEF AND MOTIVATION IN THE ACT OF CREATING, IN WHAT WOULD
INCREASINGLY SEEM LIKE A BIZARRE, SELF-INDULGENT ACT.

THE FOLLOWING CHAPTER REVEALS THE backgrounds, inspirations, and processes of five selected artists. They hail from three countries: Britain, America, and the Netherlands, and range from those in their teenage years through to those that have lived entire careers in other fields, related or not to their creative passion. All five artists produce high-quality creative portraiture, working imaginatively and innovatively. The work behind each of Kirsty Mitchell's photographs is considerable: months of preparation, hours of prop and set construction, and the sheer capital she commits to the crafting of a theatrical scene from which she produces just a few precious photographs, all in the name of her dedication to a personal series. For her, post-processing is merely a way to polish and subtly enhance her images. Similarly, Peter Kemp's work involves weeks of preparation, the preparation of a moodboard, and the putting in place of a team all working towards one common, satisfying goal that guarantees nothing at all in return but the satisfaction of creating art.

Every photographer knows what it is like to change a plan to fit along the way, to do something different they did not expect, even if it simply boils down to shifting the logistics of the shoot: but Peter Kemp's approach is one that views the models as collaborators, all in on the act of creation, as opposed to a more preestablished vision like Brooke Shaden's. She inscribes her own formula onto the models she poses, directing the worlds she wishes to incarnate. Even if simply sketched as rudimentary stickmen, a drawing echoes a definitive form in her mind, and her plans and her shooting follow that predetermined shape. Her materials—the location, model, and props—are simply raw materials for a dish made up of several layers that are fused together, baked, and risen to their intended height in the post-production stage. While all of the artists featured in this book can be compared to painters, the photographic reality of their work varies, and is more marked in the images of some than others.

For Susannah Benjamin, digital manipulation would cut into what is already delicately crafted by her eye beforehand—or at least, her work gives that impression. Her work seems to emanate a connection to performance art, to a fleeting moment delicately captured, or blatantly unmanipulated. There is something eternally youthful not just about her muses, but her own approach to them, as the invisible, omniscient photographer. This same quality can be

Peter Kemp

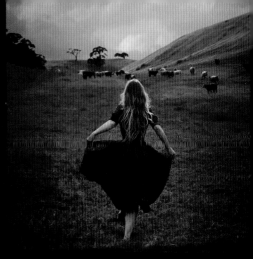

Alex Stoddard

Brooke Shaden

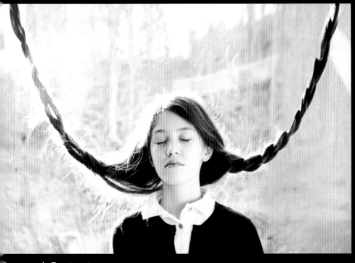

Susannah Benjamin

Kirsty Mitchell

found in Alex Stoddard's work, who seems to translate the malleable approach to form seen in Susannah's work into the conceptual backdrop found in Brooke Shaden's. His work often uses the impact and expanse of the square form, rich in bokeh and color, but he also proves willing to switch to monochrome, a form more noticeably photographic, raw, and simple. His images show a transition (or diversification) from private self-portraiture to more fashion-based images featuring models as he pursues life as a professional photographer. Thus his models must work their way into the empty spaces left by the most experienced model Alex knows—himself. Meanwhile, Susannah's aesthetic exhibits an interesting reversal: she already undertakes fashion commissions, but is also steering her career into the realm of fine art.

This chapter outlines a small but special group of photographers who are diverse enough to each offer a different story from the last. However, seen collectively, they display something as distinct as a movement in imaginative *tableaux* photography: a bold seizing of form, color, and tone, an equal attention

to both the concepts and aesthetics of a portrait, and a relationship with their models that—for each and every one of the photographers in this book—often goes beyond just a job for the subject. All of the photographers featured here know the artistic reaches of their own minds and are articulate enough to communicate them by color and form, to hold up their work as fine art in a crowded market. Their talent is multifarious: they all show the capability to turn their hands to fashion, other commercial work, or even cinema. There is a bias towards fantasy rather than reality, a desire to "create" rather than "document," and abundant evidence to mark them as existing at what I would consider as the cutting edge of creative portrait photography today.

KIRSTY MITCHELL

THE WORK OF BRITISH ARTIST KIRSTY MITCHELL DEFIES CATEGORIZATION. SHE IS AN ART PHOTOGRAPHER WHO CAN SPEND TWO YEARS ON A SINGLE SERIES. KIRSTY UTILIZES MAKEUP AND PROPS IN THE MANNER OF A FASHION PHOTOGRAPHER, AND WITH ALL THE FLAIR AND ATTENTION TO CRAFT OF A SET DESIGNER. WITH THE TIGHT EXECUTION OF A FILM DIRECTOR, HER DREAMLIKE VISIONS BECOME A PALPABLE REALITY.

FORMERLY A FASHION DESIGNER, Kirsty's career as a photographer began only a few years ago when she used photography as a distraction and as a method of escape. Now devoted to it, and having quit her job to pursue it full time, in the beginning she drew upon her background in theatre and fashion and channelled these influences into her photography. Her *Wonderland* series, her main body of work, has gained worldwide media attention. Dedicated to the memory of her mother, through her *Wonderland* art she transforms personal pain into joy and pleasure.

This series of Kirsty's is extraordinary. The locations and costumes dance with life and color around the mournful, wistful gaze of exquisitely styled models, producing an end result that goes several leagues beyond typical fashion photography, into the realm of something that cares a great deal more about story. It is an aesthetic that guarantees the delivery of a fantastical vision with more than a merely mercenary purpose. Kirsty's mastery in capturing and selecting "the shot" is evident, so too is her dedication to walking a tightrope of faith to produce the result from months of preparation and pre-planning of ideas. Her earlier work—portraits of herself and others—demonstrates the conceptual core of her mindset. Kirsty is an example of the kind of photographer for whom concept and aesthetic are not two opponents, they are one and the same.

Her work oozes a level of fantasy deceptive in a post-Photoshop age where anything is possible in post-production. Kirsty's craft is more thoroughly appreciated when accompanied by her written dialog; her journal records the process behind her creations and the long days shooting with stout commitment to a self-made brief.

The following pages look at a range of the artist's work: portraiture and self-portraiture, at once creative and grounding, and touches fleetingly upon the vast illusionary tapestry of her *Wonderland* series. Kirsty Mitchell shows that craft is very much present in art, that art is present in beauty, and that beauty can be made from the worst shocks that life brings.

▶ **WONDERLAND 21**
"Part of my *Wonderland* series, the model here is Elbie Van Eeden, who did the hair and makeup for the entire series. It was taken in a snowstorm, with the umbrella and props made by myself, and the colored effect in the snow created with powder paint. It was shot with a Canon 5D Mark II, a 50mm *f*/1.4 lens, and natural light. It was just the two of us, and will remain one of the most precious memories I have of the project."

CREATIVE CONVALESCENCE

Art was my passion when I was growing up. I studied the history of art, photography, fine art, and then went on to train in costume design for film and theatre. Having graduated and worked for a short time in the industry, I returned to university to study fashion design, and worked as a designer for a global brand. I have a love for intricate sets and creating make-believe, which is deeply rooted in my background. I am far more influenced by art, film, music, and fashion than photography. My pictures are an expression of that, and photography is my way of recording the results.

I first picked up a camera in the summer of 2007, when I was in the process of recovering from chronic insomnia brought on by post-traumatic stress. The drugs and my exhaustion had numbed my senses to the point where I had lost all awareness of touch, temperature, and the daily lives of the people around me. I was undergoing hypnotherapy and slowly things began to return, but my sensitivity seemed to change to an almost heightened state. I had an overwhelming urge to record the unseen moments in my daily journeys to work, and the people in them. So I started with a little point-and-shoot camera I kept in my handbag, and took as many pictures as I could. It was an insatiable need, but also a release and a therapy, and it honestly felt like my eyes had been opened for the very first time.

I started making self-portraiture, which was driven entirely by a need to express my emotional state. It was only a few months after I began taking pictures that my mother was diagnosed with a brain tumor, and my world fell apart. I couldn't talk to anyone about how I felt, and taking the self-portraits became a place to vent my emotions and also a way to escape the reality of what was happening in my life. I would say all of my photography is driven by emotion even if it is not always apparent to the viewer. After my mother died I carried on taking the self-portraits but began to struggle more and more with them, until I eventually lost my self-confidence entirely. It was then that I began the *Wonderland* series in her memory, and I was forced into photographing others. It just happened out of necessity and was a natural progression.

The relationship with my online audience is hard to explain. When I first started taking pictures it was a world I lost myself in, a place in which I could be 100 percent myself. I could show my face, my body, share moments of utter sadness in a very public space, but in an entirely anonymous way. It was like having an alter ego, and it helped me greatly to express what I felt inside. But as time went on and the pictures became increasingly time-consuming to produce, I simply couldn't keep up with my contemporaries who were uploading every other day. My *Wonderland* pictures can take up to a month to prepare for just one shot, so it was impossible to produce anything quickly, especially as I was still working full time as a fashion designer as well. So I chose to focus on making the series the best I could make it, and not concentrate on gaining fans. As a result I felt my audience changed, mainly into a more genuine and caring one. Many people write to me about their own loss, or the emotions they felt watching the series develop, or just thanking me for explaining how I took the pictures in my diary entries. It's ironic, but since I stepped back, people have come forward in such a deeply touching and motivating way. To be honest, after losing my mum, all I care about is creating something beautiful that people can lose themselves in, to the best of my ability, and that's it.

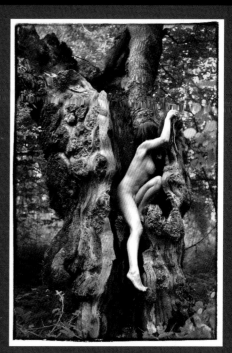

ABOUT MY ANGEL

My Angel is a deeply personal project that spanned a year between 2008 and 2009, and is a record of my best friend's first and second pregnancy during which she lost her unborn child after only a few months. The pictures start seven weeks into her first pregnancy, and ends with her three weeks before the final birth of her son Connor. It began depicting the relationship between her body and nature, and ended very differently with her almost naked, shivering on an abandoned road just after the dawn. These final images were about the journey she had been on, and the traumatic loss she had gone through. The final shot, shown below, was taken after I asked her to let go and show me how it felt to survive all the heartache, to know it would soon be over, and that she and her child had made it. It was indescribable to me; I will treasure these pictures and the memory of them forever.

▲ **MY ANGEL**
This was Sharon, seven weeks into her first pregnancy.

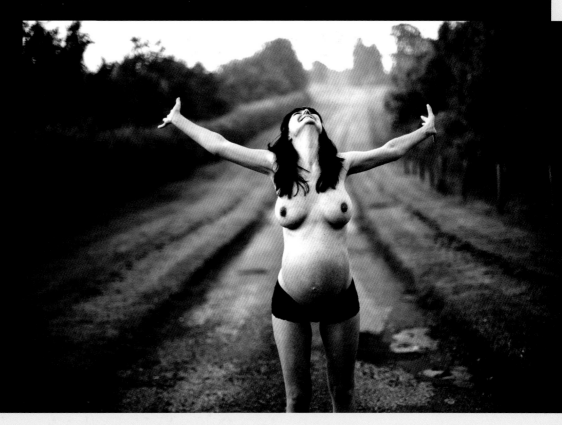

▶ **SUDDENLY NOTHING ELSE MATTERED ANYMORE:**
The model is Sharon Simmonds-Burns, shot at dawn, three weeks before the birth of her son Connor.

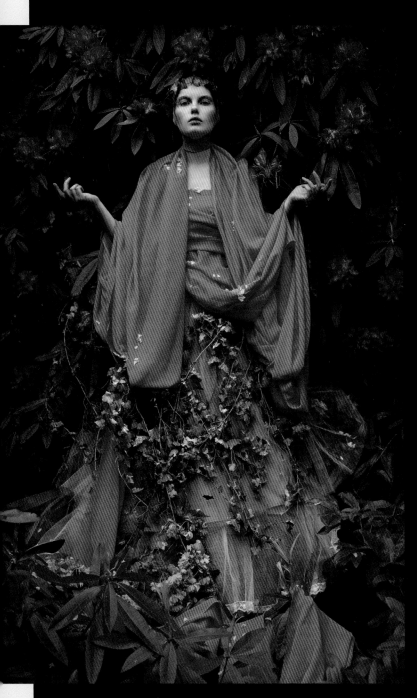

▲ **WONDERLAND 27, THE PINK SAINT:**
Model is Anna Sychiova, taken in a giant rhododendron wood with the model standing on a stool, shot with natural light from the top of a ladder, in order to gain equal height with model. The costume was made by myself, and hand-dyed to match the flowers.

FANTASY FOR REAL

Portraiture to me is about expression and emotion. No matter what the situation, real or make-believe, I am looking for the moment where there is a connection between the viewer and the subject. It can take two hundred shots to get the one that means something, but it's that glimmer that drives me. That moment when someone is "true" and their essence is projected: that to me is portraiture.

It is incredibly hard to sum up my series *Wonderland* in a few words, which is why I write a diary of its progress and will produce a book of the series once it is finished. But it will always be the way I have dealt with losing my mother, and also the celebration of who she was to me. I found my grief unbearable, and reality a dark and ugly place. So I created an alternative world to run away to, full of color and beauty, soaked in the memories of the stories she read to me as a child. She was an English teacher and inspired so many children as well as myself, and this was how I wanted her to be remembered. Making the series has changed my life, I have experienced things I never imagined I could produce, or simply witness for real. I have seen the dawn in the forest with a giant girl spinning in shards of light, waded into lakes at sunset up to my neck in lily pads, and battled through a snowstorm with an umbrella covered in flowers. It has been surreal, magical, and awe-inspiring, and I feel that now despite losing the person I loved the most, I know I'm truly living.

The level of work that goes into each image varies greatly, but they are all extremely labor-intensive. Everything you see within the frame of a *Wonderland* picture has been made completely from basic materials by myself and a few friends. They've been designed by myself or created from individual pieces I have researched and bought from vintage fairs or eBay, or have been donated by people who want to help. There are no stylists, or designers, I art-direct the entire image and work with my hair and makeup artist Elbie Van Eeden to bring the final characters to life. It's normal to dye the fabrics by hand to match the flowers they will be shot against, make model ships, necklaces, and wigs out of flowers as well as spend a great deal of time scouting magical locations that will give the picture the edge I'm hoping for. It's exhausting and takes a long time, but it is what I love the most.

Looking to the future, I purely wish to work as an artist. I have no interest in being a photographer of other people's ideas. Creating everything within the frame is absolutely vital to what I do. Sometimes people call me a fashion photographer, which I'm not very comfortable with, and other times they call me a digital artist in the sense that people assume I create all my backgrounds and effects in Photoshop, which can be very frustrating when I spend so much time making things for real. I am currently in talks about extending my work into a new direction which I never imagined, which is extremely exciting, and could possibly define where I end up in the next few years.

I just hope my images are a place for people in which to lose themselves. There's a lot of sadness in the world, and without trying to sound like I'm in a beauty pageant, I hope to counteract that a little. There's as much or as little as you want to find, and I'm sure escapism never hurt anyone.

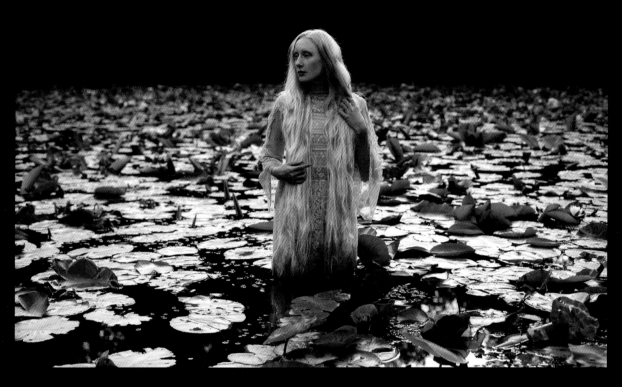

▶ **WONDERLAND 6,
THE LADY OF THE LAKE**
Model is Katie Hardwick. This
was shot at sunset while standing
in a lake up to my neck in water! I
used a Canon 5D Mark II and
50mm ƒ/1.4 lens.

▶ **WONDERLAND 11**
Again shot with Katie, in the
grounds of King Henry VIII's old
hunting lodge. The effect was
created in-camera with a smoke
bomb, and the flower collar was
made by myself.

ARTISTIC PROCESS: *THE VOYAGE*

Wonderland. 41, The Voyage, comes at a transitional point in my series where the character is transformed into the beauty that she has always dreamt of being, only to find she has been tricked and the spell has her changed into a doll. She is a metaphor for the mood of the series shifting to a darker place. The color red and the tiny ships are a motif from previous images, which suggest a journey has begun. There is relevance in all the aspects shown, nothing is included simply to make the image more pleasing.

The scene was shot indoors next to a window to create a strong directional light on the subject. I was aiming to achieve the appearance of an old painting with both the mood, and the static pose of the model. The entire costume and carousel umbrella were made by myself, and the hairpieces were made by Elbie Van Eeden to my design.

Happily this image came out as intended; it was a tight shoot with only one pose. All the hard work was in the preparation and post-production.

This is one of the few *Wonderland* images with obvious photo manipulation, and it was important to me that it looked as natural as possible. The focus of the post-production was to create the ball and socket joints for the model's arms and legs. I researched close-up images of doll joints, and then layered these over the areas required. I erased through to the skin beneath leaving the outlines and shadows as a guide to work with. These were warped into a natural position, and retouched until the effect was convincing. The tiny ships were made by creating a galleon silhouette from old maritime maps, and then layering them onto the skirt and red fabric "sea" using a low opacity setting.

THE PROCESS
The extremely long process of creating the model's circus hair.

PROPS
The very slow process of making the carousel umbrella. It took around three weeks to finish. Everything was handmade by myself.

▲ **WONDERLAND 41, THE VOYAGE**
Model is Katie Hardwick. Shot indoors in front of a window, using natural light. The costume and umbrella were made by myself.

◄ **WONDERLAND 29:**
Model is Francesca from Profile models, shot in a bluebell wood. The book chair, headdress, costume, and necklace were all made or designed for the shoot by myself and my small team. Taken using natural daylight and a reflector with my Canon 5D Mark II 50mm f/1.4 lens. Special thanks go to Affirm Heart Factory for making the dress."

ARTISTIC PROCESS: *WONDERLAND 30*

This picture was taken in May 2010 in one of the most beautiful locations I have ever discovered. I had waited a whole year for this shoot after finding the location the year before and spent two solid months making the costumes and props. It was a secluded wood that blooms with a dense carpet of bluebells for roughly two short weeks before it disappears. For me it is about as magical as nature can get, and I absolutely had to have it in the series.

The headdress was one of the hardest pieces I have ever created. It was extremely heavy and had to be covered in strings of fresh flowers cut from the location the night before the shoot. The chair was made from a collection of books dating back to the 1800s and the dress was stitched with hundreds of pages from the books with the intention of blending the model into her surroundings. All the books were over 120 years old, and the huge bible on the model's lap was 250 years old: they had all been donated and were a perfect example of the incredible kindness people have shown me in helping with the project.

I had been imaging the storyteller character for a year, so by the time of the shoot the picture was very clear in my head. I wanted to create something very special for such an amazing location, and also bring back the motif of storybooks into the series. Once again the finished shot did not really deviate from what I had intended.

I also made a closer portrait from this same setup, layering a photo of some bluebells on an f/1.4 setting to blur all the colors into a rich, vibrant bokeh. Whenever I create additional effects like this for my pictures I always make sure that they are created with elements that were part of the original scene. It was my way of communicating the magic I felt in this extraordinary place.

PROPS
Two solid months were taken making the costume and props.

STORYTELLER COSTUME
Creating the "storyteller" costume, hand-sewing hundreds of pages into the frills of the dress.

STORYTELLER'S CHAIR
Creating the storyteller's chair was done by securing ancient books to the frame of an old high-backed wicker chair with wire and screws, 11 p.m. the night before the shoot, and attaching the strings of fresh bluebells to the papier-mâché headdress base.

FINISHING TOUCHES
Making finishing touches on location to the model.

PETER KEMP

FOR PETER KEMP, A STUDIO IS NO ORDINARY SPACE WHEN IN HIS
HANDS. HIS PORTFOLIO IS AWASH WITH INTRICATELY CONSTRUCTED
PORTRAITS INSPIRED BY EVERYTHING FROM GREEK MYTHOLOGY
TO FASHION PHOTOGRAPHY, ACHIEVING A SURREAL SYMBIOSIS
WITH A NOSTALGIC MOOD AND TONE.

FOR PETER, who resides in Delft in the Netherlands, photography is mainly a hobby—but a labor-intensive one. He has a diverse photography background from which creative and surreal portraiture has emerged as his favorite genre, coming almost full circle and returning to picturing fantastical figures from stories he enjoyed as a child. Bringing together his own props and sets, often retro or antiquated and carefully sourced, Peter also allows his shoots to come together organically with the contribution of his models' ideas and belongings. Rather than imposing a tight concept or formula onto his subjects, he becomes the orchestrator of a creative team who all bring their own contributions to the outcome. Combining a flurry of ideas into the final form, Peter shoots several images for a short series from any one session in line with the storytelling nature of his work. He often shoots his models in glamorous lingerie following their own sartorial input which sends a frisson of sensuality through his images. With poses and expressions reminiscent of '50s pin-ups, but with more attention to bizarre and even postmodernist concepts, Peter often subverts the positioning for amusing effect, turning women into bell boys and old men into glamor models.

This artist's imagination is reminiscent of a more fashion-oriented Gregory Crewdson, or a darker Tim Walker. To gaze through his works is to wander along a bewitching path of deftly positioned historic waxworks, frozen with varying emotions in moments of symbolic gesture with magnificent objects.

Peter's attention as an artist is focused on the characters he creates, the composition and expressiveness of the whole scene. He insists that the mechanics of photography are of second priority, though he has a clear technical competence in working with the best tools. Shooting in medium format and most often with strobes in a controlled environment, his final images are abundant in meticulous detail, only a glimpse of which is seen here on these pages.

▲ **PEARLS**
"Here I wanted to make fun of the abundance of jewellery photos in the media. I decided to create my own "jewellery" with foam balls and paint, shooting with models Rudolf Vink and Nicole Vink."

▶ **TROMBONE**
"This was part of a photo project called *Musica*, here with model Dena Massque."

COWBOYS TO BELLBOYS

During my childhood, I loved to draw. I kept busy in my own little world creating stories about knights and cowboys. Later on, my great passion became scuba diving and using photography to picture the underwater worlds that I was in love with: showing people the wonderful world beneath the sea. It was the days of analog photography, and being an impatient person I was frustrated by waiting far too long before I could see my results, so I gave up. It was when digital cameras became affordable that I started to take pictures again. Finally all details were visible directly on my camera screen, and I found that very rewarding.

My earliest digital photo works were based on nature photography, but after a trip to the Carnival of Venice I became fascinated by the mysterious masks in such a wonderful environment of the grand buildings, the palazzos. I wanted to capture and recreate them, and this was my first step into staged photography, leading to the "storytelling" pictures that I mainly do nowadays. I also work as a freelance photographer for magazines, but what I like most is my own personal work, which I exhibit. In 2011 I was chosen as one of ten finalists for the Hasselblad Masters Award, one of the most prestigious awards in the photo industry.

Being born in 1960, it is the decades between the '30s and the '70s that hold my special interest: the furniture, clothing, colors, and music inspire the vintage mood I strive to create in my images. Using lingerie, corsets, and high heels gives me the opportunity to create an elevated and glamorous kind of portrait.

When I plan a shoot, I search for a team to fit my basic plan, none of whom is paid, including myself. We simply share the passion to create something we like. I noticed this creates an optimal situation for working together with compassion and an open mind, and most of the time it leads to satisfactory results and a happy team. Since my shoots require a lot of preparation, I tend to shoot no more often than once a month.

The process requires setting out all my ideas onto a moodboard, putting together the best team I can, choosing a suitable location, and organizing all the props. It is a time-consuming but rewarding process. The makeup artists and stylist bring such wonderful details to the work. I am convinced it is not the photographer alone who makes the picture: it is the whole team pushing the release button.

My photographic skills improve by trial and error. Feedback is important to me, which I get primarily from a couple of my friends who offer me fair criticism, especially on my new works. Sharing my pieces online also offers me a first impression of how people see my new work, and gives me clues as to whether it is appealing enough to others. A useful place to expose my pieces is an online photo gallery called 1x.com, where a professional curator "screens" every photo. The moderator team makes sure there is a high intellectual standard in critique, and when a picture is rejected it makes me work harder to get the next one published. Personally it has helped me a lot in being able to harness a self-critical approach to my own work. Another advantage of sharing my photos is the possibility of meeting people who share the same passion. It is great to meet new models, makeup artists, and stylists who are interested in joining in my projects. I like to combine all these creative forces to create powerful concepts.

◄ NUDE PHOTOGRAPHY
This picture was made as a kind of tongue-in-cheek statement towards pornography and changing roles between the models. I like to use humor even for serious themes, as I believe it is a great way to convey messages. I used a 1905 old Grafilex photo camera to emphasize the "low quality" of pornographic productions. The models are Rudolf Vink and Rafaella Lorenza Huizinga.

▲ CAGED
For this portrait with model Sissi Pham, I used a grey backdrop and wooden floor, which are particularly suitable for reflecting light with a soft mood. I shot with two strobes, one in a large softbox.

► THE BELL BOY
This photoshoot took place in a wonderful abandoned stained glass tower. My intention was to create a vintage mood with a pretty bell boy and her handsome client, played by my models Tim and Ave Maria.

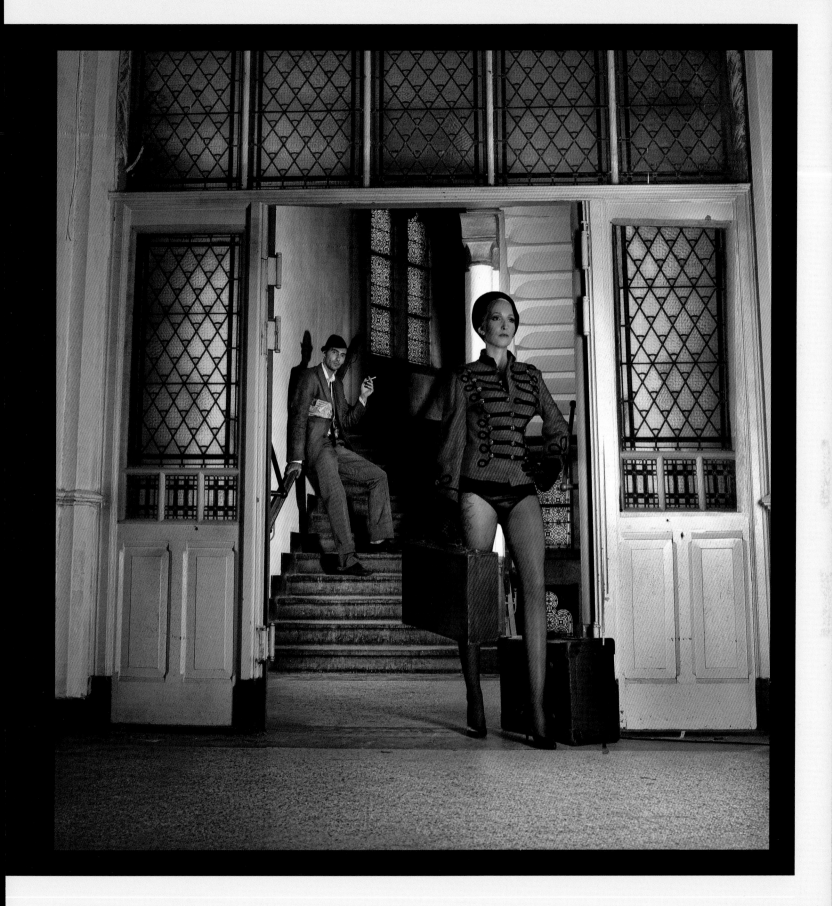

THROUGH A GLASS DARKLY

In my photography, I like to create the ambience of "the old light," which is well known from its use by the Dutch Master painters including Johannes Vermeer. I live in the same town, Delft, where Vermeer lived and painted.

Our lives nowadays are made of fast habits and attitudes. With my photos, I like to do the opposite: to slow down, stop, and freeze time. I want to catch and captivate my viewers, bringing them into "my world." For me in portraiture, the storytelling element is essential. It has to be open to different interpretations, making people look more carefully at the picture, triggering them to create stories from it. Best of all, I like it when they create their own stories, and sometimes I am amazed by reactions I do get from viewers who discover new details and meanings in my works.

Ideas for my photoshoots come to me all the time: I have more ideas than time to realize them all. I notice funny circumstances on the street, on TV, in magazines, or reading about interesting subjects, and write down the most appealing ideas in my notebook. Seeing lots of creative photography on the Internet nowadays can also trigger inspiration, and I collect photo references on my computer. Parts of modern culture, from jewellery advertisements through to plastic surgery, have inspired me to produce satirical takes on everything around us.

Fashion photography has been a big source of inspiration in terms of adding details and ideas to my pictures. I would love to specialize more in that direction, using my concepts and ideas for opportunities in fashion. My dream would be to get a free hand in creating my own photo project on a larger scale without having to worry about the cost.

My ideal picture is in my mind long before my camera clicks, but seldom does the picture come out as it is in my mind. Producing an image I am really proud of doesn't happen often; in my opinion there is always something that could have been better. But when I do succeed, it is a great moment of joy to have reached that ultimate goal after weeks of preparation, planning, and working with my team. My goal for a photoshoot is to create at least three photos that contribute to my general theme and fit the series. Strangely enough I realize with increasing frequency that my favorite picture isn't usually the one my audience seems to like the most.

I like to develop a friendship and connection with my models, as that is how I work most successfully. The models are the key ingredient in creating my stories, and most of my models have become my friends. They are beautiful people, but more importantly, they have so much talent, which is invaluable to my work. Working in a studio offers me the optimal control of light, props, and the best circumstances to work with my models. In Holland rain is common, so being inside does create more reliable circumstances in which to work. The lighting during my shoots is mainly two or three strobes with a big softbox. I do keep my methods simple, as I am not focused on the technology at all. Creativity is my passion, and a major principle of mine is to concentrate on the ideas instead of becoming preoccupied with the tools. I notice that in online photography discussions, 95 percent of the discussion is about the tools. Mastery of the tools is merely a mechanical process: anyone can learn to use them, and knowing the basics is important, but it doesn't guarantee the possibility of creating some works with impact. The difference is that which distinguishes artists from technicians.

▲ TUBES
This picture I made with the young Dutch designer Linda Friesen, who wears her own creation as my model. I found both the backdrop and the ventilation tubes, originally from a restaurant, as garbage on the street.

▲ WILD BUNCH
This one is from my first series, with no stylists and no flash as I usually use nowadays. I sourced the vehicles and location, and waited for the soft light of afternoon to shoot this picture. The dog belonged to the model (Eva Dekkers) and couldn't stay at home, but he ended up adding a crucial part to the image.

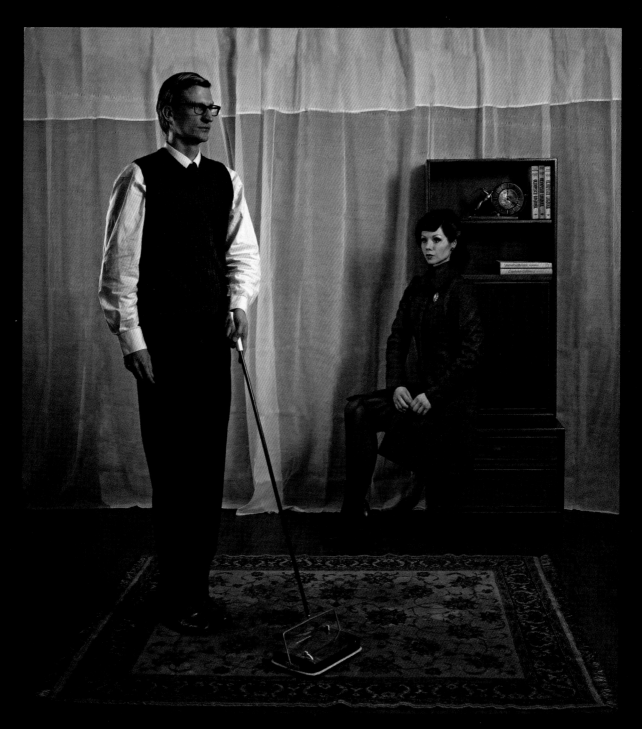

▲ **HAPPY LOVING COUPLE**
Here I wanted to embody a painful silence between the male and female form:
pale skin against an antiquated backdrop, original '60s furniture from my
parents, and a characteristic original carpet sweeper. I positioned the models,
Johan Beijers and Seraphine Strange, in a surrealist form within the frame.
They perfectly understood the emotionless atmosphere I wanted to express.

ARTISTIC PROCESS: *MATHILDE'S DRESS*

I had read a book about Mathilde Willink, the first wife of the Dutch magic realism painter Carel Willink, and had been intrigued by her story. Mathilde considered herself not to be a human being, but an "object" of art. She wore exclusive and expensive dresses, especially designed for her, and Willink used his wife in his paintings as his model.

 I was able to use one of Mathilde's own original dresses for a day, as a friend of mine received it from Mathilde herself, so I tried to infuse a kind of Willink-inspired, magic realism into my photo with the garment. This is one of three photos in this series. I like to produce more than one image for a small series per photoshoot so it becomes an inviting challenge to force myself to create more than one photo I am pleased with. I decided not to use the studio this time, but to shoot outside instead. I found an area on a beach, shooting the soft natural light towards the end of the day: the "magic hour." I wanted to use the typical cloudy skies to create a stark and slightly sinister mood.

 Together with the model, Seraphine Strange, we decided to go for lingerie without showing nudity. Willink often used nudes in his paintings, but I decided to give the image my own twist, especially as I don't like to do nudes. I prefer models to look tempting with clothing. However, in this case, my goal was to create an image with the outfit separate from the model, as I felt it would have been too obvious if my model was wearing it. We filled up one arm of the dress to stiffen it so that it was not dangling. By standing it next to the model I insinuated an embrace, an obscure relationship between the dress and the model. I brought the old lamp—in same colors as the skirt—to go with the scene and to emphasize the surreal appearance of the set-up.

 In Photoshop I wanted to exaggerate the cloudy sky by lowering levels, desaturating and cooling the tones. I used the dodge and burn tools over the sky and also on the coat, which increased the painterly aesthetic of the picture.

▼ **MATILDES' DRESS**
I felt that the chosen location by the sea, together with the cloudy Dutch skies in combination with the strange objects, created an allusion to the "magic realism" style of Carel Willink's paintings.

ARTISTIC PROCESS: *THE BIRD*

My basic idea for *The Bird* was that of a "first attempt at flying," as in the story of Icarus and Daedalus, which I've always found fascinating. I was wondering how this same kind of flying notion would look today. I decided to create my own 21st-century version of Icarus.

Being a former nature photographer, the idea of shooting with the bird theme was exciting. My models, Martin Bokschoten and Rudolf Vink, loved the idea of making fun of a nature photographer who tends to come much too close to the birds in their environment. Martin, the model who played the bird, created a pair of wonderful "wings" for me the week before our shoot. When he showed me his construction I was delighted with the direction the preparations were taking. We created our own nest by finding branches, and I also brought along some ostrich eggs.

Our team was small, literally only the three of us, and we did all the makeup and styling ourselves. For the makeup we wanted to create an innocent-looking, yet dramatic bird, so we went for black eyes. We had to sort out appropriate clothing, wondering what a human bird would wear, and added racing goggles, gloves, and a flying helmet. We were ready to go.

One of the qualities of a top model is their openness to trying to express the feeling you want to show in your picture. My bird model was able to portray a wistful, innocuous, and slightly mournful expression. The other model Rudolf had to personify the fanatical nature photographer going for "his winning picture" with an old Russian espionage camera.

For the lighting I used two 400W flash heads, one of which was in a large softbox creating soft light close on "the bird." I shot with a Hasselblad H1 camera and a Leaf Aptus back, as from experience I have discovered that this combination offers me the best possibilities of fine-tuning the light and emphasizing the textures: in this case, of the skin, the wings, and the nest.

We worked on location in a big shed without heating, only hot tea, in the middle of winter. Afterwards, I realized there might have been a better location than the shed we used and I wondered if the visual effect would have been stronger if I had done this shoot in another place—perhaps outdoors, sitting in the snow, with the sun going down and an old tree in the background: but then I might have had to defrost my models after a couple of shots. I accept the final result and feel I achieved what I wanted to do, and it was great fun: one of the photoshoots where I laughed the most.

◀ **THE BIRD**
I used a grey backdrop, which I'd found by experience is good for creating a moody soft light. Later on I increased the yellow color in Photoshop to match the final ambience I had in mind.

SUSANNAH BENJAMIN

WHEN SUSANNAH BENJAMIN DESCRIBES WHY SHE CREATES PORTRAITS, HER PASSION FOR CREATIVITY IS PALPABLE. THE INTERESTING ELEMENT TO SUSANNAH'S WORK IS HOW SHE CONVEYS FANTASTICAL STORIES WITHOUT ANYTHING MORE THAN A TONAL ENHANCEMENT: HER PHOTOGRAPHS ARE GROUNDED IN THE REAL, WITH THE AUTHENTICITY OF TRADITIONAL PHOTOGRAPHIC MASTERS. THE REAL EMOTION LIES IN THE MOMENT CAPTURED: THE EXPRESSION OF THE FACES HER CAMERA LENS PORES OVER, AND THE JUXTAPOSITION OF THE SURROUNDING ELEMENTS: FROM MAPS, TO BRAIDS, TO ENVELOPING DARKNESS.

▶ **UNTITLED**
"This is a photograph of my muse, Saskia, who is the star of many of my photos. The blooming of the red flowers is supposed to parallel the blooming and maturation between childhood and adolescence."

SUSANNAH'S WORK CAN OFTEN appear to be a collection of candid moments; she is one of those photographers who is devoted to setting up scenes for *tableaux* photography, but whose selection of one final image can be seen as unusual in terms of pose, expression, and message. The result is a series of caught "moments in time" as played by cinematic characters.

Susannah's creativity is paralleled by other young photographers, including others in this book who also reach for their camera as a tool to express a burgeoning young consciousness to both document and embellish their existence. With Susannah's work, her use of the fantasy aspect does not necessarily lie in trickery or enrapturing contexts to cushion or decorate the human element: she gets closer to the subject, often with a sense of sobriety, a psychoanalysis of a monochrome face. Shooting her favorite model Saskia regularly, she expresses herself through a muse with all the emotional attachment of a self-portraitist, but with the advantage of artistic detachment.

Her black-and-white images can be considered to be amongst her most powerful, because they are where this aspiring conceptual artist flexes her mental muscles seemingly effortlessly. Reduced to tone and shade, the focus is left on the shape of the subject, their expression or lack of face, and delicate strands of hair, plastic, or fabric. Reminiscent of the childhood portraits by Sally Mann, Susannah's nubile subjects ooze innocence: slightly troubled, lost in thought, unable to be rationalized as in Susannah's literal portrait of a young girl being presented with a Rorschach test by a male psychologist figure (below).

In Susannah's work, boldness is played down in favor of poetry—a verse that is whispered softly into the ear of the viewer, but which takes on poignancy once the reverberation of louder artists plays out. Photoshop is not as crucial a part of her arsenal as it is for other photographers, or at least does not appear to be so. Some of her most engaging juxtapositions are made *in situ*, taking on a particular poignancy for being captured in-camera. What really matters from an artist is honesty, and their constant striving to express the ever-shifting nature of their relationship to the world and place within it.

▼ A HOPELESS CASE

"This was supposed to be the classic Freudian psychology scene, where the psychologist holds up a Rorschach print to his 'hopeless case.' To me, it highlights how everyone can be viewed as crazy from one perspective or another."

as time passed. Looking back on my photos, I can see my improvement in each image. The Internet has been invaluable for networking and publicizing, although it also brings the danger of people stealing or copying work. Because I am a conceptual photographer, I spend hours planning my images and the message I am trying to convey. To me, the originality of the idea is essential to making photography an art form.

The last thing I want to do is take pretty pictures of pretty girls in pretty landscapes. For me, art is not as much about beauty as it is about conveying something important or evoking an emotion. Photography

CAPTURING CHAMELEONS

At the age of twelve I was given a small point-and-shoot camera for Christmas. I was disappointed with the gift (I had never had any interest in photography, and had no intention of using a camera), but I knew that it was a lovely thing for someone to give me, and I didn't want to hurt my mother's feelings. Subsequently, I went around clicking photos and took the camera on our Christmas vacation so that she'd think I was pleased with it. I've been hooked ever since.

I have lived in Greenwich, Connecticut all my life, and am now eighteen, so have moved to New Haven for college. Though my town is very quiet and ordinary, I don't find location to be very important in my photos; I simply isolate small bits of scenery and try to transform them into a place that is nondescript and thus universal.

Photography engrosses me because with art, I am always a storyteller. My models become the heroes and villains in my personal stories, so photography is a form of narrative that enables me to actually speak and interact with my characters in the flesh (rather than simply imagining them). To me, photography is the purest art form, because it is simply the ability to see things. I make entirely new worlds out of the ordinary one that we live in; so in this way photography has conditioned me to look for what is exceptional and magical in our world.

Very early on, I started experimenting with posting my pictures online. Once I found Flickr, I developed much more rapidly, as I could post in discussion groups, get feedback on my work, and see my own progression

attracts me because it enables me to connect with people on an entirely new and profounder level than I would without the camera in my hands.

I have met many of my best friends because of their faces—let me explain that. When I see a face that I love, I become completely inspired; they suddenly become a new character in my stories. I have no trouble going up to people and telling them that I must photograph them. The bonds that I establish with those who model for me are very strong, which is why I find it funny that every single person who views my work thinks that my main model, Saskia, is me.

Saskia is my muse—she is a chameleon in photos, transforming from a housefly to a butterfly to a sculpture. I suppose one could say that she is the protagonist of the vast majority of my photos. For some reason, people that view my work (even my family and close friends) think that Saskia looks identical to me once she has been photographed. I have read online that some people who analyze my work think that Saskia was intentionally chosen for her similar looks to me, but this at least was not a conscious intention of mine, and I really don't see much of a resemblance. I suppose on one level, however, that she truly has become an extension of myself; we are able to work together with barely any communication, as she perfectly understands the different stories I am trying to convey. I have not made any self-portraits, or not yet. I think that by using other models I can more accurately follow their movements and capture that decisive moment that is essential to an image, rather than taking photos through trial and error with a self-timer. I also don't find my face particularly interesting.

◄ IDENTITY CRISIS

This is a photo that is all about self-image and the different ways in which we can see ourselves. Sometimes it is hard to distinguish which "self" we truly are, as we put on so many different fronts depending on the situation.

▲ DANAÏD

This photo is part of a series called *Danaïd*, which I realized later was subconsciously inspired by a Rodin sculpture by the same name which I had so admired throughout my childhood. I don't like to say much about this photo because there are many levels of interpretation.

STYLE AND SUBSTANCE

I define portraiture far beyond the traditional image of a person's face. To me, portraiture does not even need to feature the face—it needs to capture something ineffable about the character or soul of a person. Even though most of my photos transform the model into a new person or character, there is still a trace of the models themselves, because it is their rendition of my character. Who they are and what they represent become intermingled.

When I photograph someone, I am giving them every bit of my attention, and, as the subject of my photo, they become vulnerable. The model is inevitably placed in a position of vulnerability because every detail of their identity is undergoing examination. With the camera I am able to "look into" people and see them in ways they wouldn't usually reveal.

I think an important aspect to my photography is that my other passion is writing. I love literature, and will most likely be majoring in English in college. As a result, I draw my ideas from books and mythology, rather than imitating/emulating other photographers. In fact, I rarely look at other photographers' works: instead I formulate my images just as I formulate my stories. I think that's what gives me the hope of originality—I feel as though I am approaching photography from an unconventional angle.

Photography is my natural high. In my entire life I've only taken five or six photographs that I am truly satisfied with, but the feeling I get when I capture something I am proud of is indescribable. I am filled with a happiness so intense that I know the reason I am here is for this. I am so grateful to have something in my life that makes me wake up with a purpose every day. When I am in the midst of a photoshoot I am on edge—I feel anxious and am holding my breath because I know I am getting closer and closer to "the" image. I am always worried I won't capture that single moment which makes a photo truly exceptional, so it is a thrill fuelled by adrenaline and exhilaration when I know I have reached the "golden click." One of the interesting (and simultaneously frustrating things) about photography is, no matter how much planning I have done in my notebook, the photograph never ends up as I had originally expected. Sometimes the most meticulously planned shoots end in failure, and the most spontaneous shoots are my most successful. It is unpredictable.

▶ A MILLION MILES

This photo is part of a series called *A Million Miles*. It expresses my desire to travel and see all the corners of the world, but more importantly, my wish that the inches on maps weren't miles in reality, and that I could reach out and touch my loved ones no matter where they are in the world.

▼ METAMORPHOSIS

The model is my friend Kira who has a stunning profile that has always fascinated me. It is part of a series I spent a year working on, which featured photos all inspired by Ovid's *Metamorphoses*. My models were always transforming from one creature, or object, into another. The models were always teenagers, because the metamorphosis of form was also paralleling the constant changes/growth going on during those teenage years.

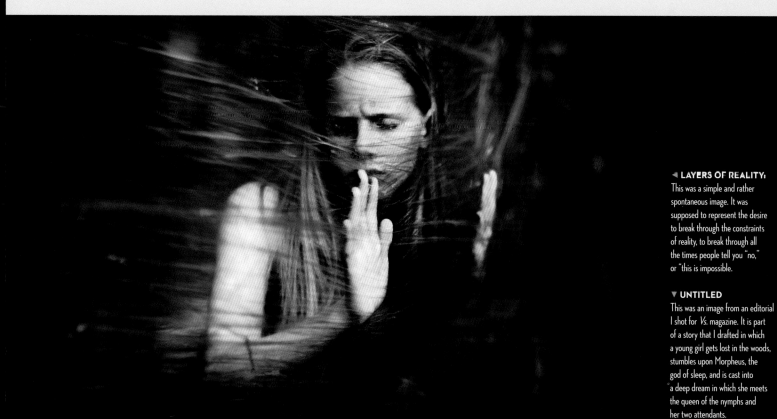

◄ **LAYERS OF REALITY:**
This was a simple and rather spontaneous image. It was supposed to represent the desire to break through the constraints of reality, to break through all the times people tell you "no," or "this is impossible."

▼ **UNTITLED**
This was an image from an editorial I shot for *Vs.* magazine. It is part of a story that I drafted in which a young girl gets lost in the woods, stumbles upon Morpheus, the god of sleep, and is cast into a deep dream in which she meets the queen of the nymphs and her two attendants.

People often say they enjoy my black-and-white photos the most. I think black and white simplifies things and cuts right to the point—there are no distractions, simply the expressions of the people and the substance of the story itself.

In terms of my dreams for the future, I have always been ambitious to a fault, and want so many things. I want so badly to change the world forever with my images: I'm not afraid of sounding naïve, because I am determined to push myself as hard as I can to go as far as I can. I want to take iconic pictures that move people in ways they never thought possible. I want my work to be as definitive of human culture as Shakespeare, or Picasso, or Da Vinci, so that the images are never forgotten. Though ideally I want to make my living as a fine-art photographer, I realize that it's close to impossible to make a living simply selling images. Therefore, I think it's inevitable that I will shoot for magazines, publications, and books for a while, and hopefully publicize myself enough that I can begin making my living simply as an independent artist. Most of my work explores that no man's land between childhood and adolescence, as well as themes of isolation and metamorphoses, but perhaps this will change as I mature, both as an artist and a person. All I know is that I truly want to change people, and leave a mark on the world to show that I was here. My work is who I am, and so if my work is celebrated and passed on to future generations, I could not be happier.

ARTISTIC PROCESS: *BLINDNESS*

This image was taken on an extremely misty day in my friend's driveway (mist is my favorite condition to shoot in). The two models are siblings—at the time this was taken, one was eight years old and the other was seventeen. I've always found that they look startlingly similar, and this, combined with their extreme closeness, always made me think of them as younger and older versions of the same person. I wanted to make an image that showed an interaction between a person and their younger self—that younger self we all wish we could advise, and warn away from making certain mistakes.

I dressed the little girl in front completely in white, while her older sister is all in black. The child in white is skipping in the foreground—pure and untainted, the picture of innocence, while her future self (further down the road) is lamenting her mistakes and has lost all of her child-like purity. The road disappears into the mist, which symbolizes that the future beyond this moment is obscure and unpredictable.

This is one of my favorite images because it is strongly representative of what most of my work is about; I am constantly revisiting ideas of childhood, lost childhood, and the effect of time. To get this image I was on my stomach on a rain-covered road, covered in mud and shivering. I find that often the best photos require some discomfort. I think of this picture as signifying all the mistakes that we have made but can never change.

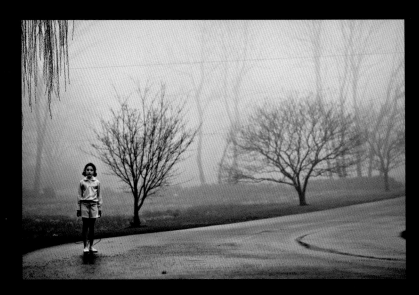

▲ ▼ **BLINDNESS**
I shot this with a Nikon D80 and the standard kit lens. I like how the silhouette of the young girl is reminiscent of one of the 1800s silhouette portraits sometimes kept on mantelpieces.

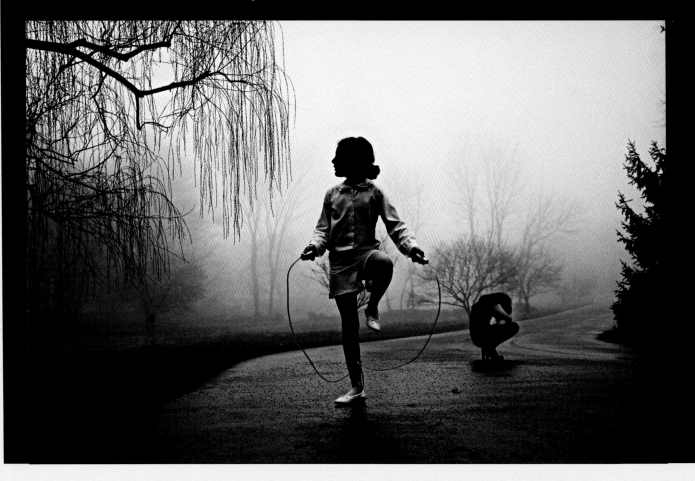

ARTISTIC PROCESS: *EVERGREEN DREAMS*

This photo was taken after the biggest storm I've seen. People were stranded for days without electricity, poles and trees had fallen down everywhere, and half the streets were blocked off. I was itching to photograph all the wreckage but it wasn't safe until a few days later.

Saskia, the model, climbed into this immense fallen pine tree in my backyard and I shot from above on top of a chair. Originally, I had envisioned her as a bird-like creature in a nest with eggs, but I soon tossed out this idea in preference for a simpler and more striking one. I then decided that the model was supposed to represent a dormant plant bulb in winter. Later on, I juxtaposed these images with photos of her amongst huge crimson blossoms (the flower in summer that blooms after a long winter, a life cycle which was also supposed to parallel coming of age). Saskia is wearing a traditional Moroccan outfit that I had recently brought back with me from a trip away. Originally, the tunic had been navy blue, but I thought the image would be even more striking if I changed the shade to green in order to match the foliage. It was ironic that, curled up amongst the branches, she looked so peaceful, yet in reality she was picking her way through all the fallen trees that the storm had destroyed and was quite uncomfortable in this pose. This was also shot with a Nikon D80 and the standard kit lens.

THE PROCESS
Saskia on the shoot, with the tree that had collapsed.
The final image gives the illusion that the tree could be standing.

▼ **EVERGREEN DREAMS**
A portrait of my favorite model Saskia, whom I shot inside a fallen pine tree outside my house after a storm.

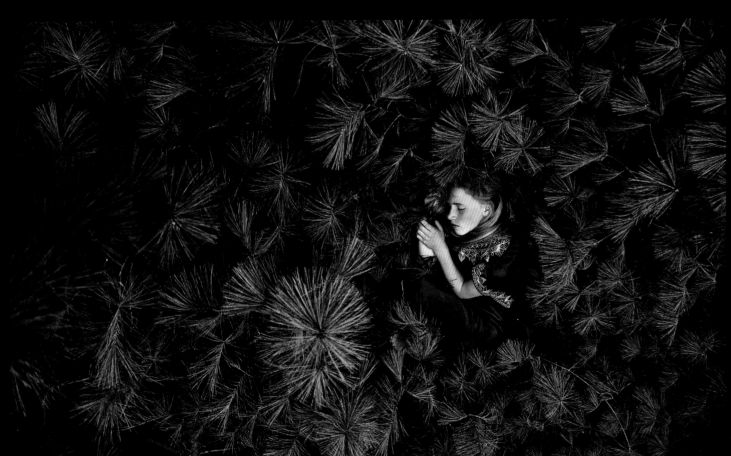

BROOKE SHADEN

BROOKE'S WORK ITSELF IS MANY THINGS: BEAUTIFUL, PROFOUND, SOMETIMES DISTURBING, AND ALWAYS PROVOKING. BUT IT IS THE MIND BEHIND THE FRAMES THAT IS FASCINATING. HAVING WORKED WITH BROOKE AND SEEN HER APPROACH FIRST-HAND, I HAVE OBSERVED HER DEVOUT COMMITMENT. SHE IS IN TOUCH WITH HER CREATIVE CORE WITH WORDS AS MUCH AS WITH IMAGES.

H AVING APPROACHED photography from the point of view of a film graduate, Brooke's vision is that of narrative cinema, but with the consistency of collectable art. Most often shooting only five to eight frames for one particular composite, her workflow is surprisingly tight. Often accompanying her images with elegiac prose describing her intent, she has the mind of a Romanticist poet delivering art with a military persistence and more stamina than most other artists. Her work follows its own self-imposed rules, with its textured, immortally square frame rendering every scene into tonal timelessness, whether it be an Ophelia-inspired scene in the murky depths of water, or a *Peter Pan*-esque flight into the sky from a hilltop, detracting the end product from being a photograph at all. Inspired by childhood, fairytales, and the subconscious mind, her work shirks modernity in favor of the human element, embodying a human consciousness that could have been that of a hundred years ago. Her approach is that of a painter, working instead on a Photoshop canvas turning pixels into brush strokes, constructing compelling composites with a ruthless efficiency.

Brooke is abundantly obsessed with the imagination: its powers, its grandeur, but also its flailing limits. Her work is a harmonious dichotomy of fantasy and terror: what she has come to call her "dark art." Brooke likes to be a "creator of worlds," inventing fictional characters in flights of fancy whom she will crash back down to earth by picturing them at their lowest ebb: distressed, soiled, and debilitated. Her fusion of beauty with profundity has seen her work become rapidly popular with a range of audiences. All artists know what it is like to have a constant desire to create: Brooke's desire is tenfold, a higher-class addiction. She manages to achieve the full package of aesthetic depth and shape married to story and concept, time and time again.

► **ADJUSTING OXYGEN LEVELS**
"This is a self-portrait created against the backdrop of my favorite mountains. I combined multiple images together to create the orbs that are floating around my head. I thought there would be no better representation of self than to show a literal representation of my imagination flowing around me."

◄ **STIRRING DUST**
"Furthering my fascination with the dream state, this image explores the idea that in our dreams, everything is possible. It was created by compositing multiple images of the girl, the fabric, and the book pages."

THINKING INSIDE THE BOX

My journey to beginning photography, and portraiture in particular, stemmed from having sudden creative freedom after a lifetime of falling into the routine of the school system. I took a black-and-white photography class in high school in which we were not allowed to shoot people, it had to be all inanimate objects. As a result I associated photography with non-creative documentation more than creative portraiture.

It was about four years before I picked up my camera again with a new mindset, and I had since been through film school where I also got a degree in English. I had many ideas coursing through me, but creating films was not the most effective way that my ideas could come to life. I found that while writing dialog and plot were lost on me, creating unique worlds within film was where I felt most confident. When I picked up my camera again after graduating from college, I suddenly had the tools to create the fairytales that lived in my mind, and I began creating self-portraits as a way to more intimately incorporate myself into the alternate worlds I wished existed. My interest did not lie solely in self-portraiture, nor has it evolved into shooting only others. My passion is portraiture: I relish the opportunity to transform a person into a character in much the same way that cinema transforms our perception of reality, even if only for a couple of hours. I love creating self-portraits because I can live in the frames that I am creating, yet I love using models to act in my images because I can create a character from the ground up and separate myself from it, like watching a movie and becoming immersed.

My desire to create characters was not only personal, in that I wanted to share these characters with a larger audience. I wanted the worlds that I wished existed to be accessible to everyone, and so I began sharing my images online. I always strive to strike a balance between beauty and darkness. I want to make beautiful the things that others find disturbing. The online community fuelled my passion by encouraging the creation of images. In a way I feel as though the more images I create, the more worlds I create; the more worlds I create, the more I share them with the artist community; the more I share those worlds, the more inhabited they become. The online community was a large part of why I decided to pursue photography as more than a hobby; the feedback that I received was so diverse and allowed me to get insight into not only who enjoyed my art, but also why they enjoyed it. Many people said that they had never seen dark art that was beautiful enough for them to appreciate it, and so I felt compelled to create more for those people whose eyes were being opened to a wider variety of genres. I have always created from the heart, and to have a group of people who understood where I was coming from personally was inspiring to me.

Photography, more than any other medium, provides an open invitation for anyone to participate. These days everyone knows what a camera is, and everyone has used one as well. If we wanted, we could all call ourselves photographers and in a sense that would be accurate. When someone views a photograph, they can relate to it no matter what, even if the content is worlds away from something they would usually enjoy. If you pair that accessibility with portraiture, the potential connection is even deeper because every

▲ A LAND OF THEIR OWN
This is a clone shot of the same model wearing a mask and a long wig. I wanted the girls to be identical, as if a whole new species existed.

▼ AN UNHEARD CRY
As the climax of a series about Ophelia, this picture shows both strength and struggle as the protagonist takes one last breath in the water before she dies.

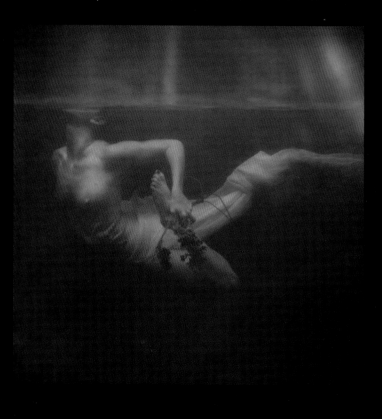

portrait is, in some small way, a reflection of us as human beings. When I create portraits I am always striving to make the character as specific yet as unidentifiable as possible. I want my characters to tell a story, and in that respect they must be recognizable as having a story and a life behind the image. I want a viewer to imagine what came before, and what comes after, the moment of time that is captured. Just as I want the character to be recognizable, I also want the character to be anonymous so that the viewer can see him or herself within the image. If a part of the face or body is obscured, then part of the image is left to the viewer to make up what else exists in the frame. If the viewer can imagine themselves in the image, there is a stronger personal connection to what is being viewed. Continuing with the theme of anonymity, I also strive to create timeless images. I want my pictures to tell of a world that is not our own, both in space and time. I create images where the time is older than the present yet there is no recognizable period being depicted: it is simply the past, a moment that is distinctly unlike our present. In everything that I create, I am making new worlds, and in every new world a character takes center stage. Creative portrait photography is at the very core of what I do.

▼ **SLEEPWALKER**
This was a self-portrait taken in the early morning hours and was shot from overhead using a tripod and an 18mm lens. I was sitting in water to create the billowing-dress effect.

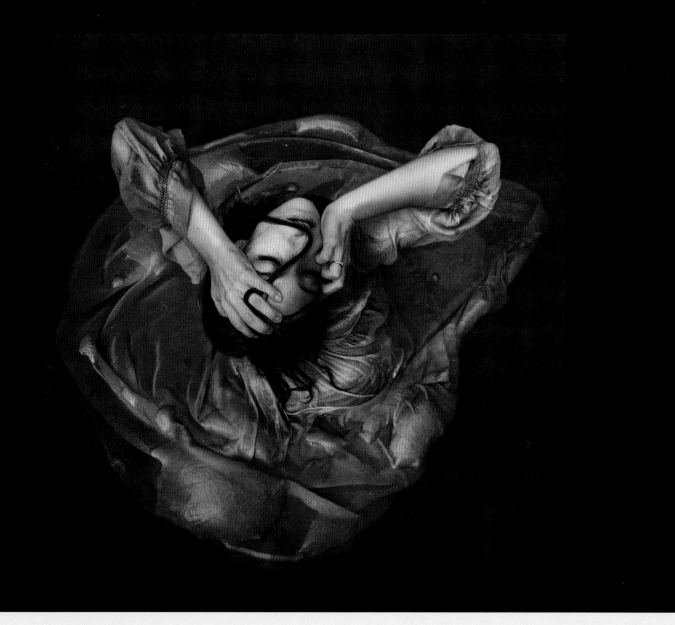

WIDE WEB OF WORLDS

I am engaged in trying to create new worlds that are different from our own, yet rooted in reality. I often shoot in nature because I am trying to capture a timeless feeling. I rarely shoot in an indoor space unless that indoor space is very neutral with only hardwood floors and a blank wall. I want the location to both fall off into darkness as well as to enhance the mood that is being created. Shooting in outdoor spaces such as the woods or in water gives a dark, beautiful, yet neutral space to surround the subject. In *A Blending of Structure*, the surroundings both fall off into darkness, yet also directly relate to the subject. The trees in the background, though abstract and obscure, roughly relate to the lines of the character's limbs, and tree limbs and human limbs combine, creating a world where people are not unlike the nature that surrounds them. She nearly fades into the background herself.

In everything that I do I want to question what it means to be alive. I want the characters in my stories to present a dynamic juxtaposition of being either physically alive yet emotionally distressed, or being literally dead yet still depicting the story of their life. When I began photography I often leant towards the slightly more obvious depictions of death where young women would be portrayed in death yet with a beautiful or lively twist. These images were certainly more shocking than some of my more current work. The shock value of that work came from the way I was working through the concepts in my mind. Nothing was placed solely for shock value, which was a critique that was levelled at my work early on in my career, though what I was creating was more basic than what I am trying to do now. I like to look back at my earlier pictures in comparison to my new work because I can clearly remember the mindset that each image encompassed. If I had not explored death so literally early on, I would not be able to analyze death more figuratively now. I have moved largely to a new way of looking at life and death, which comes across more subtly, yet I hope, more powerfully than in my earlier work.

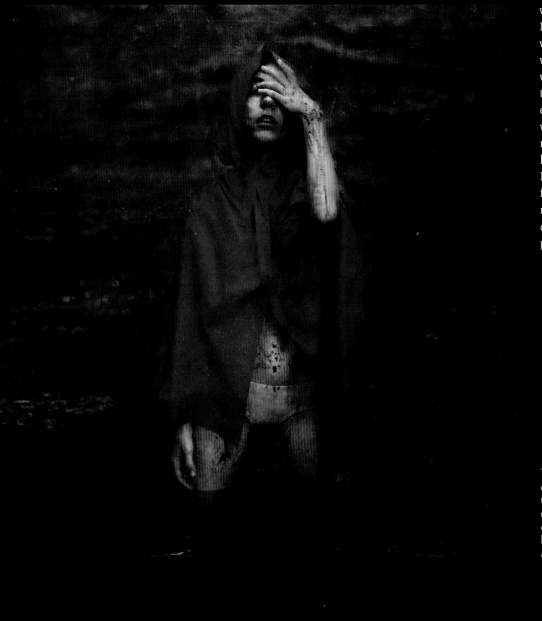

◄ **DEPTH PERCEPTION**
This was intended as a recreation of the classic *Little Red Riding Hood* fairytale, though in this story the protagonist is far more weathered and sullen. A painterly effect has been applied to further blend her into the surroundings as if she is lost and forever trapped in that spot.

Each image I create carries elements of life and death, yet those elements are not usually literal. In my image *Playground for Spirits* I depict the loss (or death) of childhood, yet also the life that went along with those memories. My style has evolved to encompass a more ethereal, beautiful, and whimsical world, with surreal elements at the foundation. I did not begin photography to try different things or to capture reality. Instead I began taking pictures because I had fully developed ideas in my mind that were best carried out through the medium of photography. Since day one the ideas have never stopped coming, and so ever since I have been creating in largely the same way with no intention of stopping.

I do notice that in the business world a different view is taken of my work than that I might experience via feedback from the online community. Instead of accepting both the darker and lighter images as accompaniments to each other, there is a bias towards wanting to exhibit and promote the "lighter" pieces. It is not always pleasant to look into a dark image and see yourself; hence, I believe, the fewer opportunities to promote my darker work in the gallery circuit. When sharing online the viewer has the option of closing the browser window and never looking at the image again: when something is in print there is no taking it away, and the industry needs to print images that are sellable.

Even though I feel the pull from the industry to create more "sellable" work, I also feel the need to create only what satisfies me creatively. I have used a very specific style ever since day one of picking up my camera, which stems from what I like to see most in art. Everything that I create is constantly building on itself to not only create new worlds, but to expand on one larger one. I have never had the desire to create any other type of photography.

The collective reaction online to my work is, I think, a collective gasp. I don't necessarily mean it to provoke a good gasp or a bad gasp, but at least people are looking. Art that isn't creating conversation probably isn't touching on anything new. It's often said that everything has been done before, but I think that is simply the wrong way to look at things. Even if everything had been done before (which is highly unlikely), no one has said it in your voice, or in mine. Everyone has an artistic voice whose expression transcends the question of whether it has been done before.

Getting to do what I love for a living is a dream in itself. I love that I can go out at five a.m. to create a self-portrait all alone before the sun has touched the sky. That kind of creative freedom is something that I think everyone should experience.

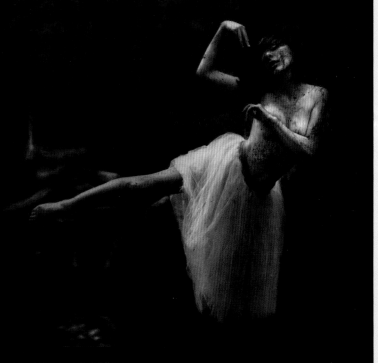

▲ **A BLENDING OF STRUCTURE**
The body of the model mimics the surrounding branches that have broken off into the water in the background. The fragility of the human form is explored.

▶ **PLAYGROUND FOR SPIRITS**
A childlike atmosphere is created with the soft colors and carousel horse, yet still sadness lingers. As the title suggests, only the memory of childhood is present.

ARTISTIC PROCESS: *RISE AND FALL*

The image *Rise and Fall* came about first and foremost from my love of photographing fruit. I have been fascinated with the concept of humans as fruit since my earliest photography days, from the way in which the curves of our spines is mirrored by the shape of apples, to the inevitability of our decay. When I photographed *Rise and Fall* I wanted to play with both the idea of the apple as the sinful fruit, as well as a lighter connotation of the apple from Snow White, as I often like to reference fairytales. The apple in both scenarios is a forbidden fruit, and so I wanted to depict a man falling over with apples surrounding him. It is assumed that he has eaten the apple. However, the image can also be looked at as the man rising from the ground instead of falling, adding an interesting tension to the piece.

While it is a levitation image, it came together mostly from compositing body parts together. I photographed the model's arms separately from the rest of his body, and for the main shot he supported himself in much the same position as you see here, one arm balanced on a chair. The part of shooting that I knew would be critical to get right was the picture I took of the shirt being swept to one side. I wanted to give the illusion that the character was in motion, and so the shirt was the point of interest that the eye would be attracted to make the image believable.

Because the clothes that the model wore were very neutral and without pattern, the picture was easier to composite together. The shirt blended seamlessly into itself for each picture because there were no patterns or lines to match up, and the same goes for the trousers. This image was shot with a Nikon D80 and a 50mm *f*/1.8 lens during sunset.

◄ RISE AND FALL
This is a play on the traditional connotations of apples used with a male model for a twist. It was created as a levitation image using multiple images composited together for the effect.

ARTISTIC PROCESS: *A STORM TO MOVE MOUNTAINS*

The image *A Storm to Move Mountains* came to fruition when I decided to combine several elements that I love to shoot into one concept. Red is my favorite color to photograph since it is so striking and bold. The connotations associated with red are many, including life, death, and even menstruation. I wanted to play on all three aspects in this image by using a girl who is being blown about by the wind and touched by the elements. I like to create the feeling that wind is blowing in my images, which was made even easier that day because the wind was stronger than I had ever felt before in Los Angeles. It was so strong that my extra tripod (that I use for focusing) blew into the frame when I was shooting. A family who walked past and asked what I was doing even offered to help me by keeping a hand on the tripod that was holding my camera so that it did not blow away. Another element that I wanted to incorporate was the idea that we as humans are not very different from our surroundings. I decided to have the red fabric billowing out from the character not only in a blood-like fashion, but also mimicking the line of the mountains in the background.

I began creating this image by taking my main shot and expanding from there. I composited several other shots with the final product, most of which included extra hair (taken while tossing my head around), as well as pictures of the fabric at different parts of the frame. It was important to take pictures of the fabric that both stemmed from my body as well as got closer to the camera to create believable depth. Because I took the images from all different locations around the frame, and paid attention to where they were coming from, I was able to composite them together to look like one long red dress despite the fact that I really only had a square of fabric. This image was shot with a Canon EOS 5D MKII with a 50mm f/1.4 lens in the evening just as the sun was setting.

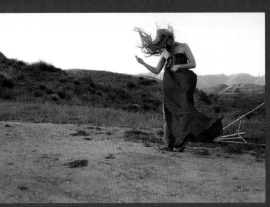

▲ A STORM TO MOVE MOUNTAINS
The red color here was used prominently to be reminiscent of blood and death, while the movement from the wind paired with the red suggests life and aggression.

THE PROCESS
Several shots were used of the fabric to create the billowing dress effect, put together as a composite.

ALEX STODDARD

SEVENTEEN-YEAR-OLD ALEX STODDARD COULD BE LIKE ANY OTHER TEENAGER, FIGURING OUT THE WORLD BY MAKING UP HIS OWN, AND USING PHOTOGRAPHY AS A WAY TO BOTH EXPLORE AND RETREAT FROM IT. NATURE IS HIS STUDIO BACKDROP AGAINST WHICH HE PLACES HIS SUBJECTS, PRIMARILY HIMSELF. SELF-PORTRAITURE HAS ALLOWED HIM TO GO OUT AND UTILIZE THE MOST CONVENIENT AND PERSONAL MODEL HE KNOWS. DRAWING UPON THE INFLUENCE OF HIS PHOTOGRAPHY CONTEMPORARIES ON THE LIKES OF FLICKR, HIS JOURNALIZED "365"-STYLE SERIES OF IMAGES MARK THE BEGINNINGS OF A JOURNEY IN EXPLORING HIS OWN MIND. THE VISUAL MOTIFS OF THAT QUEST OF SELF-DISCOVERY BECOME THE FAUNA AND LAKES OF HIS OWN NEARBY WILDERNESS WHERE HE RESIDES IN GEORGIA, USA.

ALEX'S SELF-PORTRAITS present his stripped-down, bare self, in a sense "running barefoot" through the forest. His tendency of isolating the human subject against natural surroundings, whether himself or another subject, is not merely for the sake of prettiness and privacy—Alex is also interested in harking back to the simplicity of human's origins in a natural habitat, and its immaterial existence a world away from frenzied modernity. His work is rarely ever literal, but symbolic. Often he will seek out and prepare props to insert into the landscape, as bizarre as a bed, a tank, or his own constructed umbrella of cobwebs, which can serve in his abstract visions touching viscerally upon elements of the human psyche. Even his more whimsical images, with his merry and nonchalant side-commentary, become a diary of himself, recorded in pixels as nostalgically as if from several eras ago.

Writing about his work, Alex speaks with a tone just as self-assured and innocent. With a confidence beyond his years, he reflects with irony and playfulness on his emergence into photography and his ambitions for the future. Though he might jest about his latest photographic exploit and his artistic intentions, one gets the impression that nothing is as serious to him as manifesting and expressing himself through photography.

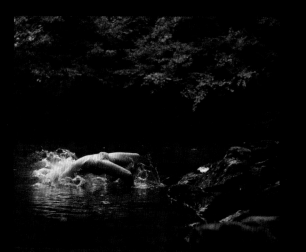

▲ FISH OUT OF WATER
"I hadn't intended for much to come out of this image, but I'm quite happy with it. I can't remember how many backflops it took to get the shot just right, and by the end, I was seeing stars. I had to keep myself from laughing through every frame, because just a dozen feet away, there was a pesky armadillo rummaging through my camera bag."

▶ THE PAINS OF CAPTURE
"I love to tell the story of the wild being contained. There's just a beauty of such heartache for freedom. I had an audience for this self-portrait, taken at some glorious waterfalls just a short drive from my home."

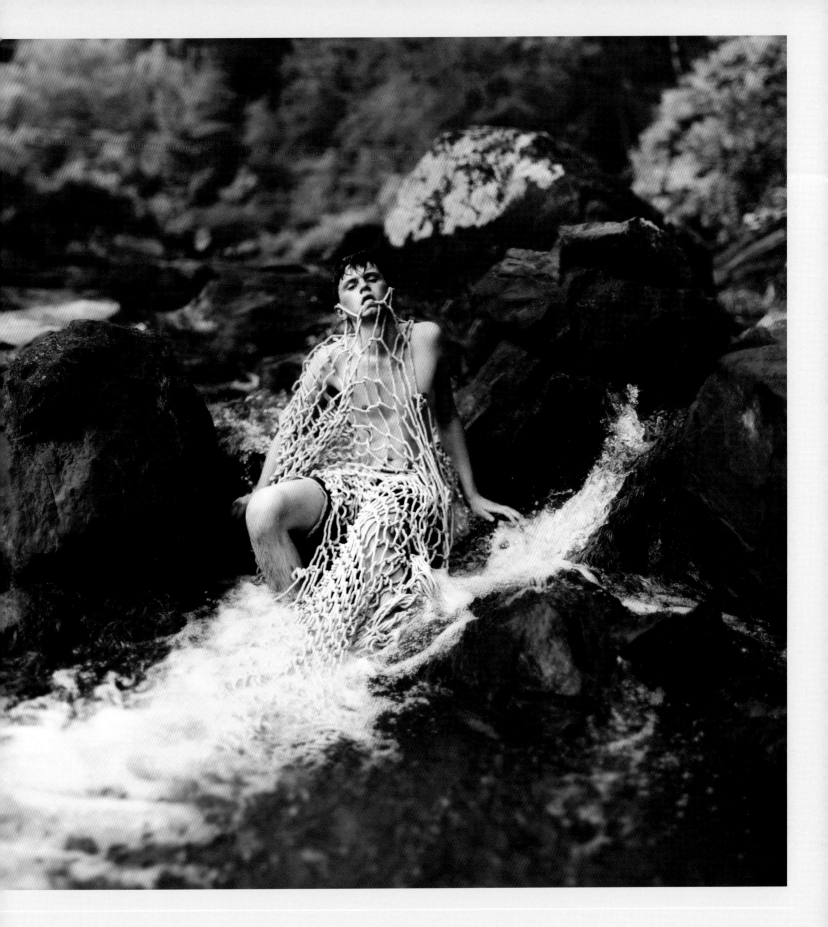

A GUILTY PLEASURE

Saying that my initial start with photography was anything but narcissistic would be an awful lie. In the days when MySpace was still socially relevant, in late 2009, I remember taking a photograph of myself on my prized point-and-shoot, then converting it to black and white and adding all sorts of effects. It blew up with comments, and I was so proud. I have always had this innate yearning to be the best—not so much an obsession, but rather a compulsion—and I figured my next and most important task would be to get more comments on my profile pictures than any of my friends. And so, I suppose that's what set off me embarking into photography.

With time, I moved from the bedroom window to the lawn, and from the lawn, to the untamed forest behind my home. With each change of location, my mind would wander just as my feet would. It wasn't just simple headshots contrasted beyond belief anymore. It was me jumping off logs, lying in swamps . . . contrasted beyond belief. All the while, I made it a top priority to keep my family ignorant of my activities. I would make sure my mother had left the room before plucking the tripod from her closet, ensure my sister had her door closed before sneaking, filthy, from outside into the bathroom we shared. My family thought I was weird enough already, with few friends and a tendency to go off on my own. Why add fuel to the fire that was my peculiarity?

Naturally, as I explored my own photography, I began to explore that of others online. I would discover a few new favorites, scribble down the websites so as not to forget. However, it wasn't until I had happened upon the work of a young photographer called Rosie Hardy that I had any inkling of what photography could become for me. I remember staying awake that entire night, hunched over my computer, eyes devouring her fantastic images, fingers slamming the keyboard for more—more information, more about this incredible photographer who had, in mere hours, suddenly seemed more important to me than my own mother!

A month later, I drained my savings account and purchased my first DSLR, a Nikon D3000. Here I was, spending all the money a sixteen-year-old had to his name on a hobby I wasn't sure I would stick to. It wasn't long afterward that I created an account on Flickr. As a photo-sharing website I thought it was much cleaner and more professional than others of the sort. On that very day, I sent Rosie Hardy a video embarrassingly expressing my adoration through a song, with the lyrics substituted for her name and things relevant to none but her. And on that very day, I gained probably my most beneficial ally yet, who would send her countless admirers my way, and thus spur on the passion I had for photography.

As of April 2010, I have been participating in the popular "365" project, in which one takes a photograph every day for one year. I often refer to myself as the worst 365er in history, as I am currently two months behind on uploads. In a project such as my own undertaking, it is almost inevitable that the majority of the photographs turn out to be self-portraits. The sheer amount of work one must turn out makes finding other models unmanageable. Besides, I began the art with self-portraiture, so why not see where it might take me? It is a piece of luck that I've always been comfortable in my own skin.

Gradually, my work seemed to gain the attention of the online community. I'd gasp and go wide-eyed at five followers popping up on my screen. At hundreds of supporters, I would breathe heavily and punch my pillow with thrill. And when those numbers turned into tens of thousands, I fled my bedroom, flailing my arms wildly and screaming into my cat's face until she resorted to clawing me in an effort to escape. It was, and still is, so hard to take in the fact that so many people from more countries than I knew existed had taken an interest in what I had to show. I am grateful for it all though, for without so many people watching, without so many people I thought I had to impress, I never would have pushed myself to improve.

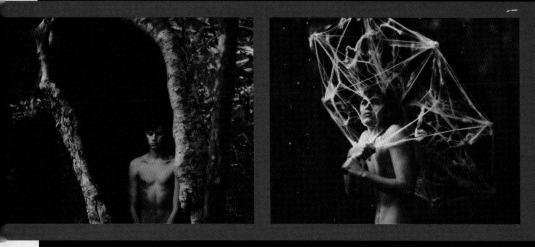

◄◄ HE DOESN'T BUILD SHIPS, HE HAS NO USE FOR SAILS

For this photograph, I endeavored to create a very solemn atmosphere. The tree itself was shaped very much like a coffin, so I stood within it, eyes closed, as though I was a new corpse. In post-processing, I left the contrast very light, but darkened the area within the trees surrounding me as if to depict the completeness and darkness that accompanies death.

◄ A CENTURY WITHOUT RAIN

This is definitely a favorite of mine, and one of the best selling in prints. It's rare that a photograph turns out exactly as I had wanted it, but this one did. I used a bunch of fake spider web left over from Halloween decorations to create cobwebs within the umbrella to symbolize the length of time that has passed since the last rain. I took the background from a spare photograph I had taken on a different day it had been raining, and composited it into this shot. On that day, I had used a very fast shutter speed—1/4000 combined with an ISO of 16000 and aperture of f/1.8 to create a correct exposure while also freezing the rain in time.

▶ SWALLOWED UP
I've always had a fascination with water in photographs. It's such an unexplored, unfamiliar element. This self-portrait was taken in the middle of a waterfall near my home.

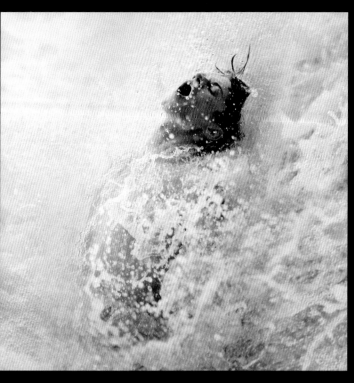

▼ SNAKE
This self-portrait was probably one of my more spontaneous photographs, and happens to be my favorite I've ever taken. I was at a friend's house, and when he brought out his pet snake, I just knew I had to have it on my head. I went outside for better light and made sure I kept my expression serene, an unlikely expression one might make when having a snake placed atop their noggin.

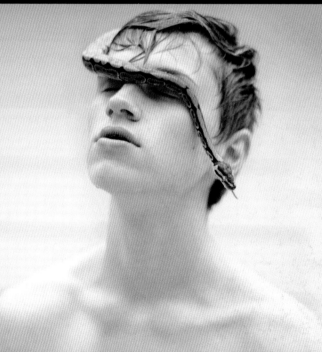

◀ LEAVES
I had originally gone to the river to shoot something completely different, but when it didn't work out, I spied some low-hanging vines and plunged right into them. I shot this with my aperture at $f/1.8$ so as to have a shallow depth of field and blur everything in front of me.

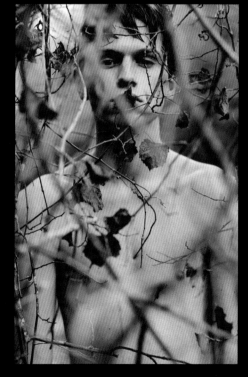

THE NATURE OF MAN

I've thought long and hard about the definition of portraiture. There's the textbook answer of "the depiction of an individual through art" or some other emotionless phrase. I don't think of portraiture as something with a clear explanation though, as something with a certain formula to be followed or with instructions to be read. It's highlighting the unique features of a subject, bringing a story, feeling, and a world to an individual that have never been imagined by any other artist.

Nature has undeniably been a prevalent feature in the majority of work. I suppose that in the beginning it is simply all I had to work with. Living in rural Georgia will provide you with countless miles of untouched forests, but for some reason cannot conjure up a post office (go figure). I've never been particularly keen on urban environments anyway. There's a certain timeless effect that woods or a field or a waterfall can lend to a photograph. Unless intended, I never want a viewer to be able to pin down the photograph to a certain era or place. Rather, I want to create the illusion that the events could be occurring anywhere at any point in history. The same thought might be applied to my decision to hide my face and the faces of my models in so many of my photographs. I want that same viewer to be able to imagine himself as the subject, which can be so easily achieved by disguising unique features like a face and by using the natural body, unclothed.

It is also because I enjoy exploring man's relationship with nature. It seems a shame that people seem to have forgotten how we once interacted with our environment. Society has made such a huge push to define "dignified" as being disconnected with nature, being clean and prim and proper, and relying on concrete sidewalks and sky rises. Once upon a time, we were all rolling in the mud and scaling trees and interacting with the natural world. I'm by no means stating that I would like for us all to revert to such circumstances, because being caked in mud is hardly fun for a timeframe any longer than that required for a photograph: it's just nice to remember through art and perhaps ground us all a bit.

As far as the future is concerned, I'm not quite sure which direction I want to head in. I'd like to have photography as a career. That's something that has become very apparent to me throughout my experience with it so far. Whenever asked, I almost instinctively answer that I'll shoot fashion photographs, because that is the genre that interests me the most. However, most of what I produce currently, and have done in the past, is more fine art. I don't know how to break free of it, but at the same time, I don't know that I want to let it go completely. I suppose rather than fighting to fit this style or that, I should just keep shooting what I love and what inspires me, and maybe I'll end up creating some new style altogether. I just know that I want to collaborate in the future with stylists, makeup artists, models, set designers, and people who hold reflectors so I don't have to prop my own up against a chair any longer, and people to supply clothing so that I don't continuously spend all my money on clothing for female models that gets stacked in my closet because I can't wear any of it myself.

▼ SANCTUARY

This is, by far, my most popular photo among the online community. When my friend Avery told me he had a giant fish tank in his shed, I jumped at the chance to use it. I didn't care that it was still winter. We hauled it into the woods and filled it up using a hose, and then I repeatedly submerged myself for twenty minutes, spluttering and yelling all the while. I used a wireless remote secured in a plastic bag to take the shots, while Avery sat to the side and laughed.

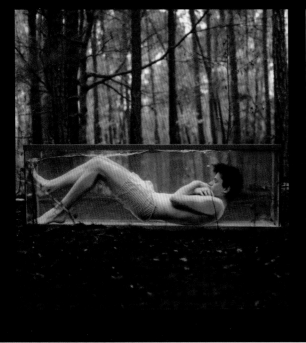

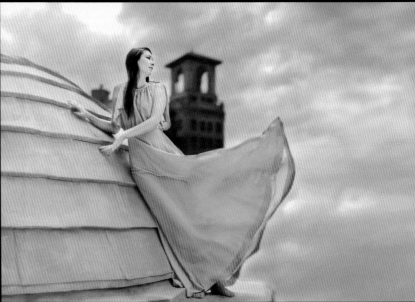

◄ **MAIDEN**

During the summer of 2011, I hosted a photography gathering in Atlanta at the prestigious Fox Theatre. The twenty-plus of us all gathered on the roof of the theatre to shoot our own interpretation of the model Ashley posing atop this dome in an almost Greek-style setup.

▲ **THE CULTIVATION OF WONDERLAND:**

Alice in Wonderland has been explored several times in photography. Here in this self-portrait, I wanted to tell a story beyond the blonde-haired, blue-dressed girl and depict a possible explanation of *Wonderland*'s creation.

ARTISTIC PROCESS: *NATURE OF THE WOMB*

As with the majority of my photographs, this was taken in the woods behind my house. I nestled myself into a little hollow in the wall of a dry creek bed. Apart from the discomfort of my new root-adorned home, I had the added fun of it being mid-winter.

This photograph was actually the prequel to one I had shot only two days prior in the very same spot. In that photo, entitled *The Nature of Man*, I was bursting through the ground above, as though being born of the earth. Naturally, I figured that I would follow up with a before-photo of the creature huddled in his earthy womb, awaiting birth. It all relates back to man's relationship with the earth, how everything we are comes from her, and how essentially she is our mother.

Shooting the photograph only took minutes, yet it was nerve-wracking as I was in clear view of our neighbors' home—should they have glanced through the kitchen window, they would have seen quite a show.

Post-processing was quite a bit of work. I like to compose most of my photographs as squares, simply because I think it makes for a more aesthetically pleasing piece, more symmetrical. In order to do so, I always make sure to take additional shots of the surroundings, panned left, right, up, and down from the initial frame containing the subject. I will then combine all of the photographs in editing almost as if they are puzzle pieces I am fitting together. *The Nature of the Womb* required twelve photos combined into one. Aside from the process of building the picture, I do little else in post-processing other than fixing up the colors and contrast with Curves and Levels adjustments. However, I did a bit of additional work sculpting my body for this photograph. I wanted to appear fragile: almost malnourished. Using the Liquify tool, I dropped about fifty pounds from the subject, creating a creature out of a boy.

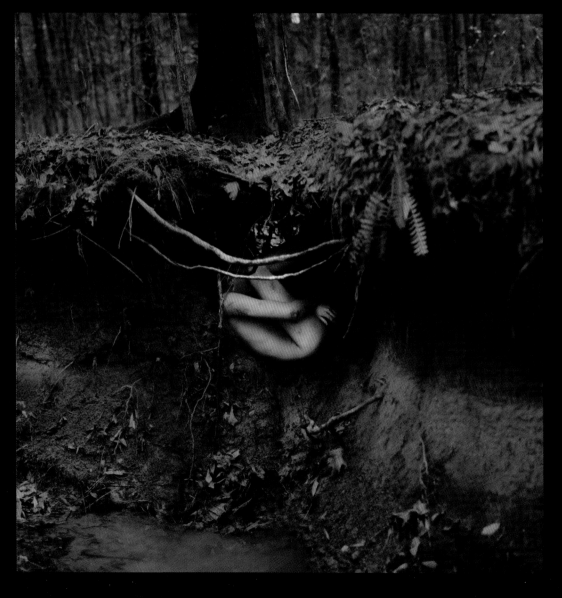

◄ **THE NATURE OF THE WOMB**
For this self-portrait, I used my Nikon D3000 and a 50mm ƒ/1.8 lens with a wireless remote.

ARTISTIC PROCESS: *THE FORGOTTEN HOUSEWIFE*

This photo was all about firsts for me. It was my first time shooting in an abandoned home that I had just discovered, as well as one of the first shoots with my newly-purchased camera, a Canon 5D Mark II. Similarly, it was my very first time shooting with a fellow photographer. My friend Karrah Kobus had travelled down to Georgia from Minnesota the previous day in order to co-host a photography gathering I was having for other artists from Flickr. We had met over the website, and noticing how similar our styles were, decided that we needed to collaborate.

After shooting a couple of fashion photographs, I had Karrah sit in the rocking chair I had hauled from home (without my mom's knowledge), and we went to work creating this wild image. Inspired by the deteriorating room, I wanted to portray a woman who had gone mad from desire for the return of a husband who had abandoned her. It was a lot of fun shooting, and Karrah was natural with posing, having shot mostly self-portraits herself. I coughed my lungs out for the following weeks, but I don't regret it.

Like *The Nature of the Womb*, this photograph required several photographs to be stitched together in post processing. I'd say this particular photograph is composited of maybe twenty to twenty-five different images, ranging from additional shots to building out the frame, to those capturing the subtle movements of her dress, and of course the crazy hair. I shot with a 50mm *f*/1.4 lens.

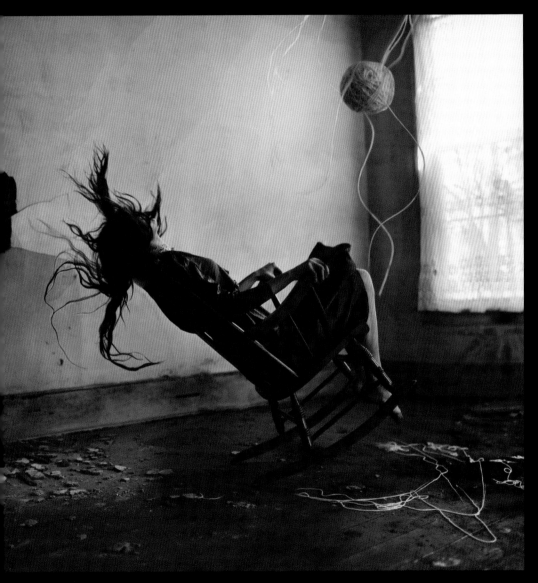

◄ **THE FORGOTTEN HOUSEWIFE**
Shot in an unfamiliar abandoned location, with a new camera and a new model. The result was composited from several photographs I shot of the model, Karrah.

THE PROCESS
On the shoot, spinning the wool around the model; and further below, the whole composited scene just after being merged.

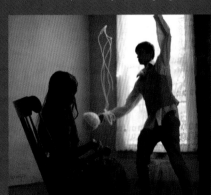

CHAPTER 6
BUILDING YOUR
OWN PHOTOGRAPHY

THIS FINAL CHAPTER IS INTENDED AS A GUIDE TO HELP YOU AS AN EMERGING
OR PROSPECTIVE PORTRAIT PHOTOGRAPHER: TO ADVISE ON BROADENING YOUR
EXPERIENCE WITH MODELS, BUILDING YOUR WORK AS AN ARTIST, AND GOING
ON TO MAKE A LIVELIHOOD FROM YOUR WORK IN THE FORM OF EXHIBITIONS
AND COMMISSIONS.

IN ORDER TO TALK about marketing one's photography, it is important to establish why you create the work, and to determine to whom it should be marketed. That is not always clear at the outset, because many people begin photography simply with a passion for making images. The photography featured in this book has been a mixture of fine art, created to be exhibited and sold as prints, commercial and fashion work, produced for a purpose given by a client, and photography created during workshops and collaborations. I started taking pictures purely out of a desire to create images, without an ostensible goal. The first "purpose" I demanded of my own photography was that of fine art, arranging the images into a collective series and printing them for exhibition and for sale as limited editions. Another way to make money from photography "after the fact" is to sell the images as stock, which is not always ideal for those pursuing fine art, but a potentially profitable avenue for those looking for multiple commercial avenues. The goal of most portrait photographers is to be commissioned to create images specifically for clients on the basis of their personal work.

In today's age, we are saturated with photography shared through the Internet. It is the norm for anyone beginning a hobby in photography to share their work before they have even decided what kind of genre their work belongs to, or before they have even produced much work to label. This mini-guide is intended as an overview to those aspects of marketing your photography of which I have experience, with a view to enriching your work and hopefully making it lucrative.

▶ **A MODEL TO RELY ON (2011)**
Shot by Daniela Haug, at Miss
Aniela's "Fashion Shoot Experience,"
March 2011.

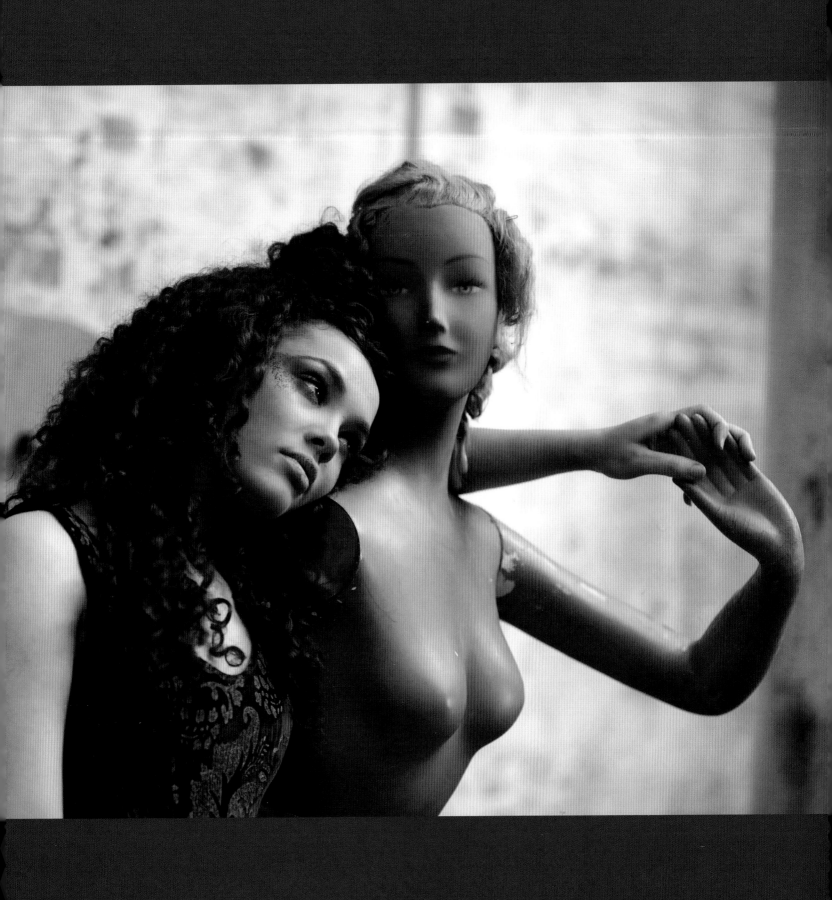

ON STUDYING PHOTOGRAPHY

Everyone finds their own way into photography, to the extent that it seems there is no longer an unconventional route. Every photographer needs time and self-nurture to find their own place within photography. Before focusing on the "marketing" aspect of your work, I encourage any aspiring photographer to actually give themselves time to explore and to create work. This might be in the form of dedicating time to your photography without putting too much of it out there to start with. In terms of financial feasibility, whatever your disposition in life, you might decide to keep photography on the side without jumping into dependence on it as a job: as a hobby, as part-time work, or you might decide to go and study photography.

While there are many photography-related degrees that really don't show you enough of the mechanics of how to actually make a living as a photographer (whether that is fine art or commercial), a degree gives you time to develop intellectually, to work out what you want to actually do, and give your "style" chance to develop. The part that I personally find highly problematic is the notion of having one's work marked and assessed, which I believe is not correct for art, though it may be more appropriate for specific types of commercial photographic practice. I highly encourage anyone undertaking studies to supplement the time with plenty of practical hands-on activities: assisting, taking part in workshops, simply going out and shooting independently as much as possible, and even creating a small business, in order to engage with the "real world" as early as possible. Even if your aim is to be a fine-art photographer and hence not might not be necessarily keen on "commercializing" your work, you'll find that self-promotional, communication, and presentation skills are just as important, as they relate to the overall life-skill of making ends meet. You don't necessarily need to attach your business endeavors to your real name or the one you'd wish to use in the future, so you could take advantage of a pseudonym to separate it from yourself and be as experimental as you like. The most important point is to keep active and not to let studies stifle or suffocate creativity, or to assume that studying in itself is enough.

The problem with studying, or spending too long keeping photography on the side or in a drawer, is that it can incapacitate you from actually understanding and experiencing the real world(s) of photography that you want to enter. You must have enough confidence in your work and abilities to at some point put it out there, but you should start off on the best foot and your work should come first, not the promotion of it.

DEVELOPING A STYLE

It is important to give yourself time to develop your style, as much as it is important to just "go and do it." When I speak of "style," I refer to the traits to your work that will not be individually original, but collectively come to represent you in a particular context.

I think of the word "style" as "how my work is seen by others," i.e. it's something that doesn't actually matter until you want to sell your work in some way. I'm aware that my art itself pours out in an often impulsive, uneven and unkempt flow, and that the "business" side of myself checks in on it to organize, shape and package it in the form of exhibitions, portfolios, books and so on. Maintaining a balance between "what I simply want to do" and "what would be popular or successful, to create better foundations for everything I do want to do"is one of the key seesaw conflicts I experience as an artist, which I know I will have to deal with for as long as I live.

The first time I really started to get a feel for the style of my own work was when I saw it in a book alongside other people's work. After all, style is about difference, defined comparatively, so context is all. I saw that my compositions, lines and curves were quite bold by comparison to the other artists, and there was a distinct use of primary colors. Seeing your work alongside other people's can help you understand your own idiosyncrasies, your ways of doing things, giving you confidence to say "yes, this is me." Another exercise is to simply look at all of your work together, as prints laid out, or thumbnails stacked on a screen for example, which can be helpful to visually observe your own trends in using color, light, tone and composition, laid out as a visual tapestry.

List ten things—whether these are other photographers, other kinds of artists, films, music, literature. For each thing, say what inspires you about it. But also, be aware of aspects of each item that don't necessarily inspire you so much. You will have favorites, which are attractive to you for a reason (an easy but interesting task is to review the pictures on photo-sharing sites that you've added as favorites). The relationship between the inspiration and yourself is unique—because there is an aspect you choose to highlight above all its others. In the end, you have a shopping bag of your own chosen parts of those inspirations. Once you realize what it is about something that inspires you, you can make sense of the component ingredients that go into the production of your own work.

INTERNET EXPOSURE

Sharing your photos online on websites such as Flickr, 500px, 1x, and PurePhoto can be beneficial to personal growth and yet is different, in my opinion, from having a website. Photo-sharing is something you can do from day one, because it has the appearance of a "work in progress," studio-like context, where you can build your work, and in fact, build your own identity as a photographer. They can also form the basis of a peer group for mutual support and a sense of community from like-minded photographers. I found Flickr tremendously useful for both of these reasons: watching my work grow and figuring out where to take it, and gaining feedback from others that have given shape to my identity as an artist. However, I do recommend taking a step back from the culture of photo-sharing at regular opportunities, because sometimes the commentary from people on such websites can be misleading: either by being overly positive, or too shallow. The online audience congratulate the consistent, which may help you maintain a style, but won't help you diversify. Overall, the noise of an online audience speaks louder toward emotive, melodramatic images which might not be in line with your style or your direction, and may bias your reception unfavorably or favorably. Most people online are impressed by spectacular visuals than conceptual content, so while you might get a lot of feedback on your technical skills, you might not get so much about the actual content of your images. Because most of the audience are non-photographers or amateurs seeking to become photographers, there is a leaning towards the "how" over the "why" which won't necessarily help you to strengthen the deeper dialogue within your work. You want to strike a balance between following the vibe you get from an online audience that can help you shape your visual "style," and following your own heart for the concepts you truly want to develop.

Photo-sharing is a form of marketing that anyone at any stage can benefit from, but it can be done without actually labelling or packaging yourself. That part comes when you put a website together in order to actively say to the world "this is me, this is what I do, and what I offer". First of all, do you have enough good

work to put together? You need to have a wide selection of work from which to pick a portfolio: if you find yourself scratching around for old school projects and "bits and pieces" such as a crude gathering of family shots or holiday photos, then it's likely you haven't done enough. You should hopefully know in yourself whether you are ready to put together a website and to call yourself a photographer. While photo-sharing demands little more than an avatar shot and an informal name, a website will involve giving yourself a professional name, a portfolio of images, a CV or client list, and other credentials such as press clippings to stamp your name as a substantial photographer. When you're starting out, you won't have many credentials, but it's a matter of putting together the most interesting information and keeping it minimal. No matter how many credentials you do attain during your career, your pictures should always do most of the talking (of course, the professional photography and art worlds won't always prove that principle right, and you will find there is often more attention paid to accolades: exhibitions, awards, publications, and so on, than to the work itself).

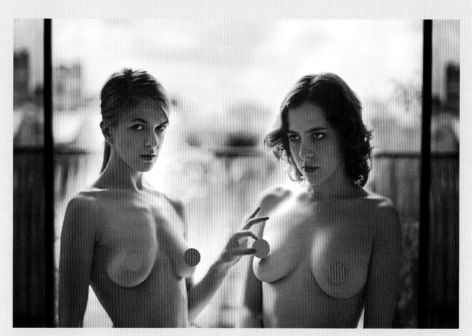

See pages 94-95

FINDING MODELS

Professional models can be a delight to work with. They are experienced in being directed, posing, and moving, and are often the most reliable as they are backed by an agency, who scout and represent a refined group of professional people. However, not everyone has the budget to afford to pay an agency to hire a model, and indeed, unless you are doing a portrait or fashion commission where the budget allows for it, there are other advantages to sourcing models through other independent means. For many of my own shoots, I source my own models through casting websites and word of mouth through networking (a website I use often to place casting calls and source models is Model Mayhem, there are also many other alternatives.)

The first and most important reason for searching independently is that I want to have my own agreement with my models, and if the shoot is a workshop, it is important that all my clients have their rights released too. When a shoot is paid, it is straightforward enough that the pay is given in return for the model's work and their signing of the model release. In other cases where the shoot is not paid, it is particularly important to clarify what the model will get in return, which is most commonly images from the shoot to use for their portfolios (TFP or TFCD; time for prints or a CD of images). I always contact models beforehand to check they are happy to sign a release for whatever we've agreed they are receiving in return, even if the shoot is spoken cheerfully of as a "collaboration," because I always wish to know that I can use the images afterwards for a variety of potential purposes without problematic strings going back to the subjects in the images.

Sourcing models independently is a good way for photographers to gain experience shooting portraits. Another way that emerging photographers gain subjects to shoot with is through testing new models from agencies or by contacting them for a list of their newest models. Plenty of emerging photographers practice photography this way which also opens the doors for potential networking. However, if you wish to have the freedom to use the images for commercial purposes afterwards (for example to sell them as stock, to sell prints, or to publish them), then it is important to note that a model release will be needed, and the agency will likely have restraints set on the usage unless you negotiate your own worded release. It is generally trickier to acquire full rights to images of models through agencies, which is why I prefer to source models directly. Sourcing independently also means you have direct contact with the model. The control this offers can be a good thing, although going through an agency ensures the professionalism of a company who can offer assurance and a back-up. When I contact a model directly, I always ask for recent images and I also speak to the model on the phone beforehand so that human contact is established, and I have backups planned.

MODEL RELEASES

I always prepare model release(s) for a shoot and show the models a copy beforehand. The release needs to state that the rights to the images are completely released to the photographer, without any further claim from the model for compensation beyond that agreed. You can find a template model release with a quick search online, which will have all the necessary legal jargon you need; which you can extend and personalize as much as you need to. For example, if there is a specific usage that comes as part of the particular shoot—a book or magazine publication for example—I add those details details. You will need to specify which images the release refers to: either by writing the date of the shoot and its description, or inserting specific pictures later and having them sign it afterwards. Keep the whole document to just one page so that there is no disagreement over what was attached or not attached with the release.

CREATING A TEAM

Many of the same principles for finding models also apply to finding stylists, hair stylists and makeup artists (MUAs). Often for commissions, the styling team will be put into place by the client or agent involved, but you will find yourself looking for stylists too, especially if you want to start out shooting your own images. I often advertise for MUAs and hair stylists independently online, in the same way for models, stating the full details and what the stylist/artist will get in return (pay, pictures, credit or all three).

As exemplified in this book, a good team can make all the difference to a shoot, although at other times they can make a shoot more crowded than it needs to be. Most of my own work has been shot relatively independently, as I have most often used myself as a model. I enjoy being able to jump up unannounced and shoot something spur of the moment. More organization is needed when consulting the help of stylists, but what you get from the shoot can be greater in production value, especially when you get to know and use the same team who can work together smoothly. As this book has shown, the model can bring their own contribution to a shoot, sometimes even physical objects or clothing, or a stylist can do something unexpected and creative on the shoot, that becomes a happy addition to inspire you as the photographer and complement your final results. Working with a team means more work and management, but can reap rewards through fruitful contributions from the skills of the other artists.

COMMUNICATION

See page 116

On a shoot, good communication needs to continue between all of the team, so that your intentions for the shoot can be made possible amidst the collaborative development of the shoot on the day. In situations where you might not have a certain intention or are open to experimentation, you can openly invite the MUAs' and hairstylists' creative input, asking them to suggest a hair or makeup style for example.

Communication amongst the styling team and photographer, especially where unacquainted, can often be a challenge. The styling of a model can take a notoriously long time. The styling room has the tendency to become its own cosmos in which time runs more casually than in the studio itself, where the set-up awaits. Everyone wants their contribution to count, and hair stylists, stylists, and MUAs often have a perfectionist streak that may exceed the needs for the shoot at hand. As the photographer, the ball is in your court to keep things moving on time. You'll be the one paying for, or at least managing, the studio time, equipment, and indeed everyone else's time. It is up to you to be the ringleader. The team need to be aware of the purpose of the shoot, and exactly how much (or little) detail is needed in the preparation of hair and makeup. Make sure everyone knows when the models need to be ready, and allow for extra time, as styling almost always inevitably runs over. Always be firm when giving time limits and orders. At those times you will realize there is much more to photography than just taking photos!

When shooting, try to give verbal feedback to your model even if you are not entirely sure of the direction of the shoot. When I shoot models, I almost have a cloud over my head, perpetually wondering, trying to figure out what I want to do, waiting for a spark of inspiration from the model's poses and the surroundings. So, it's not often that I can give affirmative feedback to the model, as it's rare that I see (or at least, at that point, comprehend) anything close to the final concept in the camera. What I strive for are key images which I see as potential material for a final product. I still try to keep the model content and happy by speaking as much as I can, even just to show them a nice shot, and try engaging them with insight into what is developing in my mind. I have learnt to try and refrain from making promises I can't keep, however—sometimes I've described to a model something I would like to do with the image (for example, to make them appear to be floating), which gave me unnecessary personal pressure to produce that particular picture, where I didn't actually like the result. I later feel like I have given the model futile anticipation! Instead, I show them pictures I like, but which I might not yet know how I will use, which gives me the flexibility to use them in a variety of ways.

That is all my personal process. Other photographers may have more specific intention, know what they want during the shoot, and when they get it. For you, there may be a more direct benefit in showing the model images on the LCD screen or on-screen in tethered shooting, so they get an understanding for what you are setting out to achieve.

EXHIBITING

Exhibiting your work can come about in different ways. You may be approached by a gallery or a person wanting to help facilitate a show, or you may decide yourself to pursue an exhibition. Your debut exhibition will be your first experience of organizing your work for print and sale, and there are many things to think through, primarily in choosing a selection of work that the exhibition will be themed around.

From past experience, I would encourage any artist contemplating an exhibition to first give themselves enough time to produce a substantial body of work from which they can choose the best selection. Even those images that we call "finished" and complete—those which we may have been proud of at the time—can become the most mediocre when contextualized alongside work from the whole of the year. The superlative "best" is given its rightful place: not the "best" of one shoot, or even a few shoots, but the "best" work of a year, or even years. That is not to say that you should put off your first exhibition for too long out of fear or insecurity, or the other worst enemy of the artist—procrastination. You should allow yourself a healthy period of time, within which you can realistically produce a good amount of work according to your own workflow, which you can then shape to help establish a target of when to expose a set of work.

The aim of an exhibition should never be perfection, so there is little risk in having an exhibition too early. An artist's attitude to their work is constantly changing: you might print an image today that next month you don't consider to be as strong as you thought. Even if you exhibited ten pieces that you later decided were a weak selection, it's unlikely that the exhibition would have gained so much exposure as to commit your name to those images and that style forever. What I do want to convey is the importance of the work and content coming first, then the "exhibition" in good time afterwards: while it is certainly good to have a goal to aim for, it is best that the aspiration of exhibition is not distracting to the point of debilitation, of the production of the artworks themselves.

It is also important to plan out how you wish to sell your work. It is widely accepted in the art world that photography is sold as limited editions, of a certain number for a limited set of well-differentiated sizes, which are numbered and signed and not exceeded. Per edition there can also be any amount of numbered "Artist's Proofs" that are priced higher than the edition cost, sometimes limited to clients buying for collections. These are the bare bones to the "rules," if there are indeed any, of selling photography as art: but the decisions on how many editions you sell, the sizes at which you print, the paper, and the price of your artwork is all down to you to decide—perhaps with help from a gallery if you are working with one, general research of the area and market to which you are selling your work, and advice from other artists who know your work.

Exhibitions are usually in the form of a series of works, so even if you haven't worked to a series, it will become somewhat necessary to fashion one. Often the gallery will help shape this or even just assemble a group of works with the artist name as the title. It is important that you have a say in which works are exhibited, not just because it is your exhibition and your representation in the show, but crucially because you will be the one paying for the printing, as well as potentially other costs related to show, such as framing for example. A gallery show is not all the glamor that it may appear to the outsider: there is hard work involved, mostly involving communication between gallery and artist. There is also money that is spent on both sides without guarantee of return, and a high likelihood of unsold prints that will need storage afterwards.

A successful exhibition can be any one or more of the following: a show which generates press about the artist and their work; a show which raises local, national or even international exposure through the press coverage; a show producing print sales which give the artist their first satisfying taste of making money from their art, and thus the feeling that their art is enriching the lives of others; a show which attracts interest from visiting gallerists and curators for future shows; a permanent asset to your CV to improve your image as an accomplished artist and to attract further exhibitions; and simply the experience which can be used to influence bigger and better shows in the future.

There will always be things to look back on with a wiser eye, aspects to improve upon, and mistakes to be learned from. Look not upon exhibiting as something that must achieve perfection; it is merely an event that is not set indelibly in stone for all to see, but from which it is easy to extract the positives and airbrush away the negatives.

COMMERCIAL WORK

To pursue commercial work it is crucial to put together a portfolio of your best work, but of the work that is most relevant to the kind of client to whom you are showing it. This gets trickier the broader your style tends to be. In my own portfolio, there is a general separation between my fine-art work, and my commercial and fashion work. I have found myself in a meeting showing my commercial portfolio, followed immediately by a meeting in the same room requiring the swift production of my fine-art portfolio, warranting a whole new presentation of myself. It is widely accepted that the two are completely separate arenas that need to be marketed carefully as such: taking one to a meeting with a gallery, and the other to a meeting with a photographic agent, magazine editor or photography commissioner.

However, it is not always so straight down the line. With so many photographers out there, gaining work is all about standing out, and about getting someone's attention in order to take the initial introduction or phone call to a meeting, to a rapport, and to potential work. Much of your appeal to clients will be in your fine-art work, and it is ironic that a lot of commercial photographers find attention arising from clients attracted to the idiosyncrasies in their personal work. That does not mean the work

See pages 72–73

commissioned will demand such a style or quirk, but it is the personal work that becomes the "hook." However, it's not the same with everyone and certainly in some cases, the personal work may even put off a potential client because they feel the photographer is unsuitable, out of their reach in terms of budget, or simply not "safe" enough for the needs of what could be a straightforward studio portrait commission.

There are no hard and fast rules about gaining work, or acquiring an agent to gain work. The first thing any photographer should learn is that there are no rules in photography at all. Indeed, throughout life we must endure imbalances and seeming injustices, and the role of sheer luck and happenstance. The conflict of art versus business in the life of a self-employed (or partially self-employed) photographer is not easy. Photography as an industrial landscape is forever shifting, primarily because of technology: the rise of digital increasing the volume that is produced, and the evolution of the Internet affecting the amount entering the "public space" and the speed and magnitude at which it can be shared. In summary, the price of photography is falling, threatened from multiple angles, from recession-related budget cuts across the photography-commissioning industry, to the low-cost or even free dissemination of stock photography which replaces the need for commissioned photography. The lives of professional photographers and accepted standards in photography have changed beyond recognition from one decade to the next, and are constantly reshaped from year to year. Observe shifts in accepted styles in photography, including the rise of trends that laud intentional amateurish techniques, and what is considered fashionably empty or flawed craft. This means a broader range of emerging photographers are accepted into the ever-widening pack of available photographers vying for any one job. I, myself, am testament to the way the Internet and digital photography has reinvented the wheel of the trade. Without those assets I would not be a photographer today. I cannot imagine doing anything not related to creativity and photography has been my most desired medium; however, while I encourage anyone with the same passion to pursue it, I would not pretend it is easy, or take the prospect of this livelihood lightly. Go into it with enough cynicism to know what to expect, but with enough passion to turn heads.

INDEX

ARTISTS' DIRECTORY

MISS ANIELA
To see more of Miss Aniela's work and books, and read about her exhibitions, workshops and events, please visit www.missaniela.com and feel free to say hello at contact@ missaniela.com.

To find out about joining one of Miss Aniela's international events, the Fashion Shoot Experience, please see www.fashionshootexperience.com.

CONTRIBUTORS

KIRSTY MITCHELL
http://www.kirstymitchellphotography.com
PETER KEMP
http://www.peterkemp.nl
SUSANNAH BENJAMIN
http://www.flickr.com/ireland1324/
BROOKE SHADEN
http://www.brookeshaden.com
ALEX STODDARD
http://www.flickr.com/alex-stoddard

MODELS FEATURED IN MISS ANIELA'S WORK

Andria Aletrari	Maria Procopi
Anna Sychiova	Mette Tonnesson
Ariana Diamantopoulous	Olivia Clemens
Ayla Selamoglu	Rossina Bossio
Bella Grace	Ruby True
Brooke Shaden	Samantha Jane
Chrystaline Lukman	Sammy Pearce
Cipriana Sequeira	Sandra Ngu
Grace Gray	Sofia Carr
Holly Gibbons	Sophia St Villiers
Jane Rapin	Tim Andrews
Janelle Mcpherson	Visions of Trees (Joni & Sara)
Kassy Cunningham	Yen Guo
Katie Johnson	Zane L
Little Twiglet	

IMAGE CREDITS

AKG Images: p41 (left).

ACKNOWLEDGMENTS

- Thank you to Adam Juniper, Zara Larcombe, Tara Gallagher, and all the team at Ilex for all their hard work and for making this book possible!
- Thanks to all the models featured in this book, the stylists, costume designers, and assistants who contributed to the final results in each and every shoot, and to my collaborating contributor Rossina. Thanks to my contributors Peter, Brooke, Alex, Kirsty, and Susannah, whose work has gone toward making this book a colorful tome of positively creative portraiture and have survived my torrents of questions and emails.
- Thanks to Matthew Lennard for agreeing to completely take over the cooking duties, to leave me to cover the roles of "doing all the driving and writing the new book."
- A special thank you to "Lash" LaRue for inadvertently adding further passion to the writing of *Creative Portrait Photography* with his kind gift of the fantastic book *Art & Fear: Observations on the Perils (and Rewards) of Artmaking*, as well as his own invaluable words of advice. I also thank the writers of *Art & Fear*, David Bayles and Ted Orland, as they have instilled confidence in me with regard to my own processes as an artist and inspired me during the creation of this book.
- And thanks to you, the reader, for taking an interest. I wish you the best in going on to create wonderful and artistic portraiture.

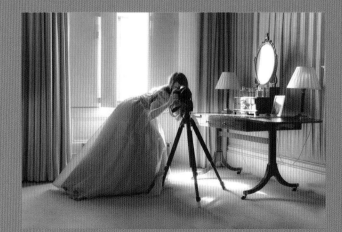

COSTUME DESIGNERS

Ara Jo	Marina Brenere
Arisa Fukumoto	Stephanie Grace Foy
Joanne Fleming	Vesna Pesic
Lenka Padysakova	Wolfgang Jarnach